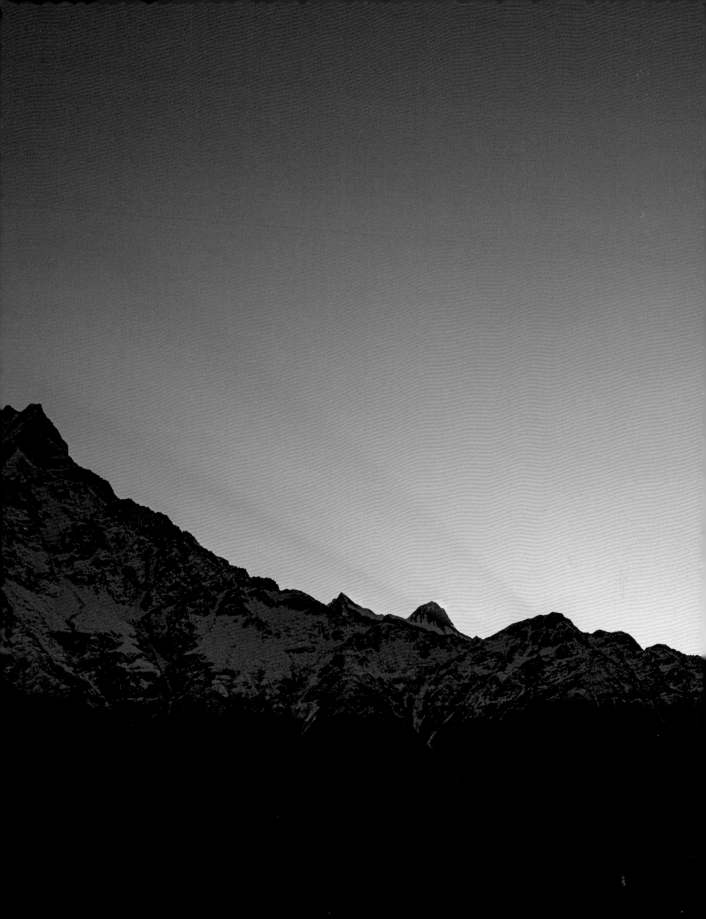

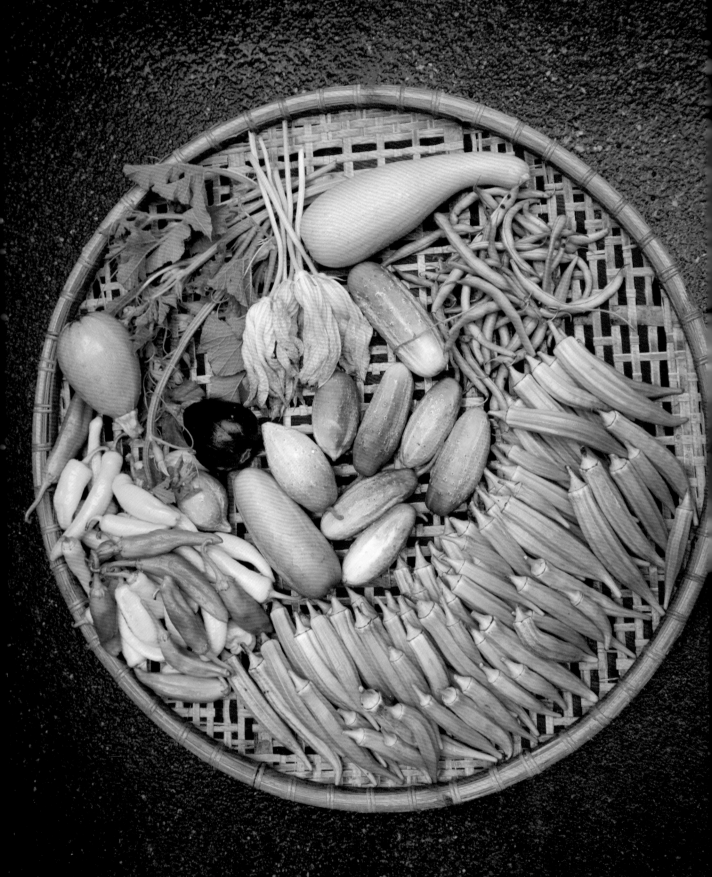

PLANT-BASED HIMALAYA

38 VEGAN NEPALI DISHES FOR A HEALTHY LIFESTYLE

COOKED, PHOTOGRAPHED, ILLUSTRATED,
WRITTEN, AND DESIGNED BY

BABITA SHRESTHA

RED ⚡ LIGHTNING BOOKS

This book is a publication of

Red Lightning Books
1320 East 10th Street
Bloomington, Indiana 47405 USA

redlightningbooks.com

Manufactured in China

ISBN 978-1-68435-192-3 (hdbk.)
ISBN 978-1-68435-194-7 (web PDF)

First printing 2022

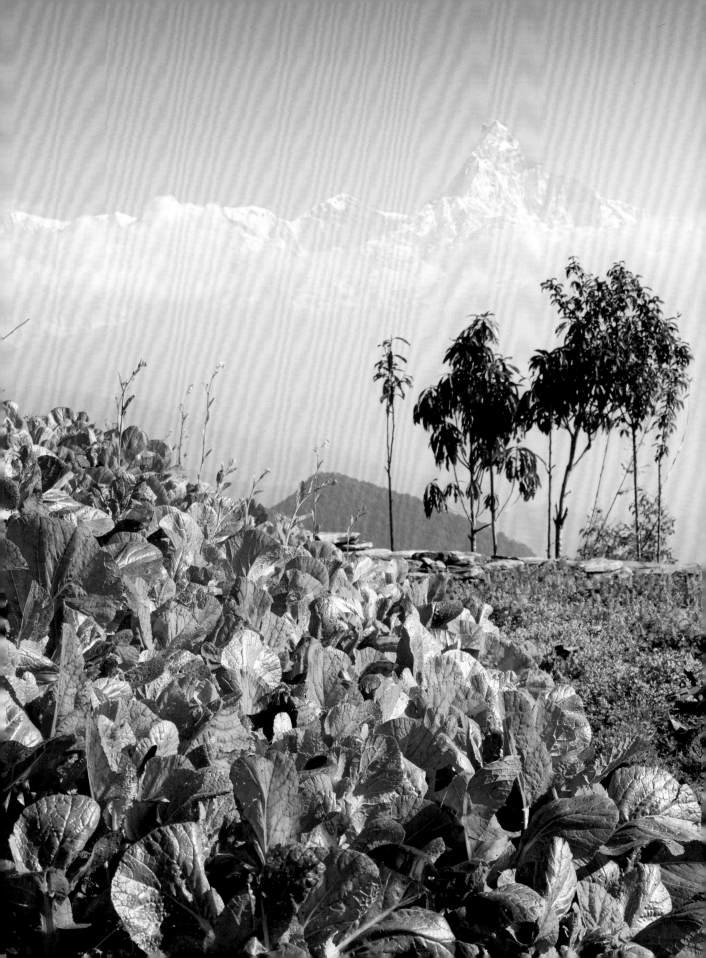

CONTENTS

Preface | Namaste!
Acknowledgments
Introduction to Nepal

Recipes

NAMASTE,

Thank you for choosing Vegan Nepal's first book *Plant-Based Himalaya*. I hope this book will help guide you toward a healthy eating lifestyle.

I handpicked 38 of my favorite recipes to give your taste buds the treat of a lifetime. This book will help beginning cooks, professional chefs, and all you foodies out there to expand your palate beyond your usual fare.

Cooking is about loving yourself and spreading that love to those around you. It is great therapy for staying happy and delighting others. Fewer and fewer people cook every day, settling instead for unhealthy processed food. This decreases overall well-being and at the same time increases the wasteful use of plastic packaging, most of which will end up in a river or ocean or polluting our farmland and ruining our natural paradises. Wherever possible, I use plastic-free ingredients in this book. I hope you will enjoy the food that results!

I give you a short tour of Nepal at the beginning of the book, but then it's on to the recipes. *Plant-Based Himalaya* is designed to inspire you to cook and eat exquisite and unique vegan home-style Nepali cuisines made with passion. Make an exceptional mean and share with your loved ones!

Yours Truly,

Babita Shrestha

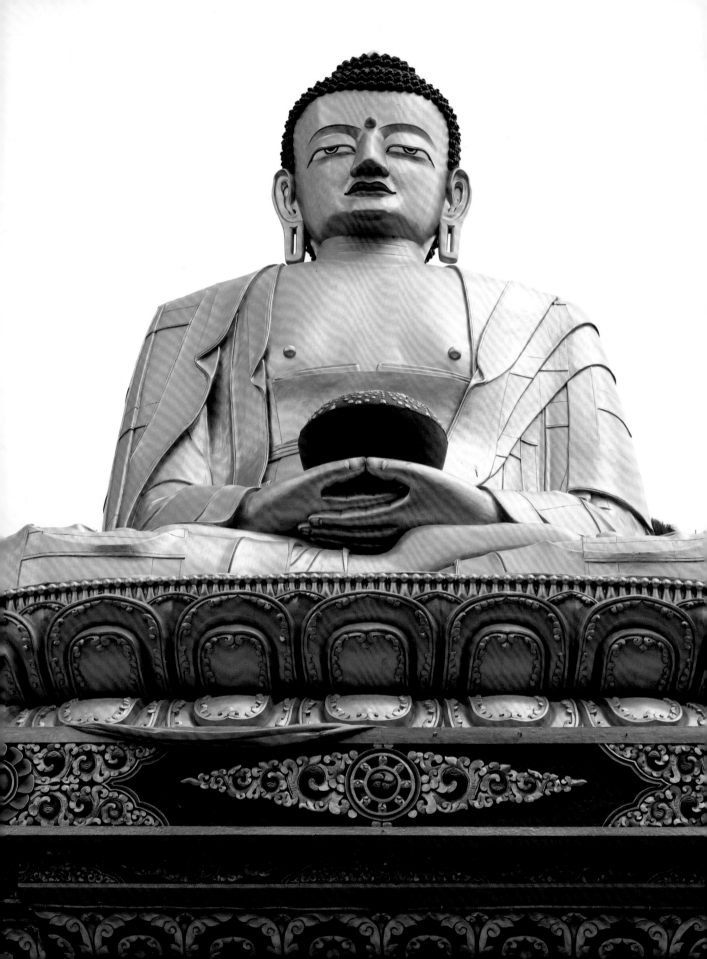

PLANT-BASED HÌMALAYA

Grow Real Food

Food That Makes You Happy

Cook Real Food

Food That Will Heal You

Eat Real Food

Food Directly From Plants

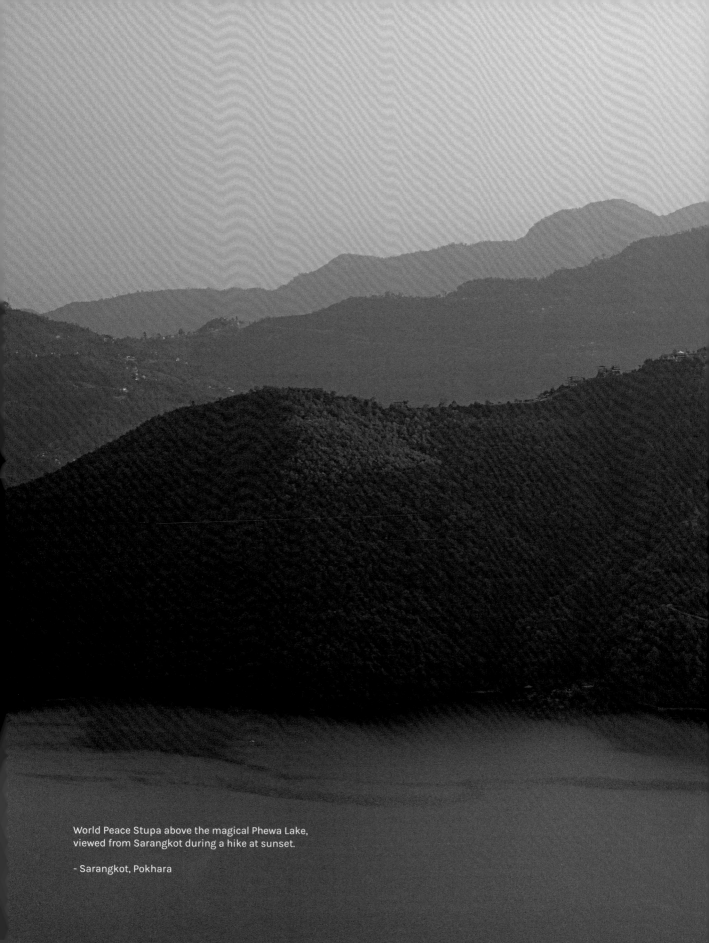

World Peace Stupa above the magical Phewa Lake,
viewed from Sarangkot during a hike at sunset.

- Sarangkot, Pokhara

INTRODUCTION TO NEPAL

Nepal is an ancient country of pristine landscapes in Southeast Asia, situated between India, Tibet, and China. Due to its wide range of geographical features, it is richly endowed with agro-biodiversity. Nepal is also a melting pot of various cultures, every group having individual traditions and cuisines.

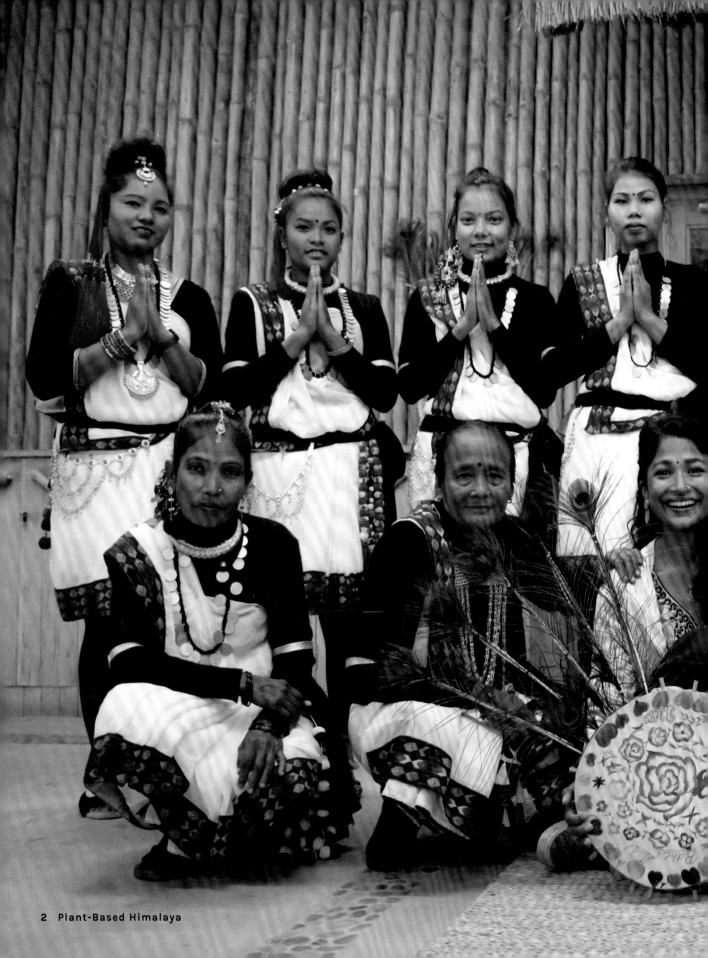

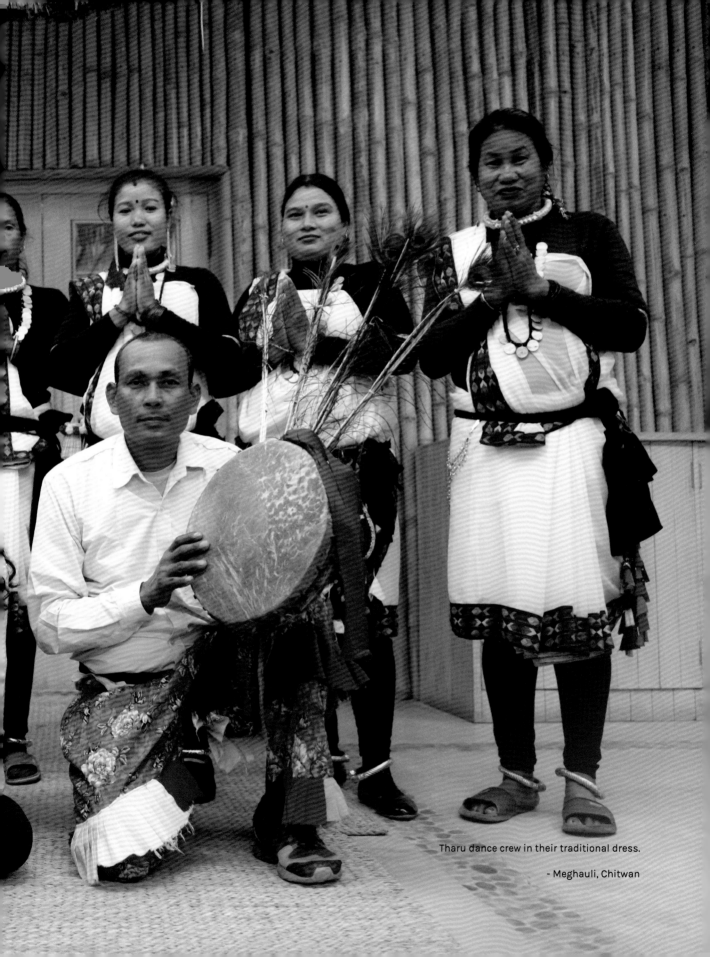

Tharu dance crew in their traditional dress.

- Meghauli, Chitwan

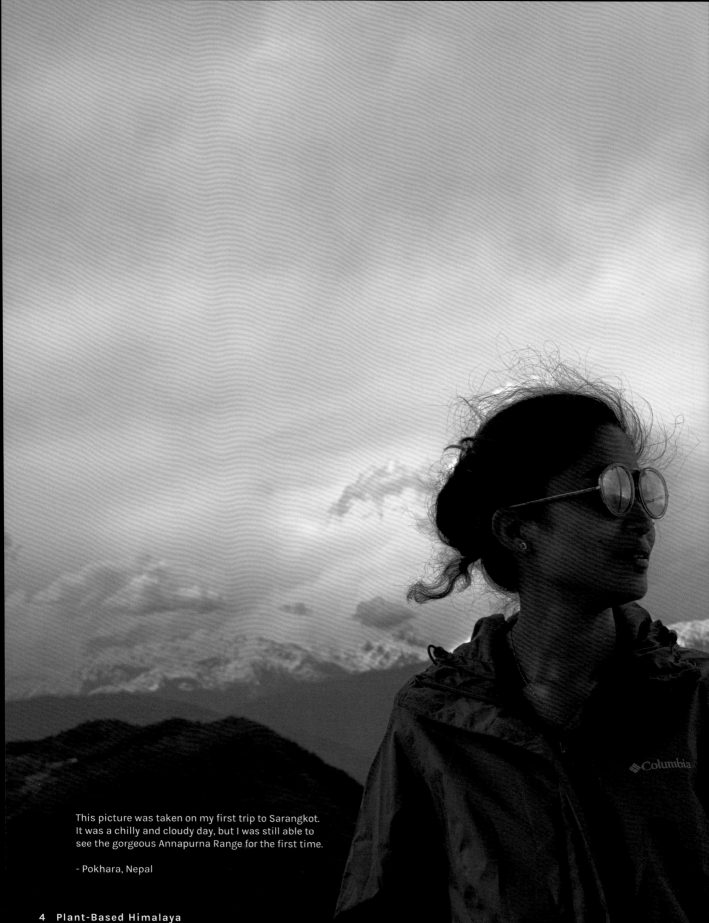

This picture was taken on my first trip to Sarangkot.
It was a chilly and cloudy day, but I was still able to
see the gorgeous Annapurna Range for the first time.

- Pokhara, Nepal

GEOGRAPHY

Nepal is divided into three different regions that stretch alongside each other from one end of the country to the other: Himalaya, Pahad (Hilly), and Terai. With terrain ranging from snow-capped peaks and crystal-clear glacial lakes to lowland rice paddy fields, dense forest, and arid canyons, to say Nepal's geography is diverse is an understatement.

HIMALAYA

The Himalayan region of Nepal covers about 15 percent of the country's total land area. It also has the smallest population of the three regions due to the cold weather and a smaller amount of farmland. Himalaya comprises more than 200 peaks that stand over 6,000 meters (m) tall and include the highest point in the world, Sagarmatha (now known as Mount Everest). People of Sherpa descent are the indigenous ethnic group of this zone.

This mountainous region of Himalaya is one of the most popular tourist attractions of Nepal, yet most of it remains unexplored and uninhabited because of extreme geographical features and harsh climate. Home to some of the most beautiful and rare animals in the world, this region is also blessed with exotic flora not found anywhere else on this earth.

Exclusive to the Himalayan region, the apples from Mustang are commonly known as the most delicious apple found anywhere in the world. It is my favorite.

HILLY (PAHAD)

Nepal's Hilly region has an unequaled range of landscapes amid towering mountaintops, rolling hillsides, deep valleys, extended flatlands, and even a sprawling metropolis. It covers roughly 68 percent of the country's total land, and about 45 percent of Nepal's population reside there. The Hilly region consists of many valleys as well as the temple city of Kathmandu and the lake paradise of Pokhara. Elevation in the region ranges between 600 m and well over 4500 m, encompassing some of Nepal's most amazing natural scenery and fascinating cultural sites.

Mostly people of Newar, Gurung, Magar, Chhetri, and Brahmin heritage populate the Hilly Region. Probably because it includes the economic hub of the country, this is also the culinary center of Nepal. Here it is quite easy to find many different fruits, vegetables, and grains as they appear throughout the year. The Hilly region is also known for preserving endangered species like red panda, leopard, bear, and several breeds of birds.

ERAI

Terai covers 17 percent of the total area of Nepal. It is situated at an altitude of 67 m–300 m and is crossed by many small seasonal rivers, most of which originate straight from the Himalayas.

The Terai region abuts India between Nepal's eastern and western borders. Most of Nepal's produce is grown in Terai. Paddy, wheat, pulses, vegetables, fruits, sugarcane, jute, tobacco, and maize are the main crops here.

Lumbini, the birthplace of Siddhartha Gautam Buddha, is in this region of Nepal. Also, Ram and Sita were married in Janakpur, where the historical Janaki Mandir temple is located.

For many centuries, Tharus have inhabited the Terai region. It also boasts some of the most diverse national parks, including Chitwan National Park, Nepal's most popular jungle.

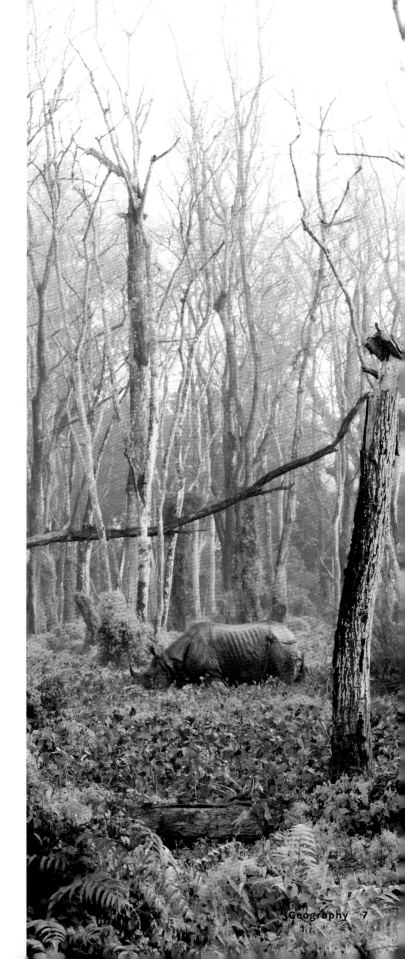

One-horn rhino in the wetlands of Chitwan National Park.

- Chitwan, Nepal

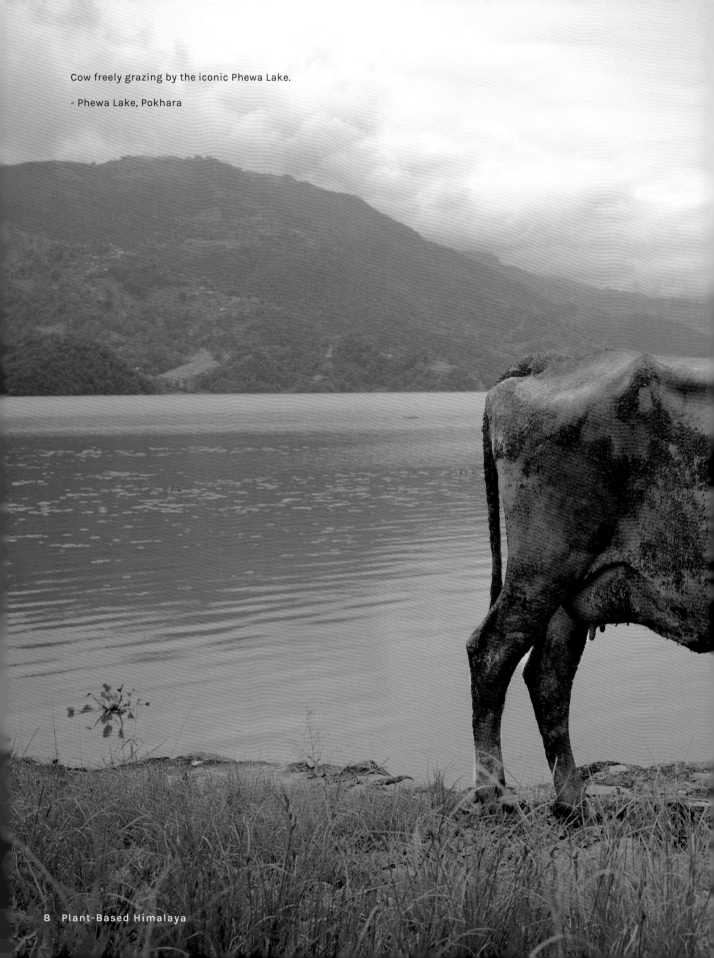

Cow freely grazing by the iconic Phewa Lake.

- Phewa Lake, Pokhara

BIODIVERSITY

The tiny country of Nepal contains microclimates ranging from subtropical to freezing. This gives rise to the numerous varieties of plants and animals that inhabit the landscapes. Most Nepali have an agrarian life style.

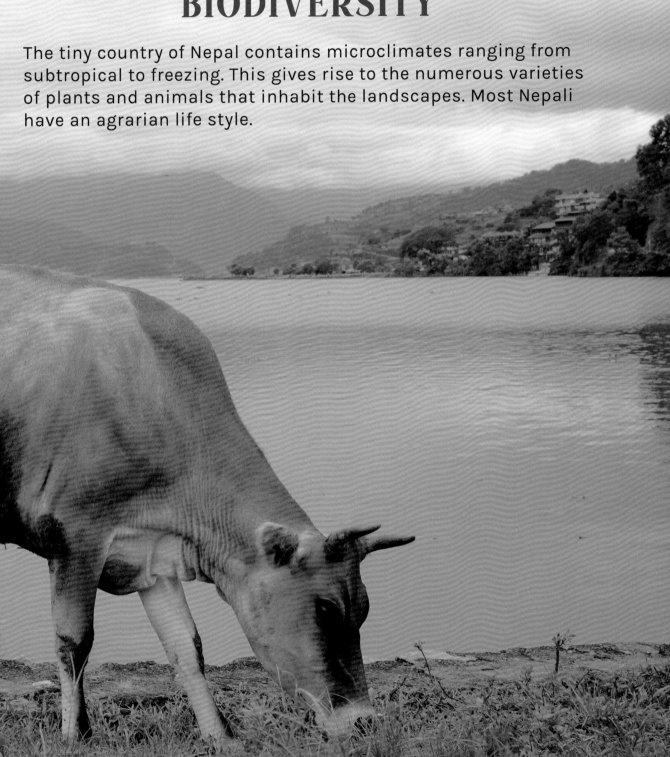

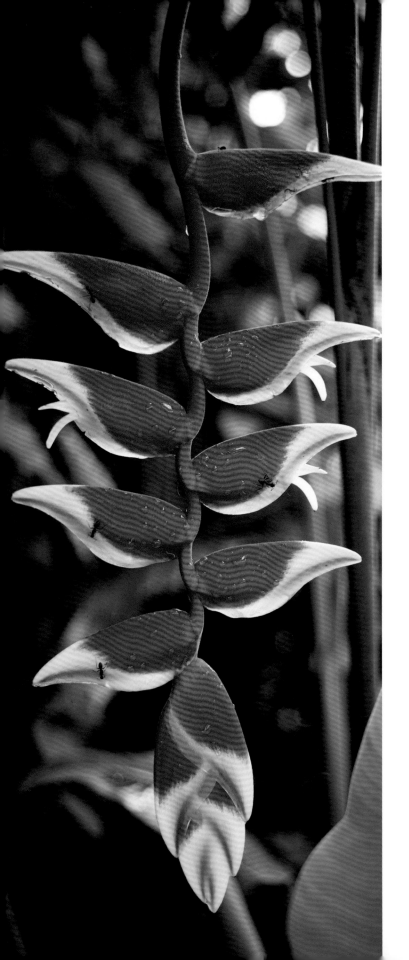

MICROCLIMATES

Numerous factors contribute to the broad spectrum of climates concurrently present in Nepal. Variance in altitudes, weather, temperature, and seasonal distinctions of the area all play a role. At 8,848 m, Sagarmatha is Nepal's (and the world's) highest elevation, while the former marshlands of Terai sit at just 60 m above sea level.

Nepal has four seasons, with the most difficult being monsoon season, from June to August. During this time, the weather is hot, and there is rain from torrential thunderstorms almost every day.

Pokhara receives more rainfall than any other city in the country. That is in stark contrast to the arid conditions of Manang, just 45 km away, which has the least.

This mixed bag of climates has made Nepal a heaven for the vegetable lover. A cornucopia of ever-changing produce cycles year-round, offering your palate tastes and textures that change with the seasons.

Heliconia (lobster claw), a native flower that blooms from summer to fall in Nepal's subtropical regions.

- Pokhara, Nepal

PLANTS

Beyond just gorgeous landscapes and an ancient cultural heritage, the Himalayas are famous for medicinal plants and nutritional produce. Many of the herbs and plants found in Nepal are used in traditional healing systems including Ayurvedic, homeopathic, and Amchi. Residing in this remarkable country are innumerable species of flowers, trees, root vegetables, and agricultural staples. Some of these flora are exclusive to the region and fetch a high price in foreign markets.

ANIMALS

Some of the rarest animals in the world find a dream habitat in Nepal. However, due to poaching, destruction of natural areas, overhunting, and climate change, many native creatures are now endangered. The black buck, pangolin, Asian elephant, snow leopard, gray wolf, wild yak, wild water buffalo, and red panda, are just a few of the Nepal fauna that are at risk of extinction.

The country's national animal is the cow, and the slaughter of cows is illegal in Nepal. To practice respect and kindness to this animal is to embody the concept of Ahimsa, which in Sanskrit means "nonviolence," an important component of Hinduism and Buddhism.

AGRICULTURE

The majority of Nepali citizens are directly involved in some form of agriculture. Although modern farming has been implemented in many places, some prefer to use ancient food-growing techniques that can be highly labor intensive. For the last several decades, farmers in Nepal have started using more chemical fertilizers and pesticides, with the goal of producing more crops per year. However, organic methods are still favored by most of the locals, especially when farming to feed themselves and their families. I love that it is so easy to find fresh, seasonal, homegrown, farm-to-table vegetables and other produce all year-round in Nepal.

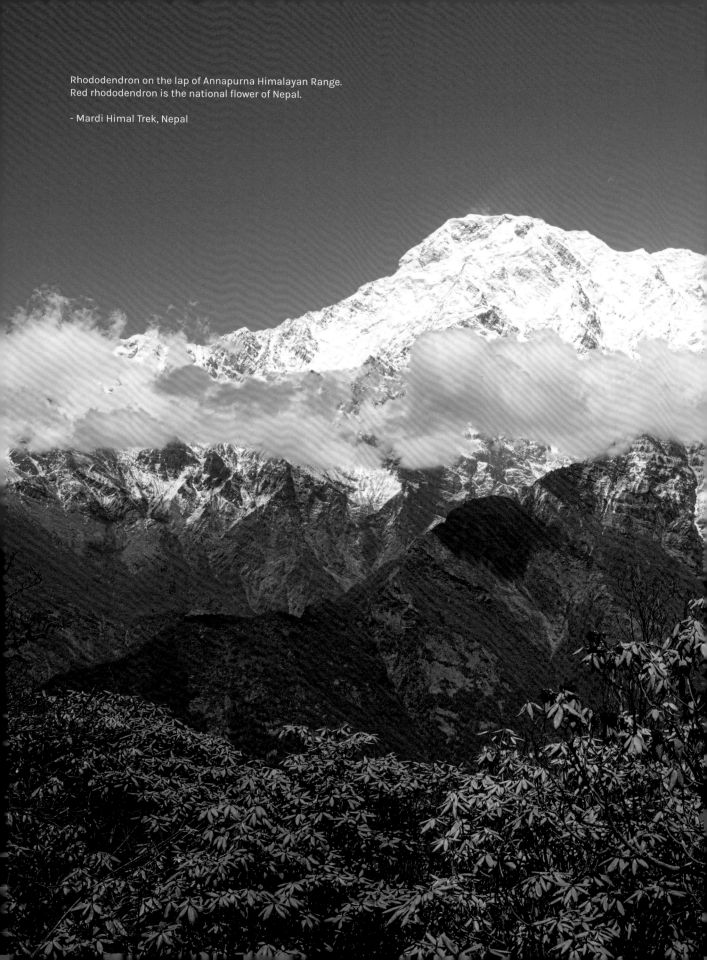

Rhododendron on the lap of Annapurna Himalayan Range.
Red rhododendron is the national flower of Nepal.

- Mardi Himal Trek, Nepal

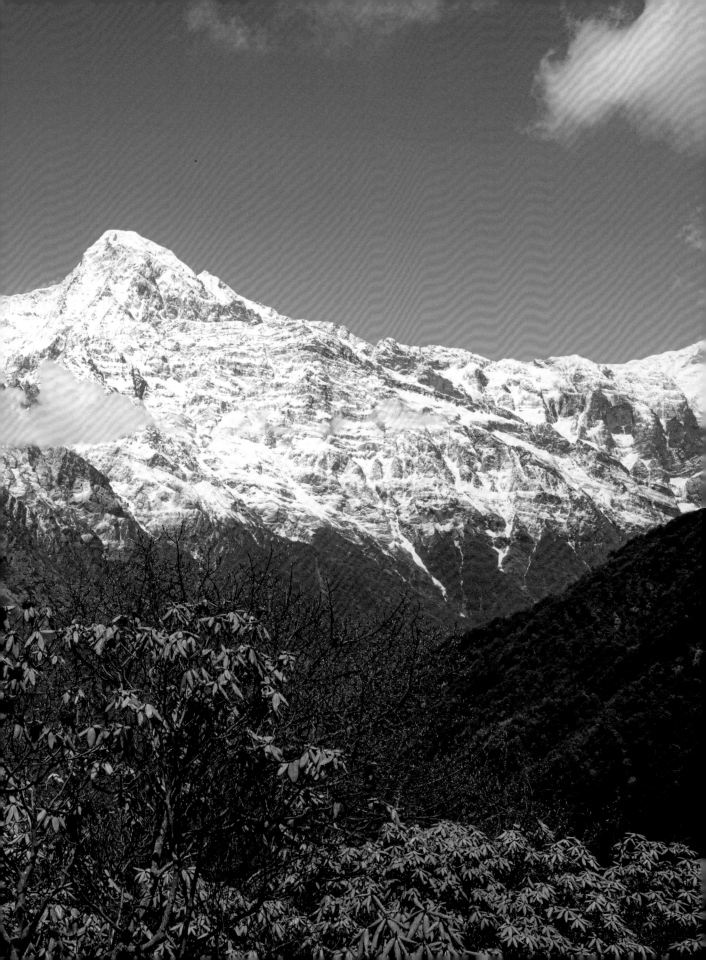

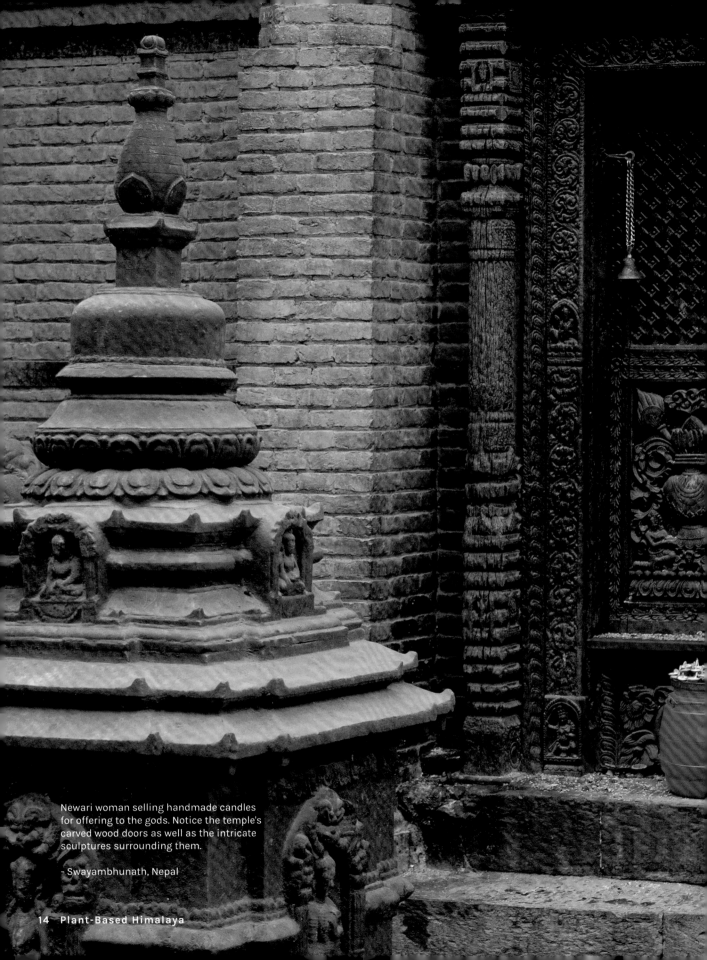

Newari woman selling handmade candles for offering to the gods. Notice the temple's carved wood doors as well as the intricate sculptures surrounding them.

- Swayambhunath, Nepal

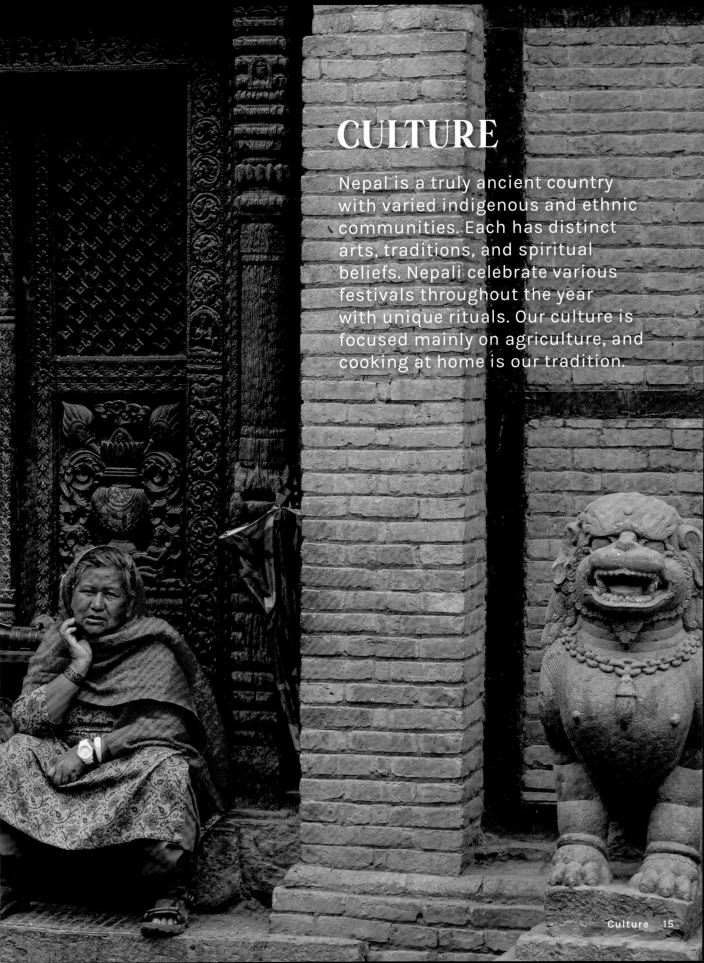

CULTURE

Nepal is a truly ancient country with varied indigenous and ethnic communities. Each has distinct arts, traditions, and spiritual beliefs. Nepali celebrate various festivals throughout the year with unique rituals. Our culture is focused mainly on agriculture, and cooking at home is our tradition.

ETHNICITY

Nepal's multifaceted heritage encompasses various ethnic, tribal, and social groups living throughout the country. This is quite evident when exploring Nepal's various forms of music, art, craft, folklore, language, spirituality, and most importantly, food!

RELIGION

Most Nepali customs are descended from Hindu and Buddhist traditions, although often there are many correlations to traditional shamanic practices. These belief systems have coexisted in harmony for centuries.

FESTIVAL

The shining jewel of Nepali culture is most assuredly its festivals, with more than fifty celebrated annually. While national festivals always have fixed dates, religious holidays are set by astrologers following the lunar calendar. The best part is that all the events are celebrated with the same enthusiasm as hundreds of years ago when people had no other means of entertainment. People adorn themselves with unique national costumes during different festivals. Selroti (fried rice doughnut) is very popular during Dashain and Tihar festivals.

HOME COOKING

The home-cooked meal is an integral part of Nepali culture. Nepali still enjoy eating homemade meals every day. There is not one distinct cooking style. Instead, authentic Nepali food showcases flavors from Newari, Tharu, Gurung, Rai, Limbu, and Thakali cuisines.

Dal (lentil soup), bhat (rice), and tarkari (curry), generally accompanied by achaar/pickle (sauce), are the staple foods of Nepal and comprise the "Nepali set." Nonetheless, momo (dumpling) is king and is easily the most popular dish.

Each area has its specialties. The lowlands of Janakpur are heavily Indian influenced, and so samosa (fried potato pastry) and chatpatey (puffed rice salad) are common there. Bara (black lentil pancake) is the primary Newari dish and is popular in Kathmandu.

Beyond just cooking at home, most Nepali even have their own garden. Most of their produce is extremely fresh, and they prepare meals according to the seasons.

Sculpture of standing Buddha located in Swayambhunath (Monkey Temple). This World Heritage Site is a spiritual oasis surrounded by the chaotic brick city.

- Kathmandu, Nepal

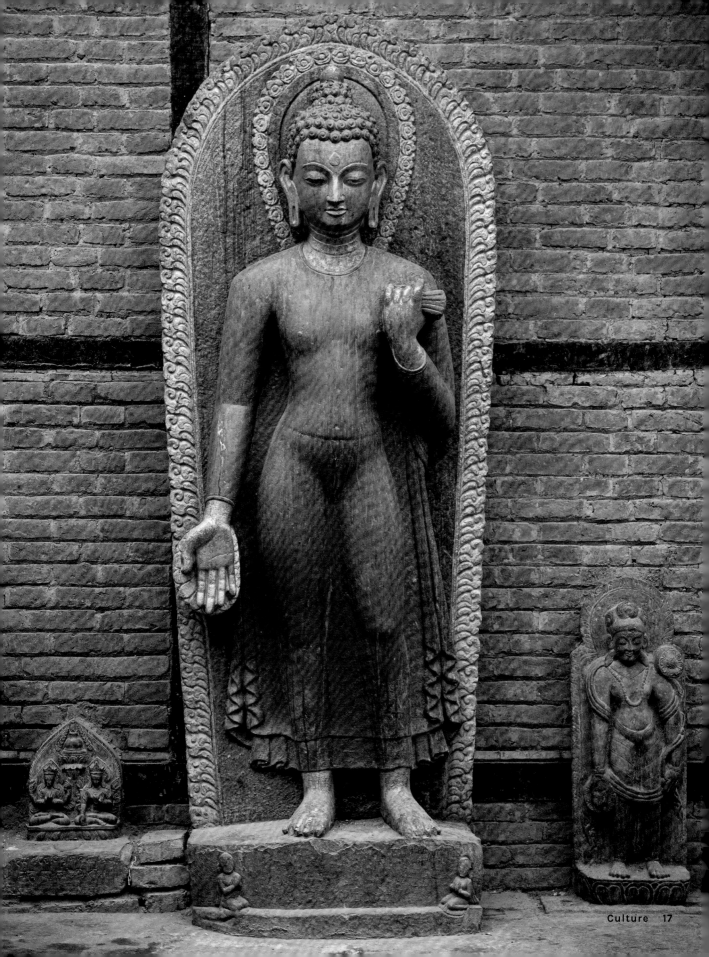

Khandeko Achaar (Fermented Pickle)

Tarkari (Curry)

Achaar (Pickle)

Dal (Lentil)

What Is a Nepali Set. ?

The traditional combination of dal (lentil), bhat (rice), tarkari (curry), saag (greens), and golveda ko achaar (tomato pickle) is referred to as a"Nepali set." There are innumerable variations, but it is central to Nepali cuisine. It is a plate full of fresh and seasonally grown produce packed with flavor. Often a fermented radish pickle and a khaja (snack) are included as well. On the side, a small selection of raw vegetables such as carrot, cucumber, onion, tomato, green chilis, radish, or lemon is also added to garnish the plate.

Saag (Greens)

Snacks (Khaja)

Bhat (Rice)

Fresh Raw Vegetable

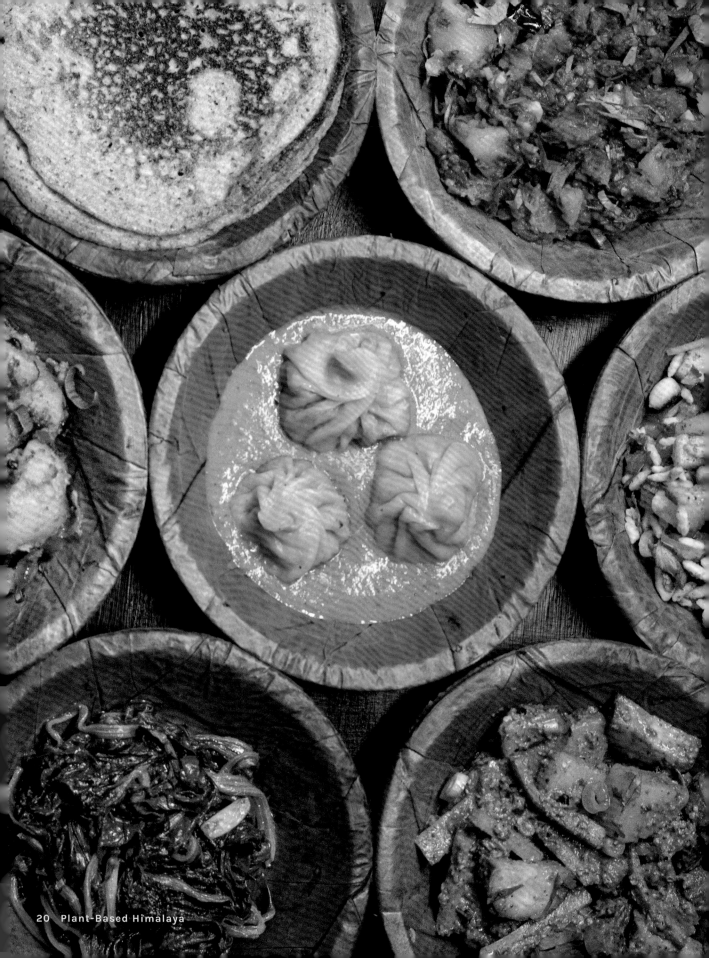

RECIPES

चिया

Chiya

Teas

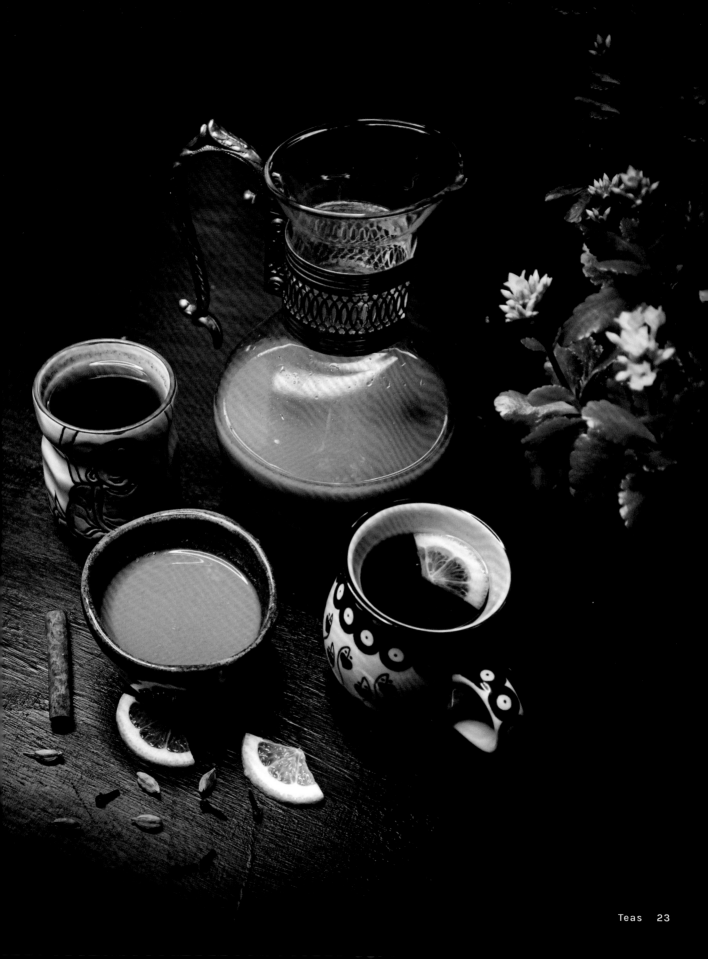

Tea is a brewed aromatic herbal beverage. For centuries, people from all over the world have been drinking tea because of its health benefits, and Nepal is no different. Nepali brew black teas mainly from the leaves of the **Camellia sinensis** plant. The Illam district is very famous in Nepal for its hills of aromatic tea gardens. Nepali drink tea in their morning rituals.

मसला चिया

MASALA CHIYA

Spiced Tea

Growing up, I drank masala tea made with fresh buffalo milk every morning. Now I recreate the vegan version with savory coconut milk whenever I need to relax and take a break.

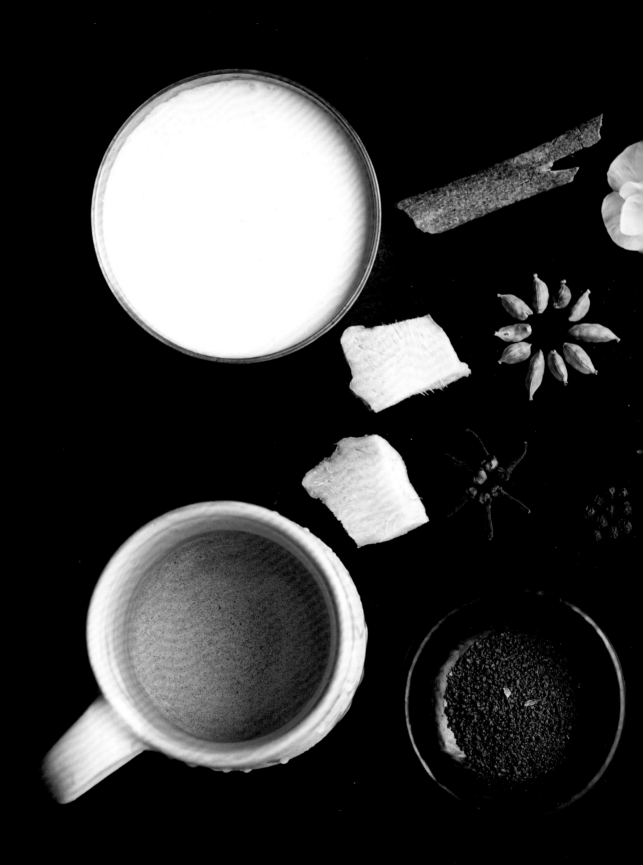

SERVES ~ 2
COOK TIME ~ 15 minutes

INGREDIENTS
Water: 2 cups
Tea leaf: ½ tbsp
Coconut milk: 1 cup
Sugar: 3 tsp

SPICES
Ginger: 2 slices
Clove: 6 buds
Cinnamon: ½ stick
Cardamom: 10 cloves
Black pepper: ⅛ tsp

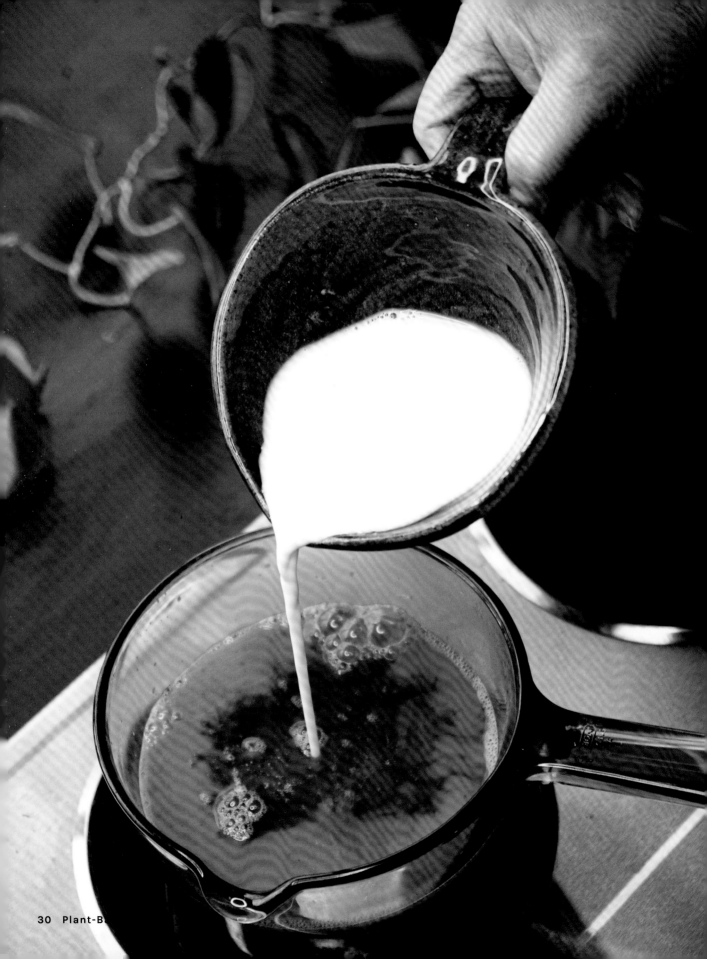

STEPS

1. Boil 2 cups of water in a pan.

2. Grind all the spices with a mortar and pestle and add them to the water.

3. Once the water boils, add the tea leaves, lower the heat, and continue simmering for 5 minutes.

4. Add coconut milk and heat on low for 5 more minutes.

5. Let the spices, water, and milk blend together until they are a rich brown color.

6. Strain the tea into your favorite cup.

7. Enjoy it with beautiful company and music.

QUICK TIPS

- *Tea is called* chiya, *while* masala *means spices in Nepali. Thus, tea with spices is called* masala chiya.

- *You can also make this tea with individual spices. They have different flavors, and I enjoy them all. Ginger and cardamom are my favorites.*

- *Add your preferred type and amount of sweetener.*

- *You can also make iced tea by brewing the tea and cooling it down. Add ice and chilled coconut or almond milk. It tastes fantastic! You can also keep the black tea in the refrigerator for a few days and make cold iced tea when needed.*

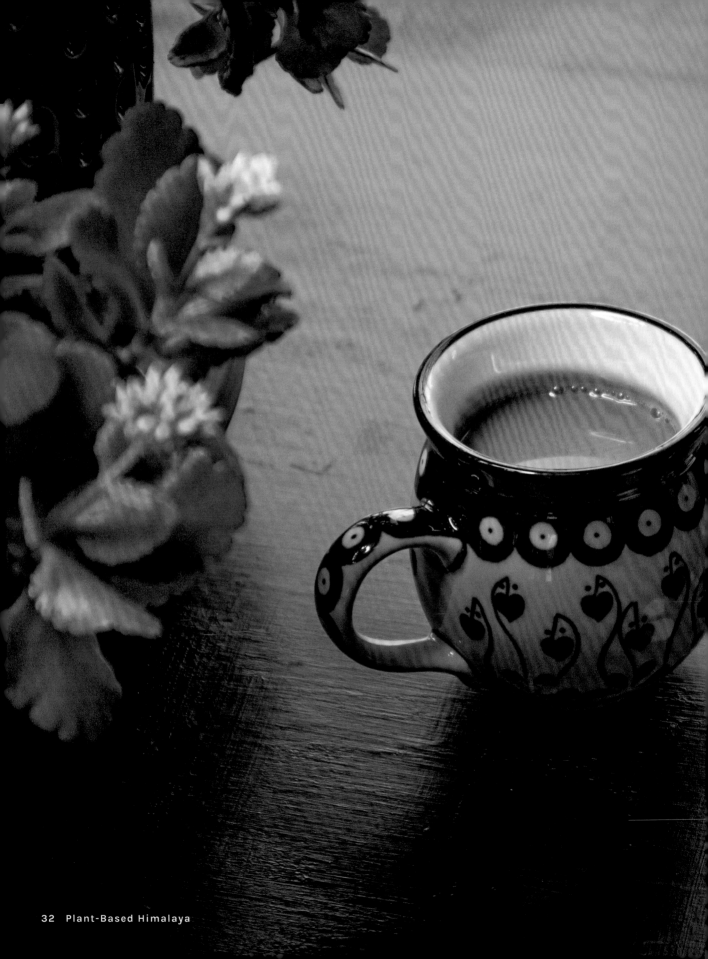

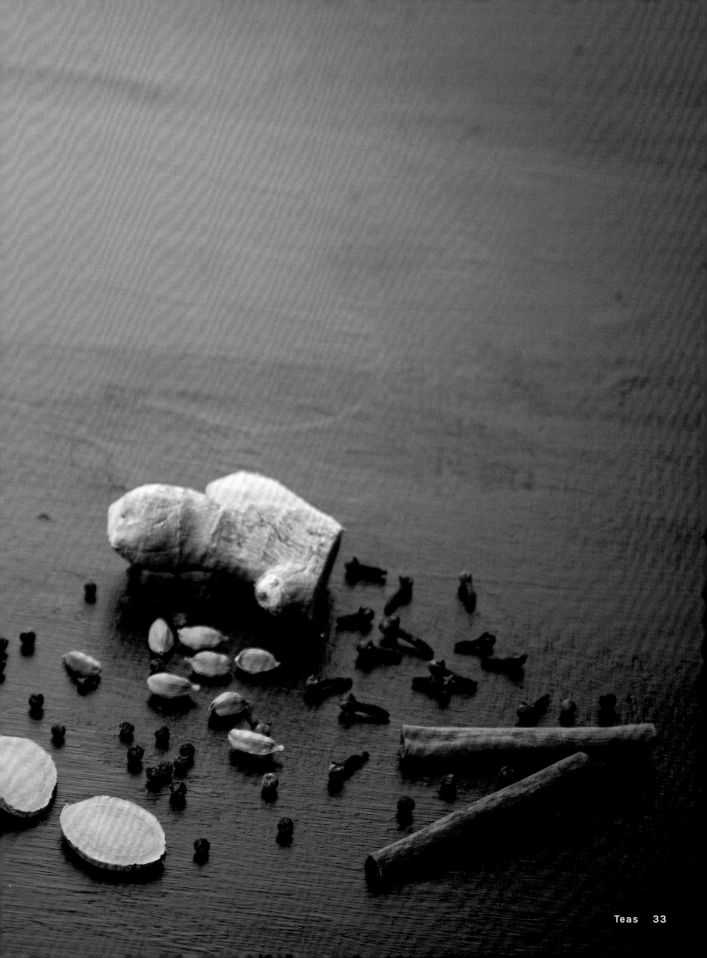

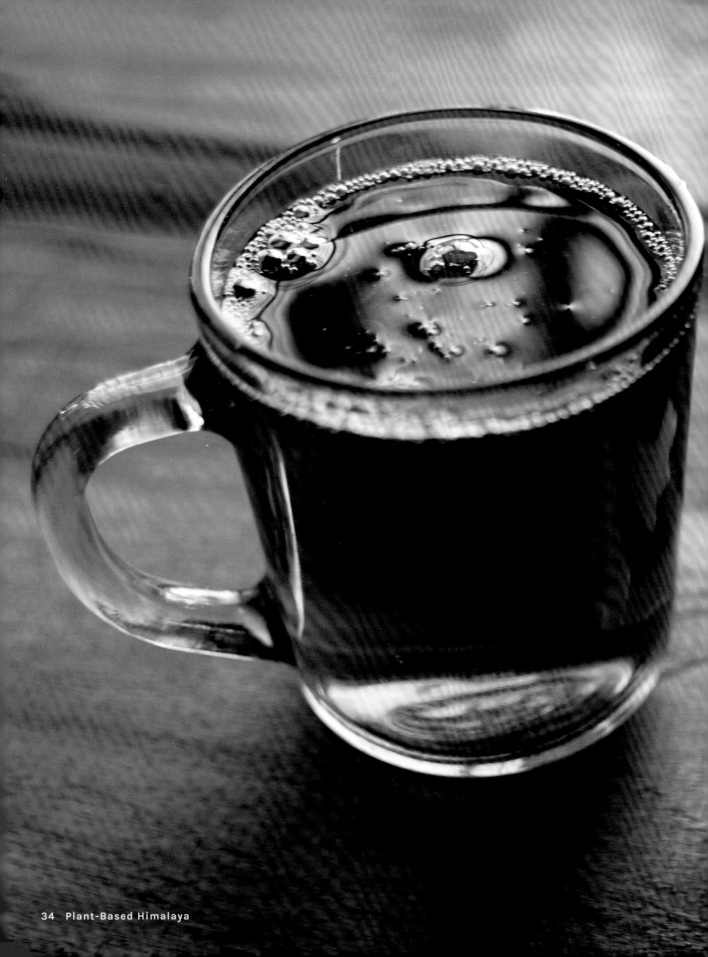

अदुवाको चिया

ADUWAKO CHIYA

Ginger Tea

Ancestral herbal remedy as well as mellow refreshment,
this simple mood-boosting beverage is a cultural staple
throughout the ancient and modern worlds.

SERVES ~ 2
COOK TIME ~ 5 minutes

INGREDIENTS
Water: 3 cups
Tea leaf: ¼ tsp

SPICES
Ginger: 2 slices (20g)

STEPS

1. Boil 3 cups of water.

2. Add tea leaves and ginger slices.

3. Simmer for 5 minutes on low heat.

4. Strain the tea into your favorite cup.

5. Add a little bit of maple syrup or agave if you want to sweeten it up, but personally, I like my ginger tea plain.

QUICK TIPS

- *You can chop the ginger in slices or slightly crush with a mortar and pestle.*

- *Add couple of cloves for an aromatic flavor. Cloves relieve tooth pain.*

- *This ayurvedic tea is a perfect substitute for coffee in the morning.*

- *Ginger tea is also beneficial when your stomach is upset or if you have a headache.*

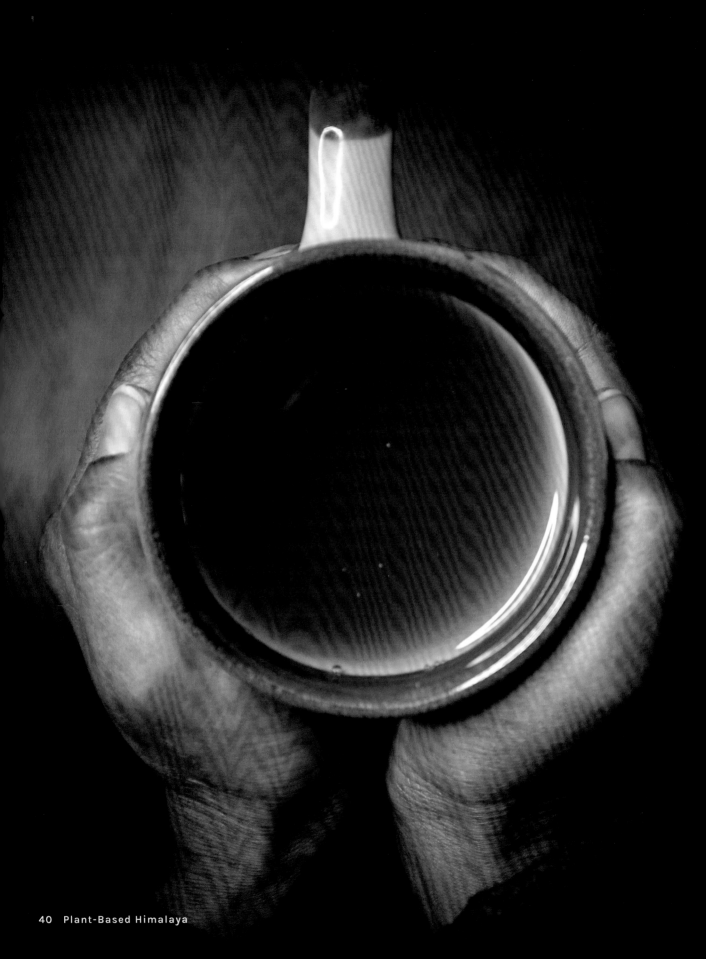

आयुर्वेदिक चिया

AYURVEDIC
CHIYA

Ayurvedic Tea

*Prevention is better than a cure. This therapeutic tea was
introduced to me at a very young age by my mother, so we
rarely needed trips to the doctor. This miracle elixir works not
only as a remedy but also as a preventative against a cold, the
flu, or other seasonal ailments.*

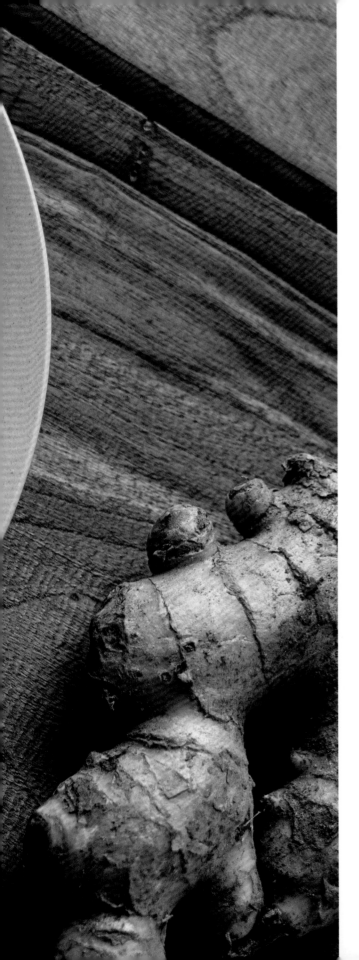

SERVES ~ 2
COOK TIME ~ 15 minutes

INGREDIENTS
Tea leaf: ⅛ tsp

Lemon: 1 slice

Water: 4 cups

SPICES
Clove: 4 buds

Ginger: 2 slices

Turmeric: ⅛ tsp

Cumin seed: ¼ tsp

Thyme: ⅛ tsp

Black pepper: 4 cloves

Cinnamon: 1 bark

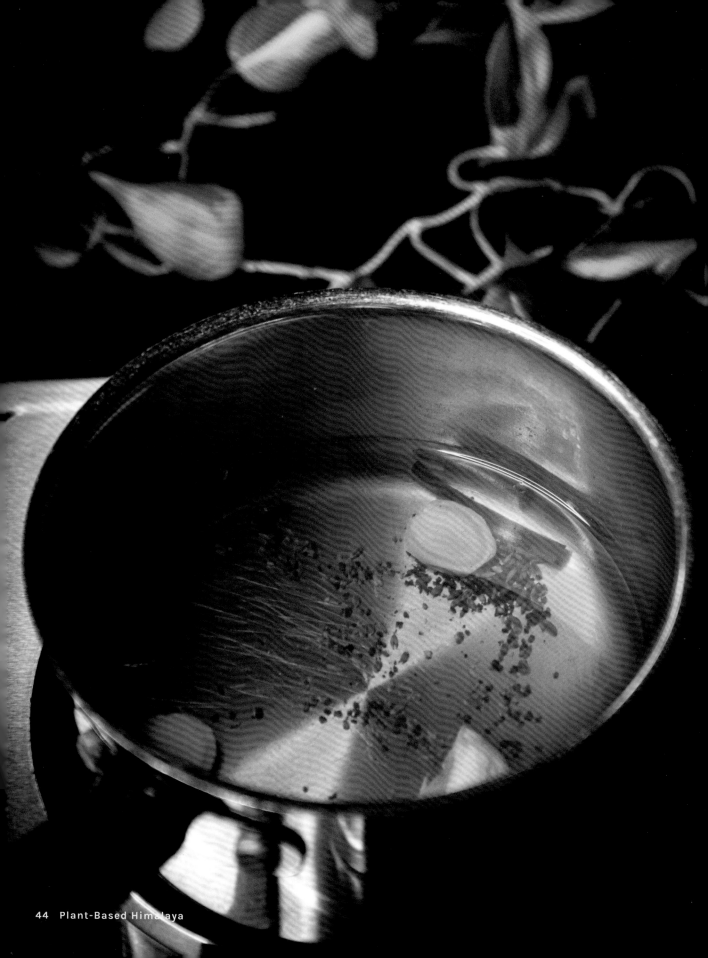

STEPS

1. Boil 4 cups of water.

2. Add tea leaves, lemon slice, and the spices. I crush the black pepper and ginger before adding them.

3. Simmer for 5 minutes on low heat.

4. Strain into your favorite cup.

5. Drink and feel better.

QUICK TIPS

- This tea boosts immunity, and I usually drink it when I don't feel well. It definitely helps with a runny nose or sore throat.

- You can make ayurvedic tea to guard against getting sick, and it helps clear toxins out of the body.

- This tea is a lifesaver during a chilly winter. I usually make extra tea and drink it throughout the day.

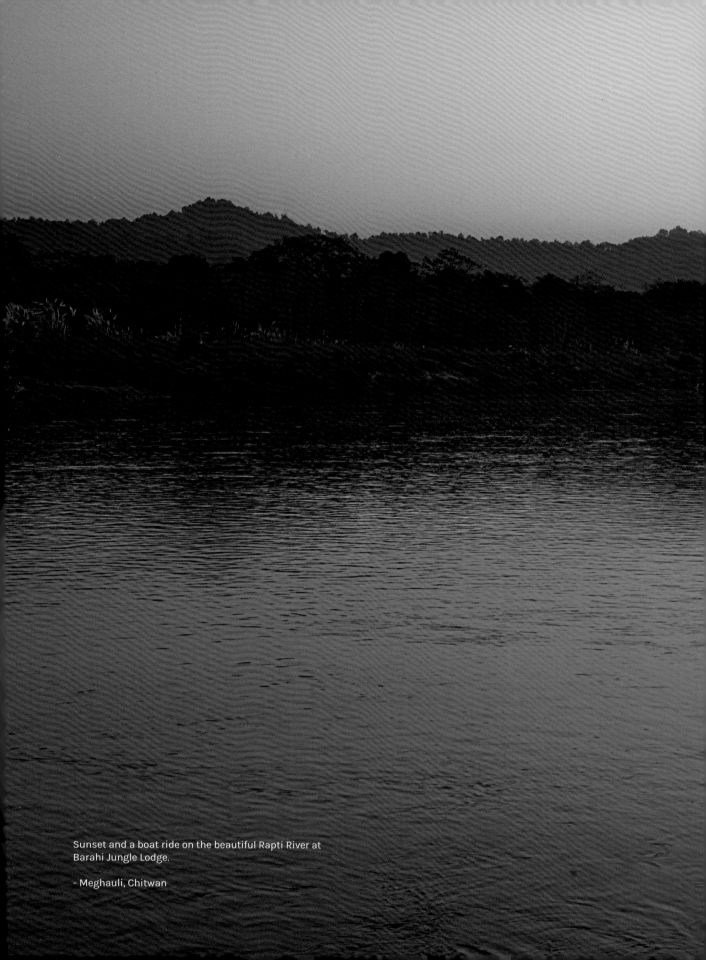

Sunset and a boat ride on the beautiful Rapti River at
Barahi Jungle Lodge.

- Meghauli, Chitwan

अन्न

Khana

Grains

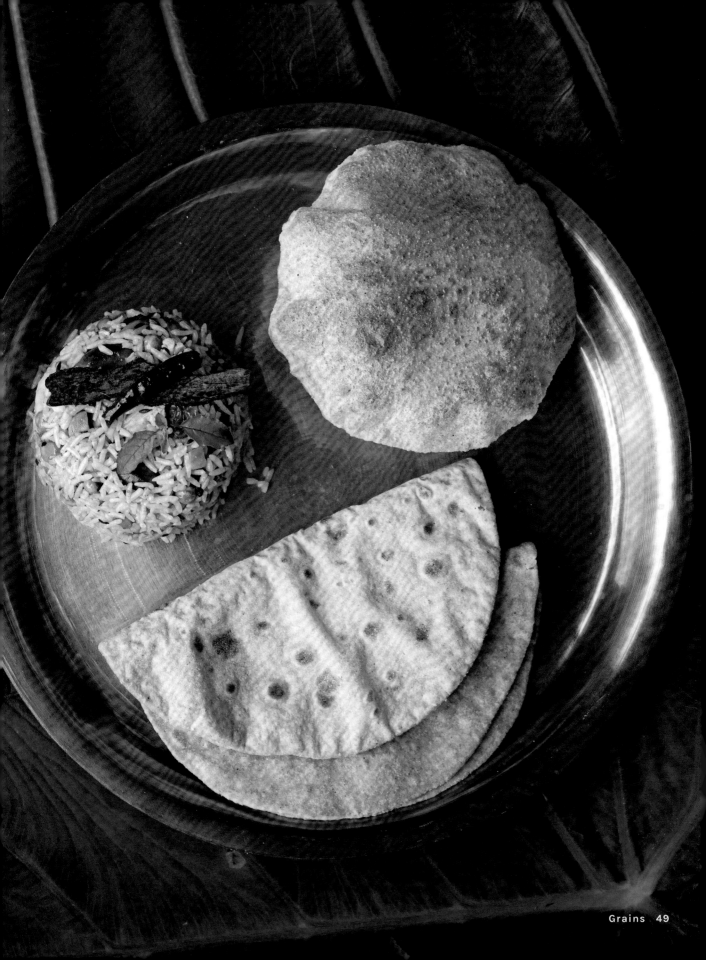

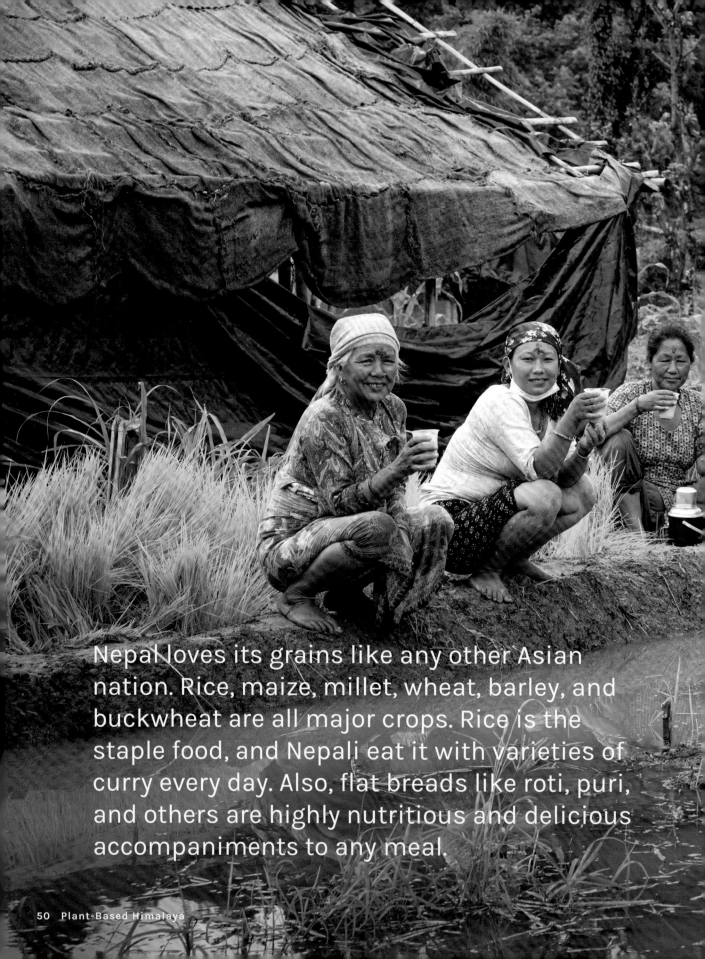

Nepal loves its grains like any other Asian nation. Rice, maize, millet, wheat, barley, and buckwheat are all major crops. Rice is the staple food, and Nepali eat it with varieties of curry every day. Also, flat breads like roti, puri, and others are highly nutritious and delicious accompaniments to any meal.

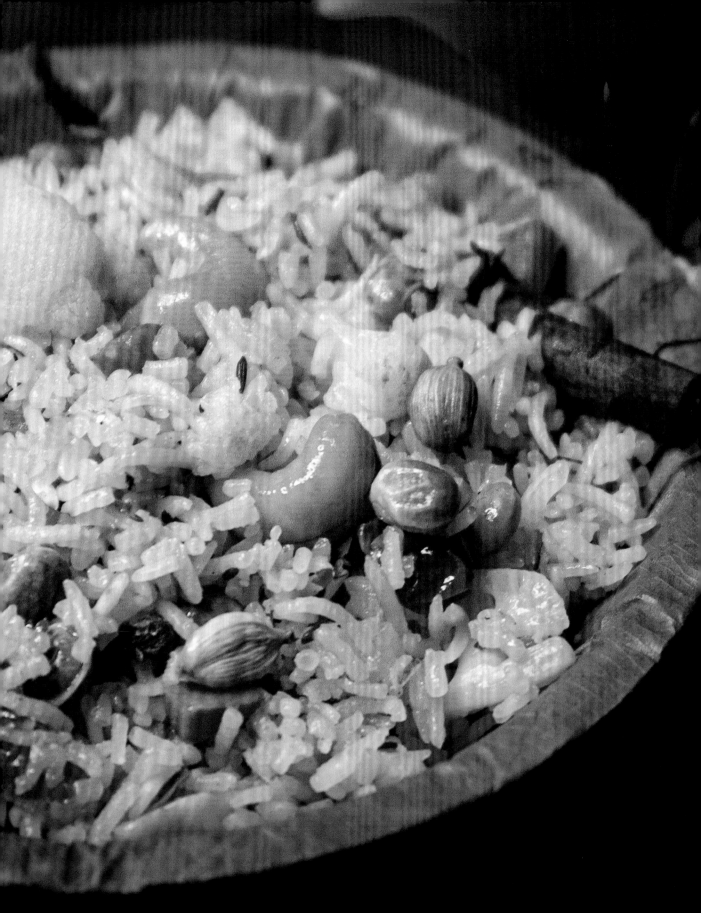

पुलाउ
PULAU

Vegetable Rice

In Nepal, plain rice is for daily life and pulau is for days of celebration such as festivals and weddings. Whenever I make this dish, it feels like a party and the flavors give a reason to rejoice.

SERVES ~ 4
COOK TIME ~ 45 minutes

INGREDIENTS

Basmati rice: 1 cup

Water: 2 cups

Green pea: ½ cup

Carrot: 1 small

Cashew: ½ cup

Golden raisin: ¼ cup

SPICES

Coconut oil: 2 tbsp

Cumin seed: 1 tsp

Turmeric: ¼ tsp

Dried red chili: 4

Clove: 6 buds

Cardamom: 8 cloves

Cinnamon: ½ stick

Cilantro: ½ cup

Salt: 1 tsp

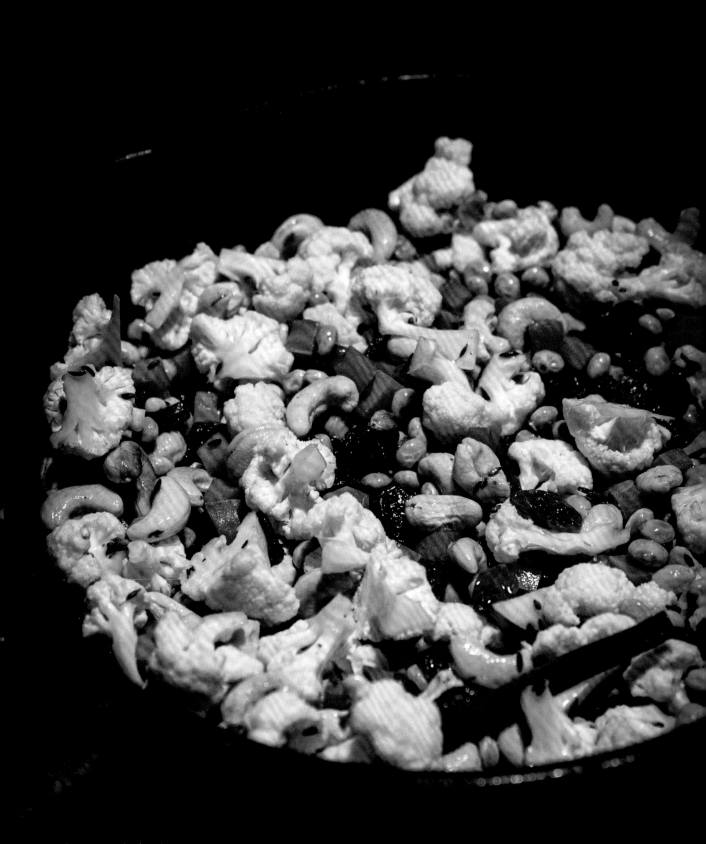

STEPS

1. Wash the rice and soak in a cup of water for 30 minutes.

2. Crush the spices with a mortar and pestle.

3. Heat a pan on medium and add oil. Once the oil heats up, add cumin seeds, temper for few seconds, and lower the heat.

4. Add cashews, raisins, and red chilis. Fry for 30 seconds.

5. Turn the heat to medium. Add green peas, cauliflower, and carrots. Fry until golden brown.

6. Add turmeric and spice blend (cardamom, cinnamon, and cloves). Mix thoroughly.

7. Drain the water of rice and add it to the pan. Fry for a few minutes until the water dries up.

8. Add salt and 2 cups of water. Mix completely, and cover while continuing to cook on medium heat for 5 more minutes.

9. Take the lid off, stir gently, and then turn the heat to low and cook the pulau for another 5 minutes.

10. Add chopped cilantro and lime on top. Hot and delicious pulau is ready to serve!

QUICK TIPS

- ☺ *Pulau is amazing with any curry or just by itself. This dish is extremely flavorful and delightful.*

- ☺ *I add whole cardamom, cloves, and cinnamon along with the cashew. However, most people do not like the taste of whole spices, so I suggest grinding them before you add them in the rice.*

- ☺ *The aroma from using whole spices is heavenly, but I make sure to take them out as I eat the pulau.*

- ☺ *Sometimes I add saffron to the pulau for extra flavor and aroma. I soak a half teaspoon of saffron in the water and mix it with the rice.*

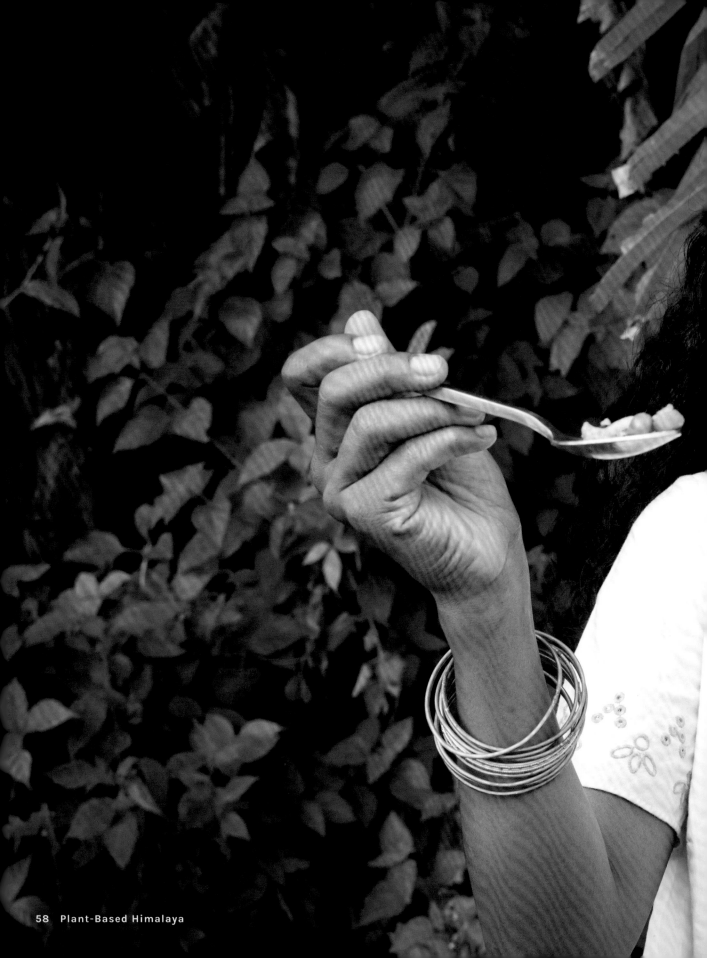

रोटी

ROTI

Flatbread

In the Terai region of Nepal, people eat rice for lunch and roti for dinner. I grew up eating roti on a daily basis out of habit and only later discovered roti is healthier than white rice. Also, factory-made tortillas will never compete with homemade flatbread.

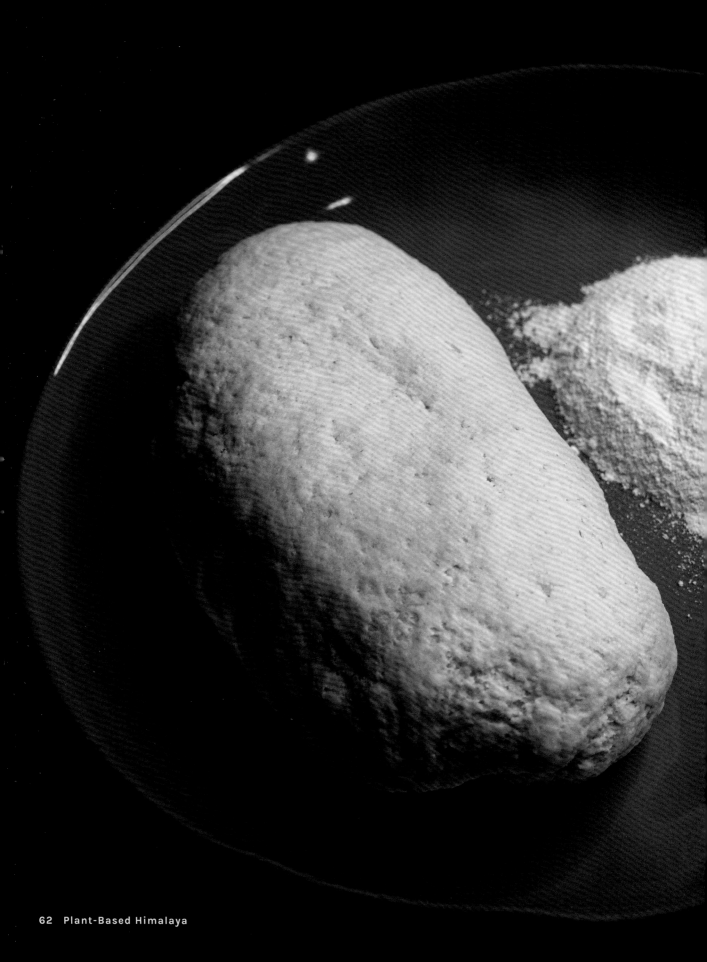

SERVES ~ 2
COOK TIME ~ 30 minutes

INGREDIENTS

Wheat flour: 2 cups

Water: ¾ cup

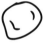

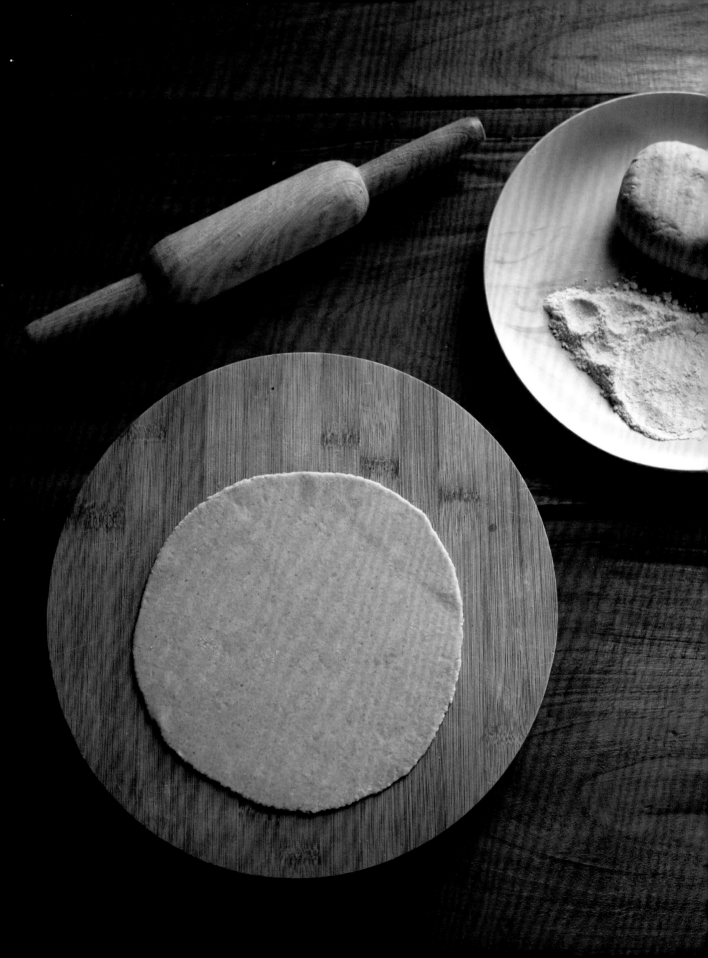

STEPS

1. Add 2 cups of flour to a large spacious bowl. Save 2 tablespoons of flour for dusting later.

2. Slowly add water and knead thoroughly with your knuckles for at least 10 minutes. Then cover the bowl with a plate for 5-10 minutes.

3. Knead the dough several times again. Take a small ball of dough and flatten with the palm of your hands. Use a rolling pin to flatten further, to 6-8 inches diameter.

4. Dust the dough as you roll to keep it from sticking to the rolling pin.

5. Heat a pan on medium. Add the roti once the pan is hot. It will slowly turn brown, and then flip to the other side.

6. Slowly tap the edges of the roti with a cotton cloth until it puffs. If this is your first time, it might not puff. Keep trying.

7. Fluffy and soft roti is ready once it's golden brown on both sides. Repeat the process with the remaining dough.

QUICK TIPS

☺ *Roti is amazing when paired with any curry. I also enjoy making wraps.*

☺ *Knead your flour adequately—I usually knead at least 10 minutes for best results.*

☺ *When making the dough, do not pour all the water in at once. Instead, add it slowly, a little at a time. It might take a few tries to make fluffy roti, but don't get discouraged. You'll get better with practice.*

☺ *If this is your first try, tap lightly on the edges of the roti. If you press too hard, the puff may break and you will burn your fingers.*

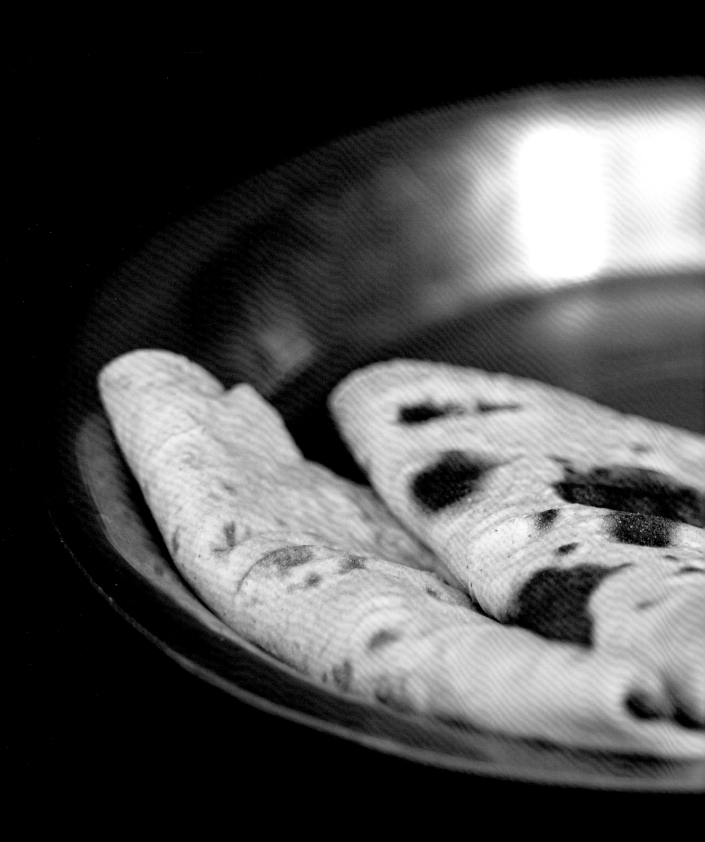

पुरी
PURI

Fried Flatbread

*Fried items are everyone's favorite comfort food. Whenever
I'm craving junk food, I make puri with my favorite curry
or taco filling. The deep-fried bread reminds me of big family
gatherings and street vendors during cultural festivals in Nepal.*

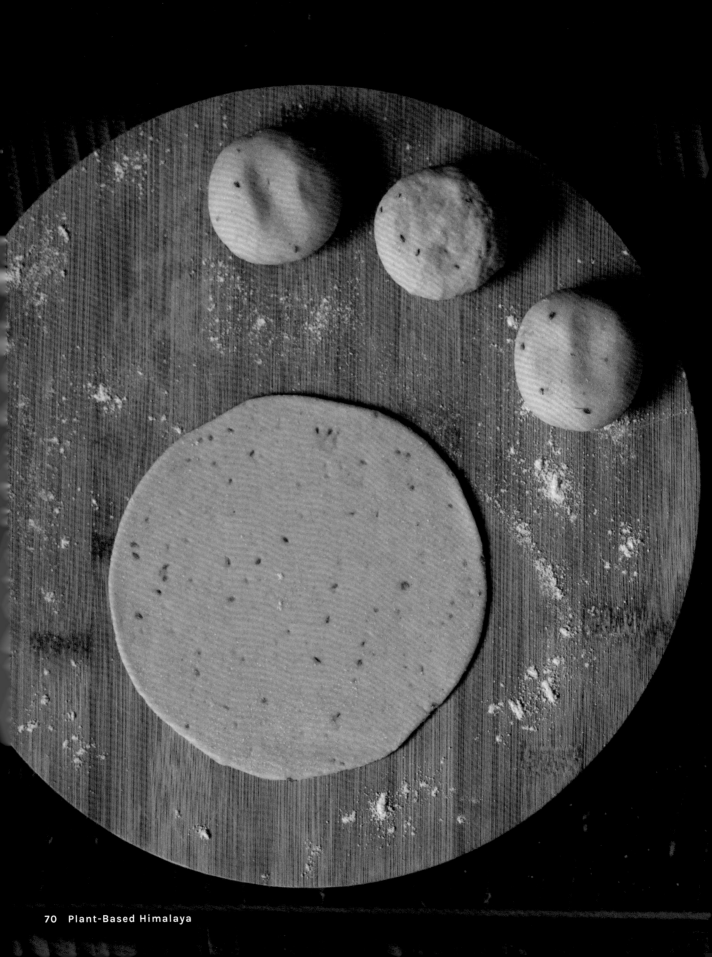

SERVES ~ 4
COOK TIME ~ 30 minutes

INGREDIENTS

All-purpose flour: 1 cup

Wheat flour: 1 cup

Water: ¾ cup

SPICES

Sunflower oil: 2 cups

Thyme seed (jwano): 1 tsp

Turmeric: ½ tsp

Salt: ½ tsp

STEPS

1. In a large bowl, combine wheat flour, all-purpose flour, thyme seeds, salt, turmeric, and 2 teaspoons of sunflower oil.

2. Slowly add water and knead rigorously for 5–10 minutes.

3. Cover the bowl with a plate or damp cloth and let it sit for 10 minutes.

4. Take a small ball of dough and flatten it with your palms.

5. Dust a little bit of flour while you flatten the dough to a 3–4-inch circle with a rolling pin.

6. Heat a pan on medium heat and add oil. Once the oil is hot, slowly slide the puri in the oil from the side.

7. Gently tap the edges of the puri with a skimmer so it will puff up.

8. Flip to the other side and tap the edges again.

9. Take it out when it looks golden brown, straining the oil on the side of the pan.

10. Hot and crispy puri is ready to serve!

QUICK TIPS

- *Puri pairs well with chana dal and golveda ko achaar.*

- *Puri turns brown quickly, so keep the heat on medium. I turn the heat down a little bit if the oil begins to smoke.*

- *Drop a tiny ball of dough in the oil to check the heat. If it is hot enough, the dough will quickly rise up.*

- *You can also make bigger balls to make bigger and thicker puri.*

- *I make puri tacos or wraps—just add some fresh ingredients on top.*

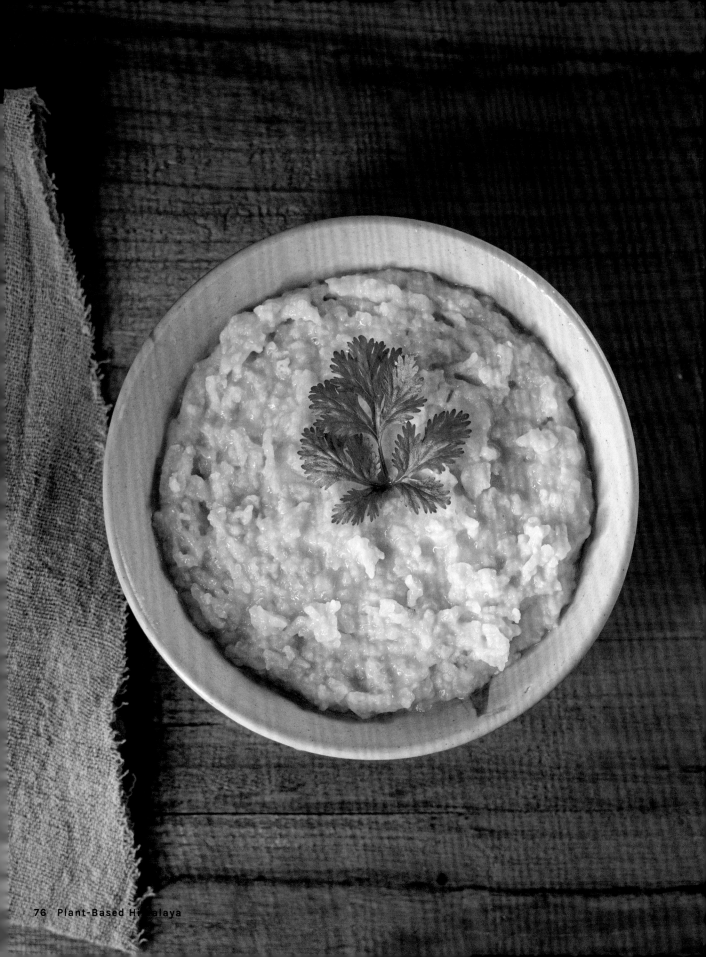

जाउलो

JAULO

Porridge

Jaulo is perfect for days when you don't feel well—exhausted and without much of an appetite but knowing that eating is necessary. Its flavors are simple, it's easy to digest, and it contains all the nutrients you need to heal and get strong enough to get back to normal life.

SERVES ~ 2
COOK TIME ~ 30 minutes

INGREDIENTS
Yellow moong dal: ½ cup
White rice: ⅓ cup
Water: 3½ cups

SPICES
Salt: ½ tsp
Turmeric: ¼ tsp

STEPS

1. In a pressure cooker, add moong dal and rice.

2. Rinse them twice and soak for an hour.

3. Add the salt, turmeric, and water to the pressure cooker. Close the lid securely. Cook in medium heat.

4. Once the pressure cooker whistles, after about 7 minutes, lower the heat and cook for 2 more minutes. Then turn the stove off.

5. Once it has cooled down, jaulo is ready to serve.

QUICK TIPS

- *I usually make porridge when my stomach is upset and I'm not feeling well.*

- *It can also be served as a light breakfast. Add some chopped vegetables such as cauliflower, carrot, beet, or peas to add flavor.*

- *It is comforting and satisfying. This recipe is really healthy for kids.*

- *To add extra flavors, you can temper some thyme seeds (jwano) in a teaspoon of coconut oil and add that on top of the porridge.*

- *You can also add fresh chopped cilantro or golveda ko achaar (tomato sauce) on the side if you want to spice it up.*

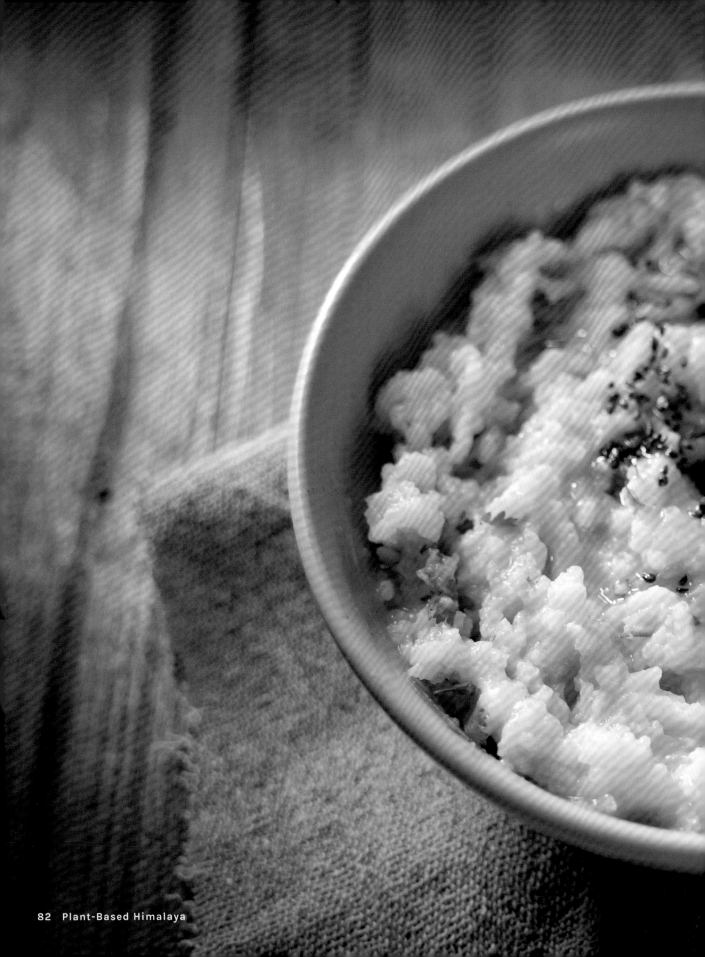

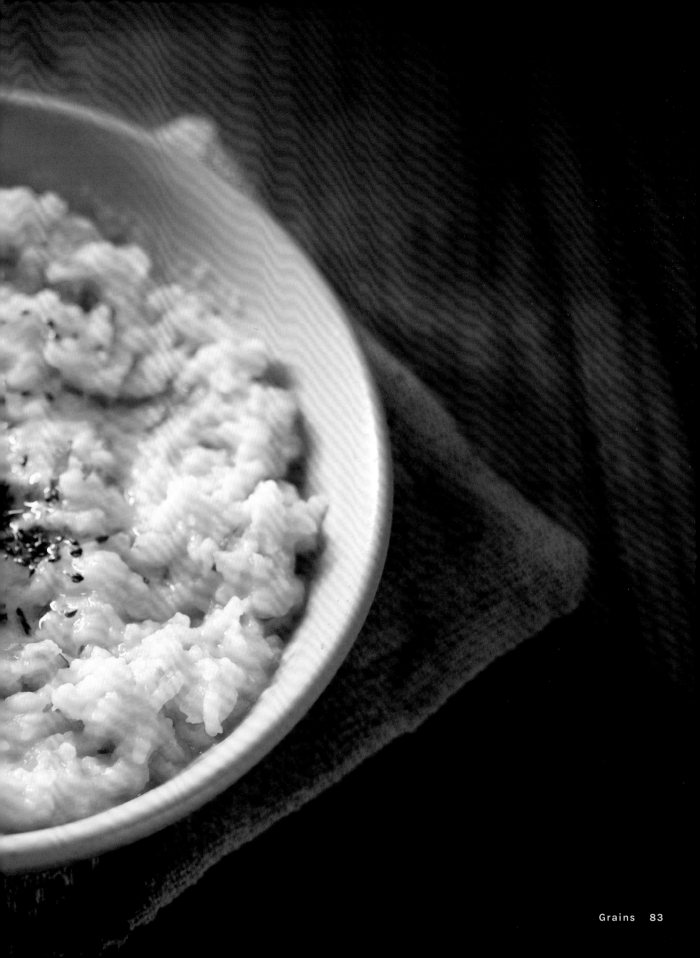

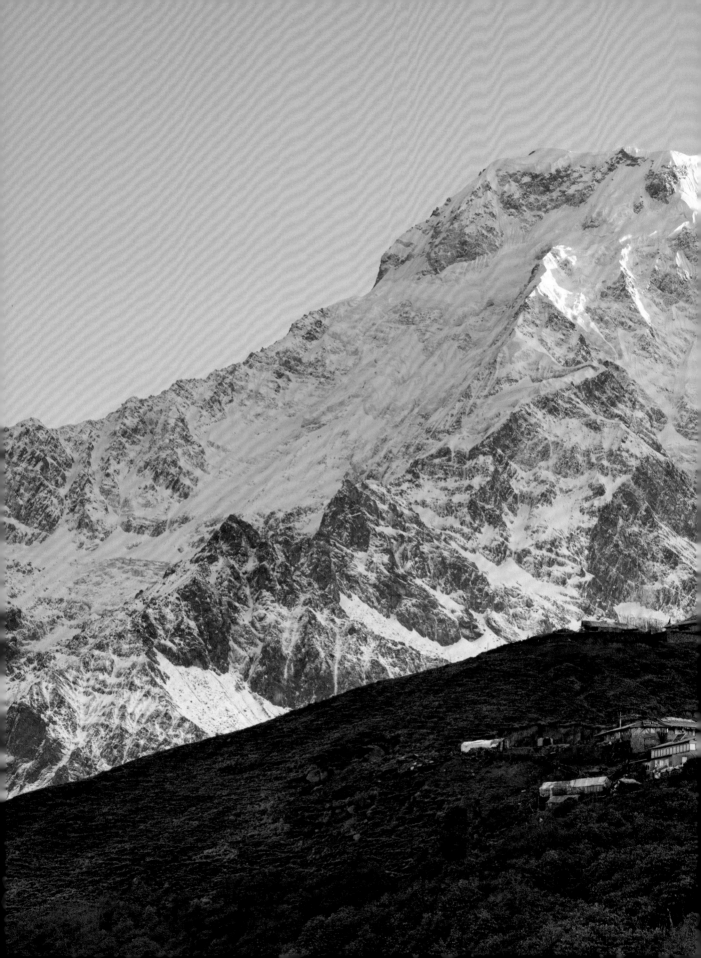

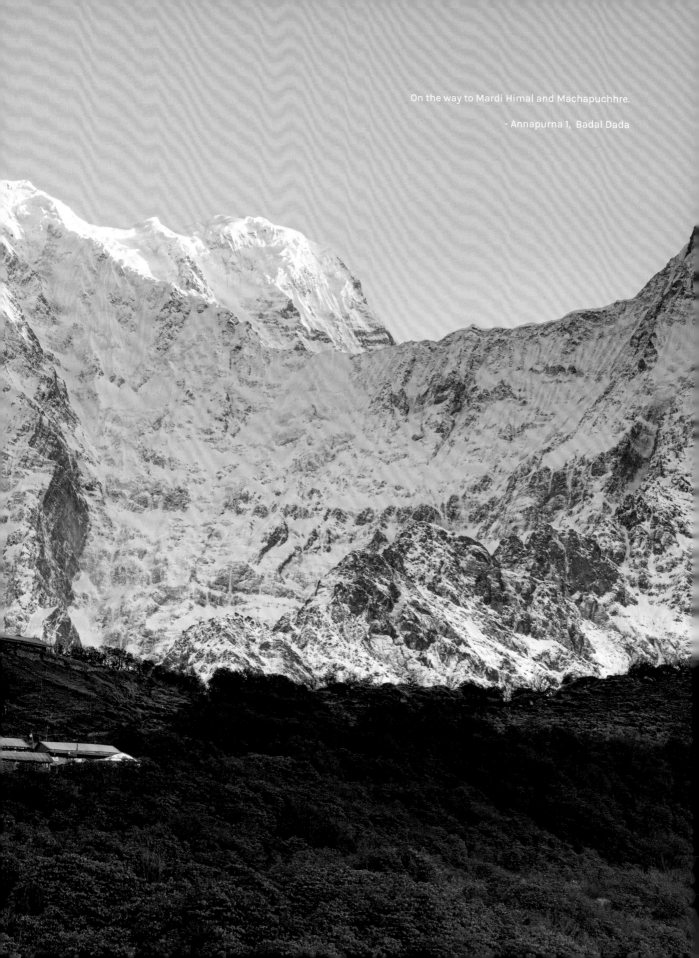

On the way to Mardi Himal and Machapuchhre.

- Annapurna 1, Badal Dada

दाल
Dal
Lentils and Beans

"Dal" is a term used for beans and split lentils, dried pulses that are part of the legume family. There are several varieties of dal to make at home depending on the season. They are delicious, packed with protein, and have amazing health benefits. Soup is the most common way to cook dal, and it is a staple in Nepali cuisine.

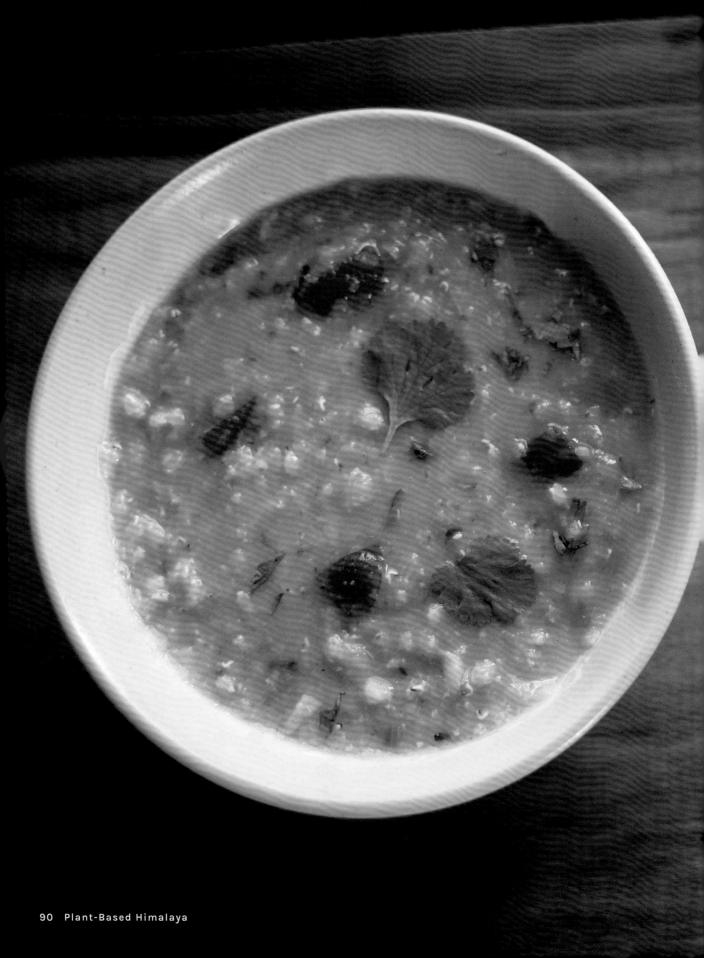

मुसुरो दाल
MUSURO DAL

Red Lentils

Red lentils are the most common dal consumed in Nepal.
They are cheap, nourishing, and extremely simple to make.
Eating them almost every day, Nepali are said to be "dal
bhat powered' with just lentils and rice.

SERVES ~ 4
COOK TIME ~ 25 minutes

INGREDIENTS
Red lentil: 1 cup
Red onion: ½ small
Tomato: 1 small
Water: 3 cups

SPICES
Sunflower oil: 2 tsp
Garlic : 1 clove
Fresh green chili: 1 medium
Turmeric: ¼ tsp
Lemon: 1 tsp
Cilantro: ½ cup
Salt: 1 tsp

STEPS

1. Wash the red lentils.

2. In a pressure cooker, combine the lentils with 3 cups of water, turmeric, and salt. Close the lid and boil until it whistles. This usually takes about 10 minutes.

3. Turn the stove off and let it cool down.

4. Heat a pan on medium and add oil.

5. Once the oil is hot, add chopped garlic and onion. Fry until they start turning golden brown.

6. Add chopped green chili and tomato. Mix well.

7. Pour boiled lentils to the pan. I usually add a little water to the pressure cooker to get all the remaining dal.

8. Let it simmer on low heat for a minute and then turn the stove off.

9. Garnish with cilantro and a hint of lemon juice on top.

10. Delicious, spicy, and tangy dal is ready.

QUICK TIPS

☺ *I like dal with rice, aaloo bhujiya (fried potatoes), and timur ko achaar.*

☺ *You can also boil the lentils with just salt and turmeric for simpler flavors.*

मास दाल

MAAS DAL

Black Lentils

*Maas dal reminds me of winters growing up in Kathmandu.
It is noticeably more popular during the colder seasons
because it warms from the inside. Black lentils are also an
inexpensive, protein-packed, and nutrient-dense dried food
that will last a long time when bought in bulk.*

SERVES ~ 4
COOK TIME ~ 30 minutes

Black lentil: ½ cup

Water: 3 cups

Ginger: 1 slice

Turmeric: ¼ tsp

Salt: 1 tsp

STEPS

1. Wash the black lentils.

2. Soak for at least 15 minutes or overnight for best results.

3. In a pressure cooker, add black lentils, water, turmeric, ginger, and salt.

4. Boil on medium heat.

5. Once the whistle blows, cook the dal on low heat for 10 more minutes. It should be soft and mushy by then.

6. Yummy maas ko dal is ready to serve.

QUICK TIPS

☺ *Maas ko dal is also called "kalo dal" in Nepal. It is amazing with white rice and pumpkin leaf curry during pumpkin season. Otherwise, I usually prepare it with fried potatoes and golveda ko achaar on the side.*

☺ *This recipe is the simplest way to make quick and plain dal. I recommend adding veggies such as carrot, pumpkin, or potato to create a tasty soup.*

☺ *Sometimes I temper jimbu (Himalayan aromatic herb) in a teaspoon of coconut oil and add it to boiled dal. It has a unique Nepali flavor. You can usually find jimbu in Nepali or Indian stores.*

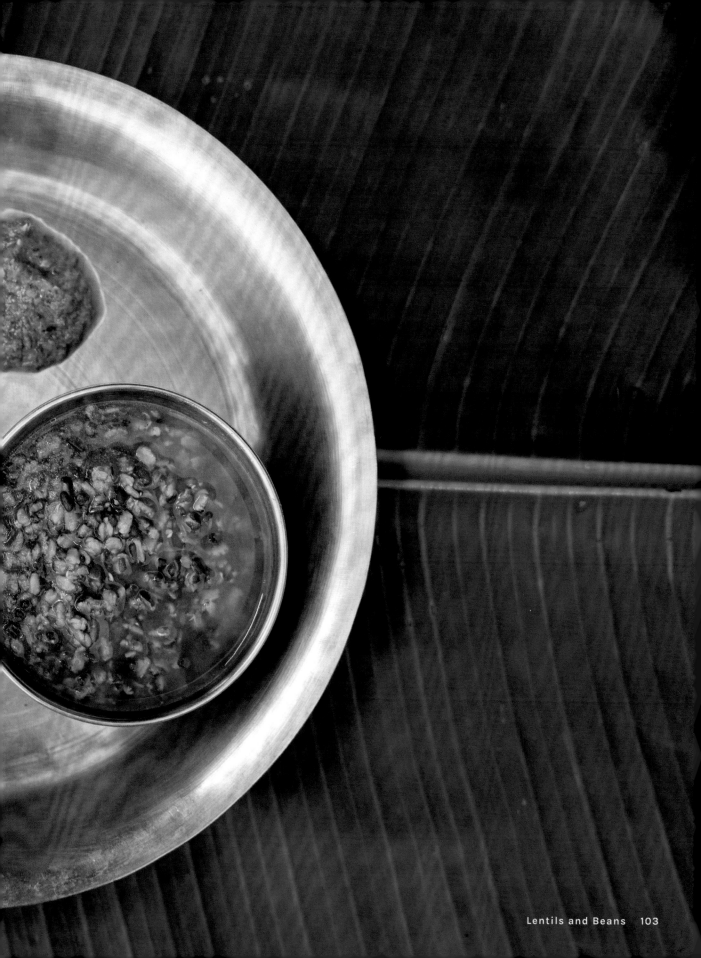

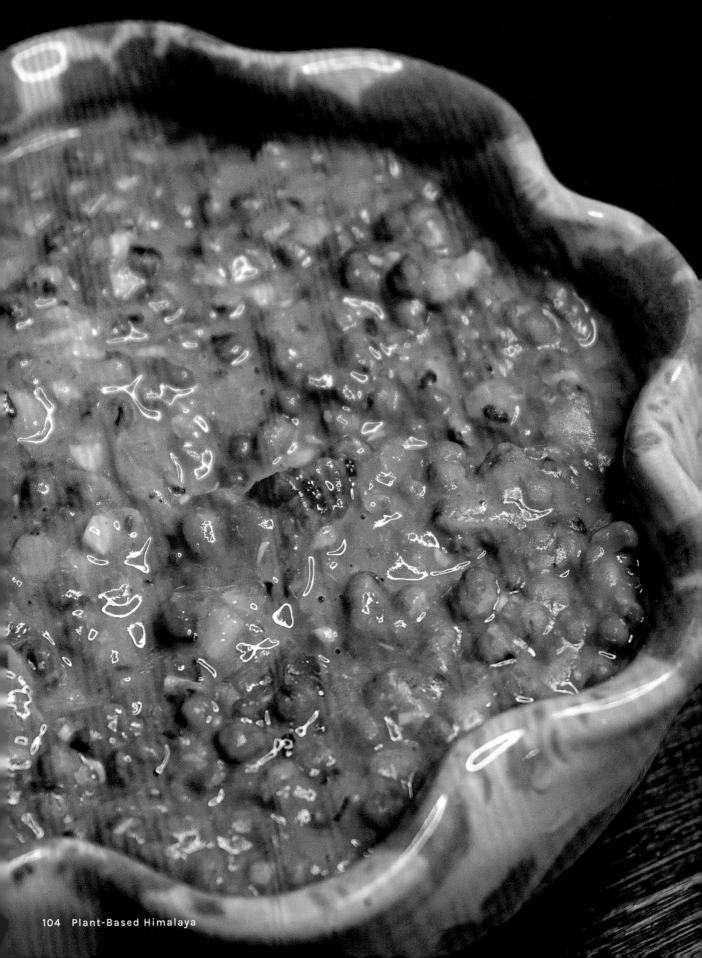

हरियो मुङ्ग दाल

HARIYO MOONG DAL

Green Mung Beans

Green mung beans always remind me of my mother's kitchen, and she absolutely adores this dish. Hariyo moong dal might be this book's healthiest recipe, with innumerable benefits including lowering blood pressure and "bad" cholesterol, aiding digestion, and being high in antioxidants and essential amino acids.

SERVES ~ 4
COOK TIME ~ 30 minutes

INGREDIENTS

Green moong bean: 2 cups

Red onion: 1 small

Tomato: 3 small

Water: 4 cups

SPICES

Coconut oil: 3 tbsp

Bay leaf: 2 leaves

Ginger: 2 slices

Garlic: 2 big cloves

Fresh chili: 4 medium

Turmeric: ¼ tsp

Cumin powder: 1 tsp

Cilantro: ½ cup

Salt: 1 tsp

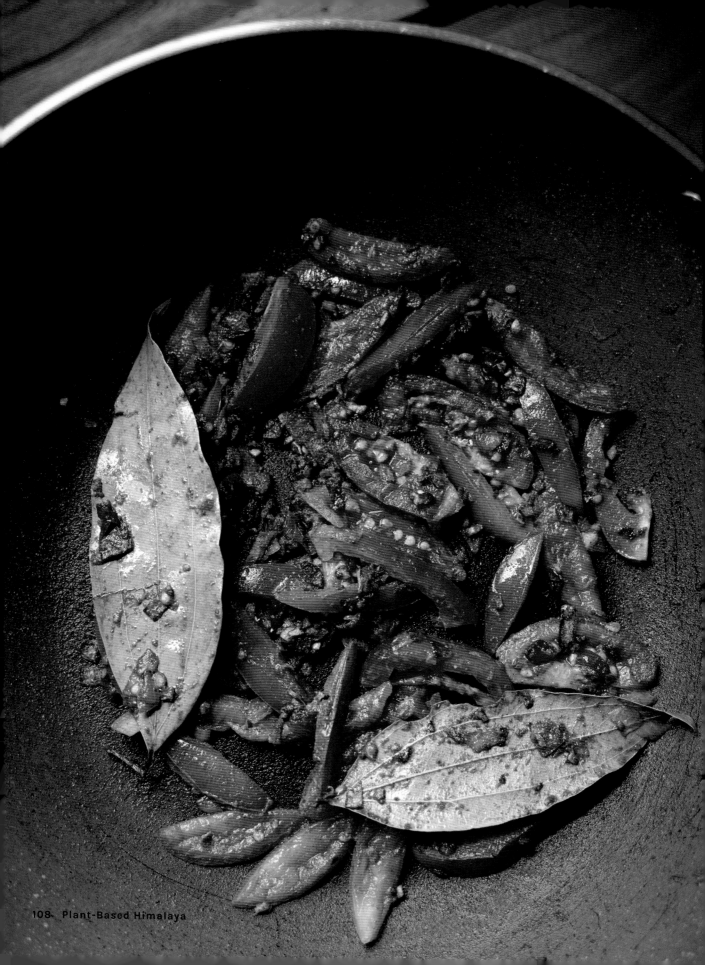

STEPS

1. Wash the moong dal and then soak overnight in 4 cups of water.

2. In a pressure cooker, add dal, water, ⅛ teaspoon of turmeric, and salt. Cook on medium heat.

3. Once the whistle blows (usually about 10 minutes), turn the heat off and let the mixture cool down.

4. Heat a pan on medium and add oil.

5. Once the oil is hot, add bay leaves, chopped garlic, ginger, and chilis. Fry for a minute.

6. Add chopped onion and fry until golden brown.

7. Add cumin powder and rest of the turmeric. Fry for few seconds and add the chopped tomatoes. Mix and cook for a minute more.

8. Pour boiled dal in with the spices and stir well. Simmer for 5 minutes on low heat.

9. Add freshly chopped cilantro and mix well.

10. Delicious hariyo moong dal is ready.

QUICK TIPS

- *I like hariyo moong dal gravy with roti and timur ko achaar, but you can eat it with rice as well.*

- *I prefer thick dal, but if you want it soupy, you can add extra water. Goes great with a baguette, puri, or sourdough bread.*

- *To make it extra creamy, add a half cup of fresh coconut milk.*

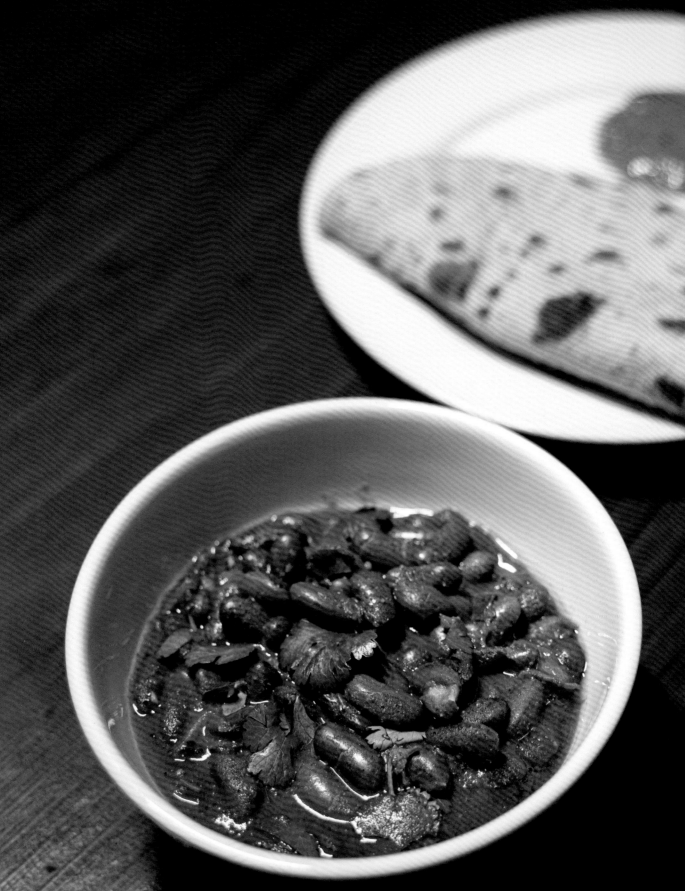

राज्मा

RAJMA

Red Kidney Beans

Like most dried beans, red kidney beans play an important role in the Nepali kitchen. Once all the fresh vegetables are out of season, dried beans are a lifesaver. This is especially true during monsoon season when it's hard to go out for groceries. Luckily, watching the storm on rainy days while enjoying savory rajma soup is a perfect combo.

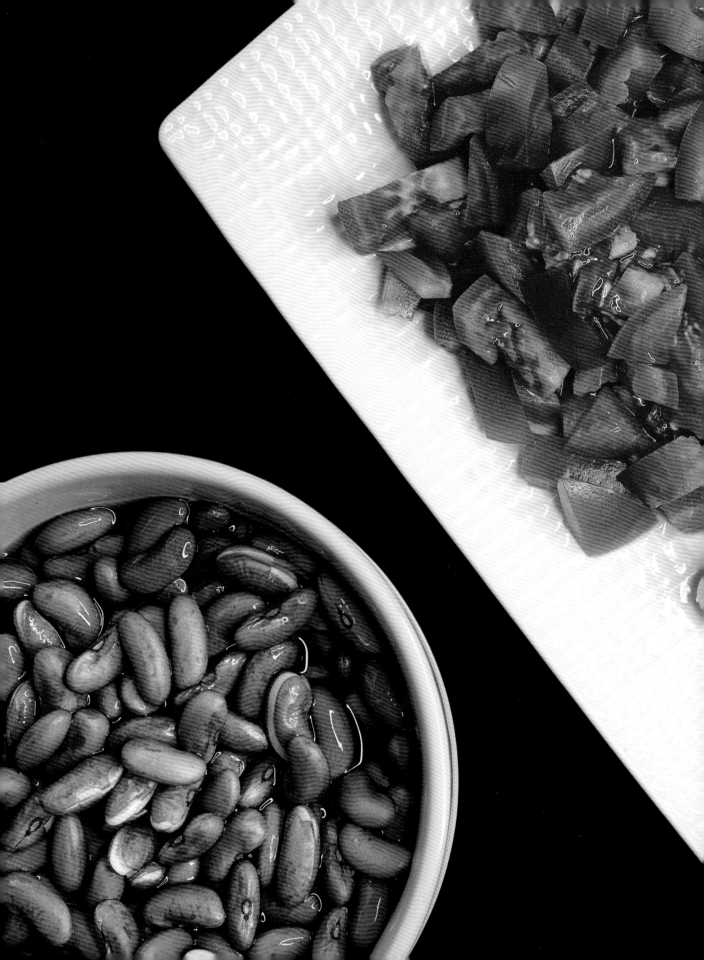

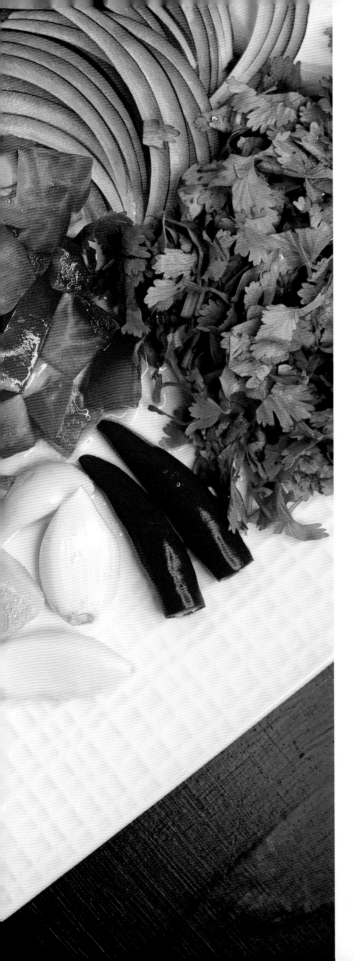

SERVES ~ 4
COOK TIME ~ 45 minutes

INGREDIENTS

Kidney bean: 2 cups

Red onion: 1 medium

Tomato: 2 medium

Water: 4 cups

SPICES

Sunflower oil: 3 tbsp

Cumin seed: 1 tsp

Garlic: 3 big cloves

Ginger: 4 slices

Fresh red chili: 4 medium

Clove: 4 buds

Bay leaf: 2 leaves

Turmeric: ¼ tsp

Cumin powder: 1 tbsp

Cardamom: 4 cloves

Cinnamon: ⅛ tsp

Black pepper: ⅛ tsp

Cilantro: ½ cup

Salt: 1 tsp

STEPS

1. Wash the kidney beans and then soak overnight in 4 cups of water.

2. In a pressure cooker, boil on medium heat using all the water and salt.

3. Once the whistle blows (usually about 15 minutes), lower the heat and cook the beans for another 15 minutes. Then turn the heat off and let it cool down.

4. Grind ginger, garlic, cardamom, black pepper, cloves, and cinnamon with a mortar and pestle.

5. Heat another pan on medium-low and then add oil. When the oil is hot, add cumin seeds and fry for a few seconds.

6. Add thinly sliced onion, chopped chilis, and whole bay leaves. Fry until the onions are golden brown and then add ginger and garlic paste.

7. As the ginger and garlic start changing the color, about 1 minute, add turmeric and cumin powder. Fry for a few seconds and add tomatoes.

8. Mix well and cover with a lid for 2 minutes on low heat to cook the gravy.

9. Remove the lid, add boiled beans, and mix thoroughly.

10. Cook on low heat for another 5 minutes, giving the spices time to fully blend together.

11. Chop and add part of the cilantro to the mixture and stir well for a rich flavor. Garnish with the remaining cilantro on top of the finished dish.

12. Rajma is ready.

QUICK TIPS

- *To thicken it up, smash some boiled beans with a spoon or spatula before serving.*

- *Rajma is excellent pairing with roti and golveda ko achaar.*

- *I usually prefer a thick gravy, but during winter, I add extra water to make it a warm and hearty soup.*

चना दाल

CHANA DAL

Split Chickpeas

Chana dal brings back memories of special occasions and festivals in Nepal, particularly Tihar, the festival of lights. We would worship Laxmi, the goddess of wealth, and then eat split chickpeas with puri. This was a rich delicacy for me as a child even though it is very inexpensive. Health is wealth, so it must be a favorite of Laxmi.

SERVES ~ 4
COOK TIME ~ 30 minutes

INGREDIENTS

Chana dal: 2 cups

Red onion: 1 medium

Tomato: 3 medium

Coconut milk: ½ cup

Water: 2 cups

SPICES

Coconut oil: 2 tbsp

Cumin seed: 1 tsp

Bay leaf: 1 leaf

Garlic: 6 cloves

Ginger: 2 slices

Red dried chili: 2 medium

Fresh green chili: 2 medium

Cumin powder: 1 tbsp

Turmeric: ½ tsp

Cardamom powder: ½ tsp

Cilantro: ½ cup

Salt: 1 tsp

STEPS

1. Wash the chickpeas and then soak them in 4 cups of water for at least 4 hours. Preferably, soak them overnight for best results.

2. Boil the chana in a pressure cooker with salt and ⅛ teaspoon of turmeric. Once the whistle blows, continue to cook on low heat for 5 more minutes.

3. Turn the heat off and let it cool down.

4. Heat another pan on medium and add oil. Once the oil is hot, add cumin seeds and whole dried red chilis. Fry for a few seconds.

5. Add chopped onion, finely chopped fresh green chilis, and whole bay leaves. Fry until golden brown.

6. With a mortar and pestle, grind the cardamom, ginger, and garlic. Then add them to the pan.

7. Fry for 1 minute and then add rest of the turmeric and cumin powder. Cook together for a few seconds, and then add chopped tomatoes.

8. Cover and let the gravy cook for 2 minutes more.

9. Add boiled chickpeas to the pan and mix thoroughly. If you are a coconut lover, add half a cup of fresh coconut milk and 2 tablespoons of freshly chopped coconut.

10. Continue to simmer the mixture on low heat for another 2 minutes.

11. Garnish with fresh chopped cilantro on top.

12. The heavenly tasting chana dal is now ready to serve.

QUICK TIPS

- ☺ *I personally enjoy my chana dal with puri, but it is also fantastic with rice, roti, or bread.*

- ☺ *Chana dal is extremely delicious, quick, and easy to prepare. This recipe is always a hit at dinner parties, so share with your friends.*

- ☺ *This is definitely a kid-friendly dish even for the most picky eater.*

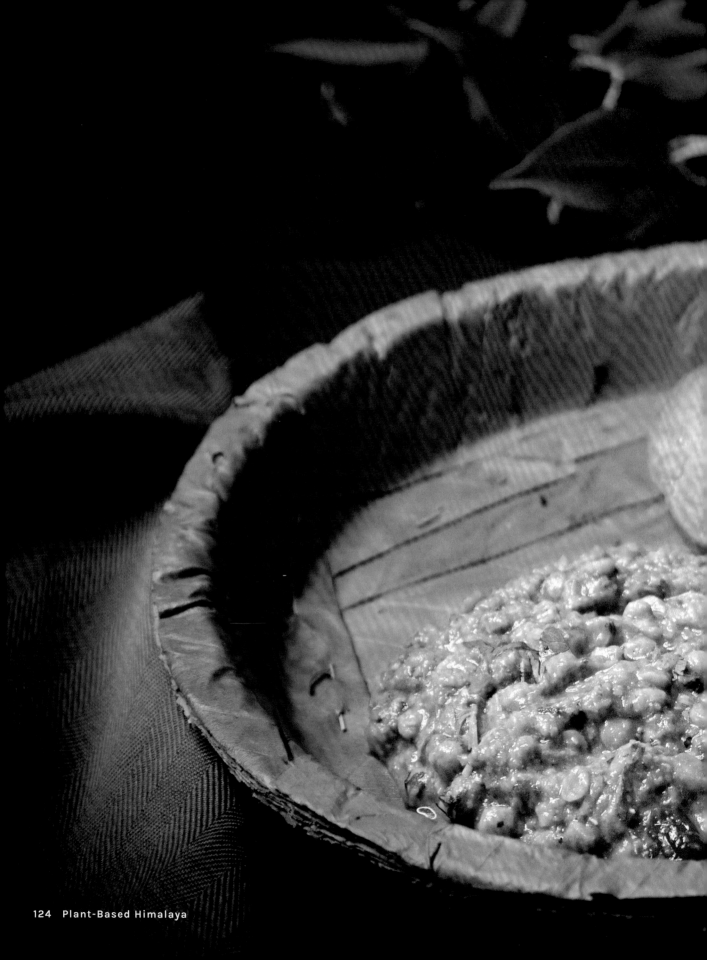

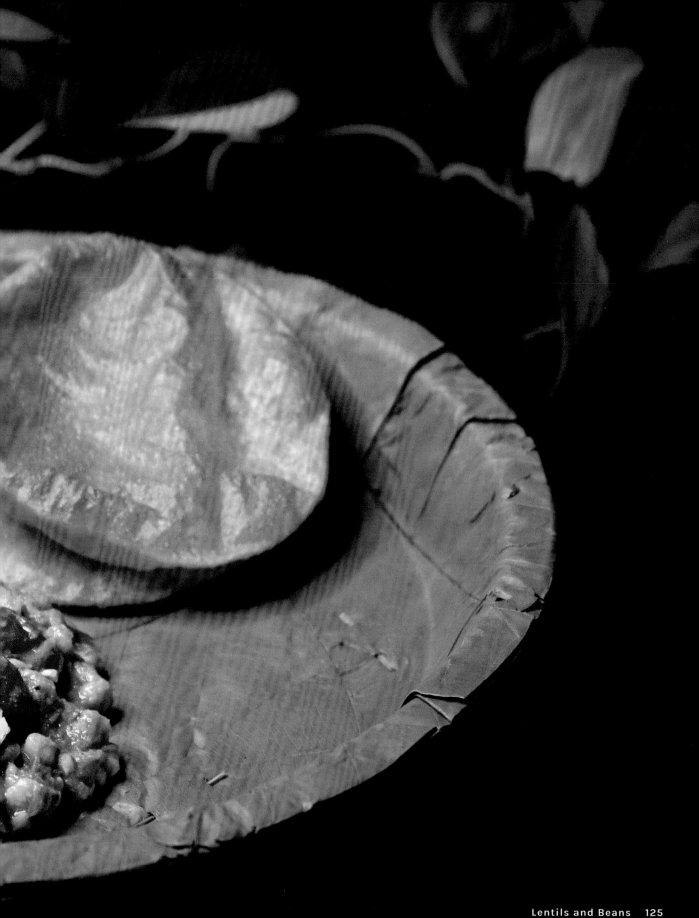

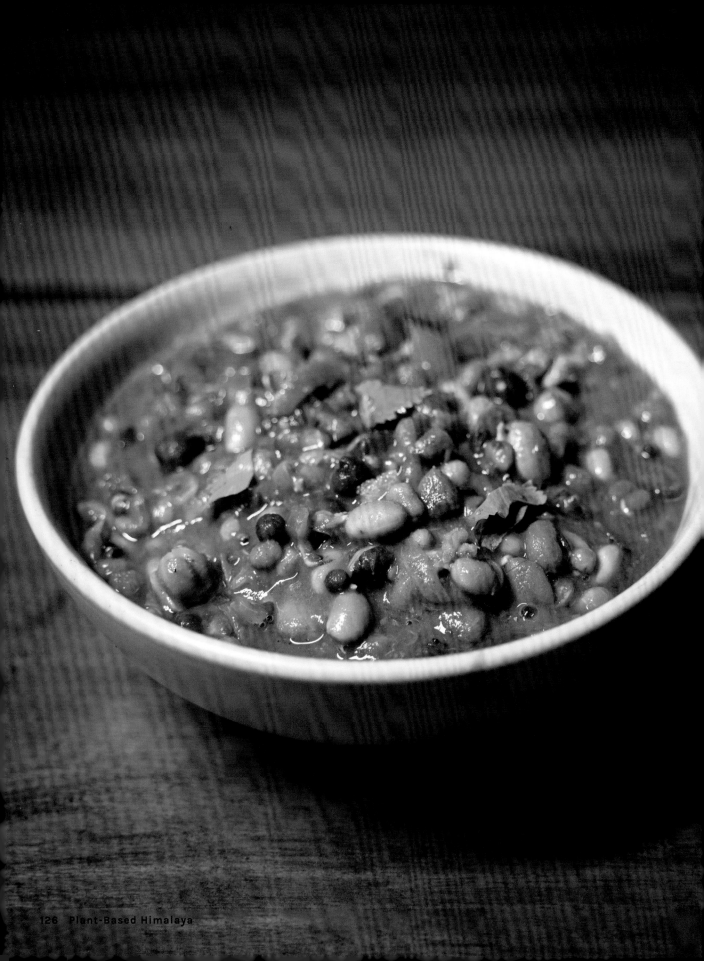

क्वाति

KWATI

Mixed Beans

Kwati (sprouted nine-bean soup) is an auspicious Newari dish. It is prepared during the full moon and during the celebration of Janai Purnima, a Hindu festival when Brahman priests change their sacred threads. "Kwa" means hot and "ti" means soup in the Newari language. The spectrum of mixed beans blends to create a truly distinct flavor, paralleling the confluence of diverse cultures that embody Nepal.

SERVES ~ 4
COOK TIME ~ 30 minutes

INGREDIENTS

Kwati bean: 2 cups

Red onion: 2 small

Tomato: 9 small

SPICES

Sunflower oil: 2 tbsp

Cumin seed: 1 tsp

Cumin powder: 1 tbsp

Turmeric: ½ tsp

Bay leaf: 2 leaves

Garlic: 5 cloves

Ginger: 4 slices

Cardamom: 6 cloves

Clove: 4 buds

Cinnamon: ⅛ tsp

Fresh green chili: 3 medium

Cilantro: ½ cup

Salt: 1½ tsp

STEPS

1. Wash mixed beans and soak overnight in 4 cups of water. Drain the water next day and put the beans in a cheesecloth or breathable cotton cloth. You can leave them on the countertop or refrigerator for an extra day to get more sprouts. Gently rinse the beans before you start cooking.

2. Boil the beans in a pressure cooker with 2 cups of water and ½ teaspoon of salt.

3. Once the whistle blows, lower the heat and cook for 7 minutes more. Turn the heat off and let it cool down.

4. Heat another pan on medium and add oil. Once the oil is hot, add cumin seeds. Fry for few seconds and then add chopped onion, finely chopped fresh green chilis, and whole bay leaves. Fry until the onion turns golden brown.

5. Grind ginger, garlic, cardamom, cinnamon, and cloves with a mortar and pestle. Add to the pan with a tablespoon of water and mix it well.

6. Once the spices start changing color in a minute, add turmeric and cumin powder. Fry for few seconds. Add chopped tomatoes and rest of the salt. Mix together well and cover for 2 minutes.

7. Remove the lid and add the boiled beans. Stir and simmer on low heat for an additional 5 minutes.

8. Add chopped cilantro to the dish for extra flavor. Mouthwatering kwati is now ready to serve!

QUICK TIPS

- *I prefer kwati with roti, but sometimes I eat it with rice and of course some golveda ko achaar on side.*

- *When I'm in a rush, I soak kwati overnight and cook them next day. Make it a thick gravy if you are planning to eat it with roti.*

- *You can also boil potatoes, carrots, or any other vegetables with kwati if you love the dish and want some variety. Sometimes I add more water to make kwati soup and have some salad on the side for lunch.*

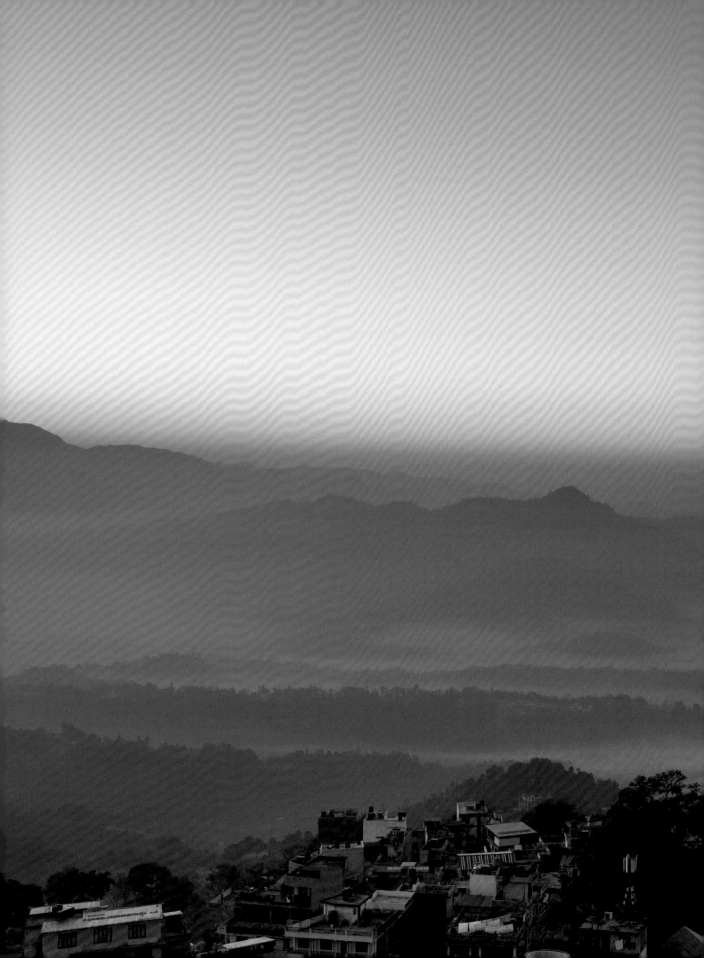

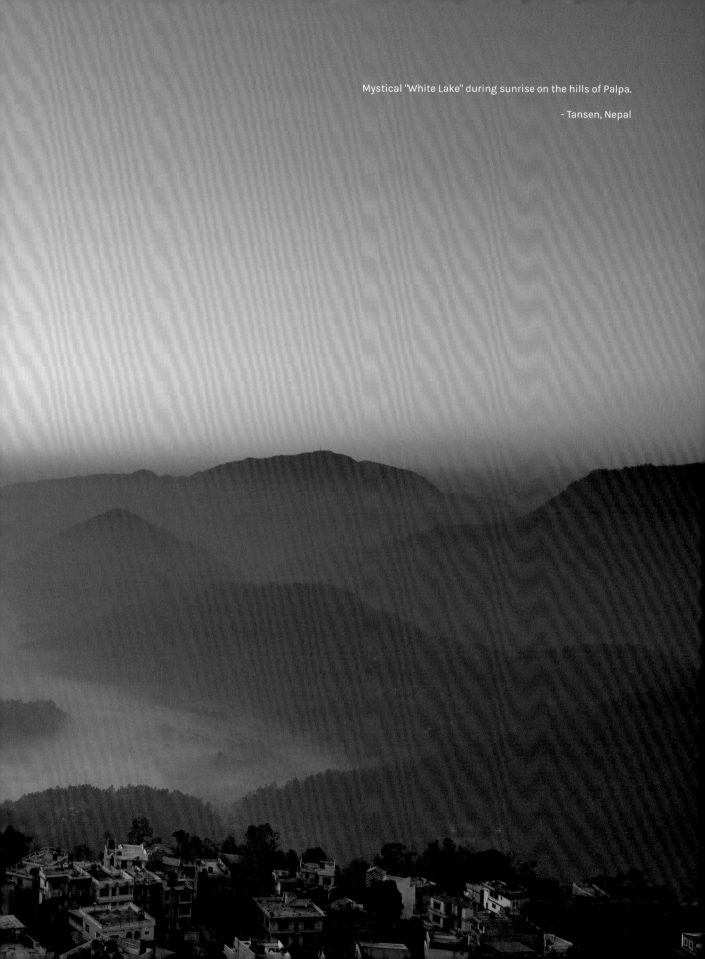

Mystical "White Lake" during sunrise on the hills of Palpa.

- Tansen, Nepal

तरकारी

Tarkari

Curries

Vegetable curry is called "tarkari" in Nepali. It is the most popular style of recipe that goes with rice or roti. Nepal produces many varieties of vegetables throughout the year, so we also have a wide array of curry recipes depending on the season.

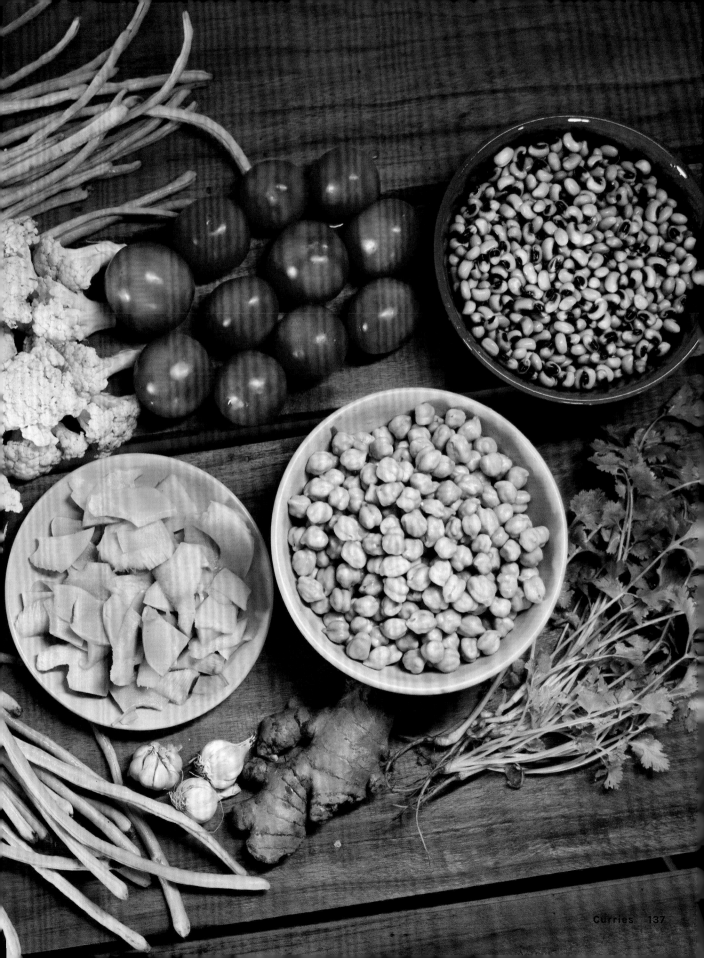

काउली

CAULI

Cauliflower Curry

Cauli is a staple of a good Nepali set. It is generally served with rice, dal, achaar, saag, and pickle. During cauliflower season in Nepal, every family delights in feasting on this nourishing entrée. Even children love cauliflower curry, regardless of whether they like vegetables.

SERVES ~ 4
COOK TIME ~ 45 minutes

INGREDIENTS

Cauliflower: 1 medium

Green pea: 1 cup

Potato: 4 small

Onion: 1 small

Tomato: 5 small

Green onion: ½ cup

SPICES

Coconut oil: 3 tbsp

Cumin seed: 1 tsp

Garlic: 5 cloves

Ginger: 4 slices

Turmeric: ½ tsp

Cumin powder: 1 tbsp

Fresh green chili: 3 medium

Cilantro: ½ cup

Salt: 1 tsp

STEPS

1. Wash the veggies and cut them into small pieces.

2. Heat a pan on medium and add oil.

3. Fry cumin seeds for few seconds and then add chopped onion and potatoes.

4. Fry for a minute and then cover the lid to cook for 2 minutes.

5. Add cauliflower, mix well, and cover for another 5 minutes on medium-low heat. Stir regularly to make sure it doesn't burn.

6. Add salt and turmeric, mix well, and cover again for 5 more minutes.

7. Add ginger, garlic paste, and cumin powder, stir thoroughly, and cover for an additional 2 minutes on medium heat. Add peas, mix well, and cover again to cook 5 minutes more on low heat.

8. Add tomatoes, stir the curry for a minute, and then cover the lid. Cook for 5 minutes on low heat.

9. Add chopped green onions and mix well. If your curry is getting dry because of the heat, add a little bit of water and then cover for another 3 minutes.

10. Add chopped cilantro on top and mix it gently. Delicious cauli curry is ready to serve.

QUICK TIPS

- ☺ *I prefer cauli and roti with some timur ko achaar on the side. If you don't have peas or green onions, your curry will still taste great.*

- ☺ *Some cauliflower cooks very quickly. In that case, adjust the time. The best time to add spices is when your cauliflower is half cooked.*

- ☺ *You can check if the cauliflower is ready by using a spatula. It should be easy to break when cooked to perfection.*

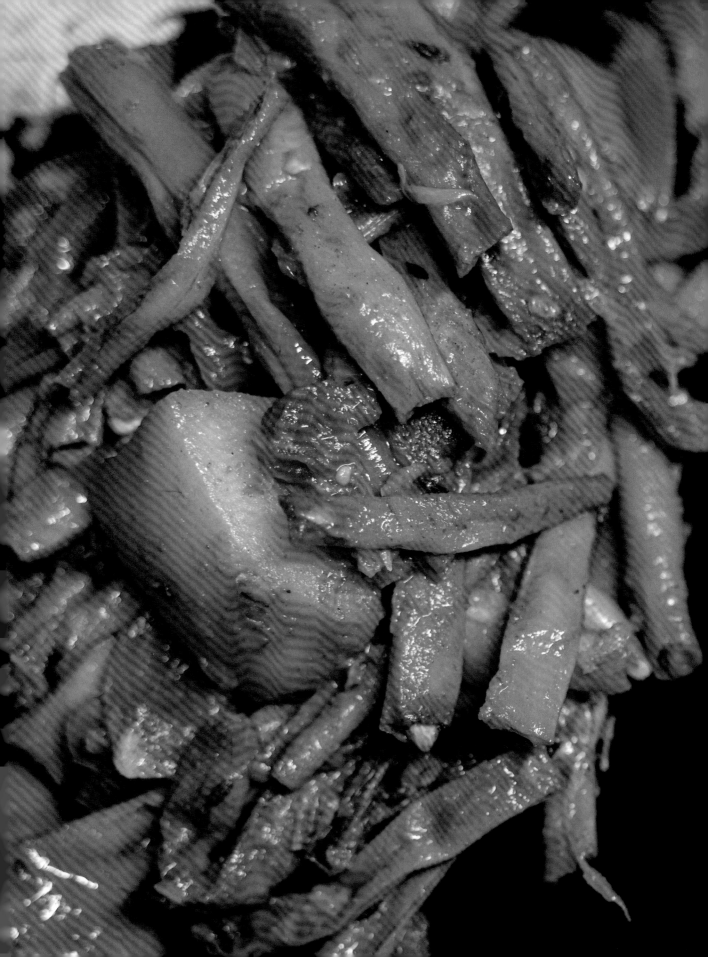

बोडी

BODI

Green Bean Curry

*Of all the beans I have ever eaten, bodi is my all-time
favorite. Bodi brings back visions of summer days in Nepal
when ropes reaching all the way to the rooftops were fully
covered with vines of hanging beans just begging to be
picked. Green bean curry has a distinct flavor that is as
appetizing as it is nourishing.*

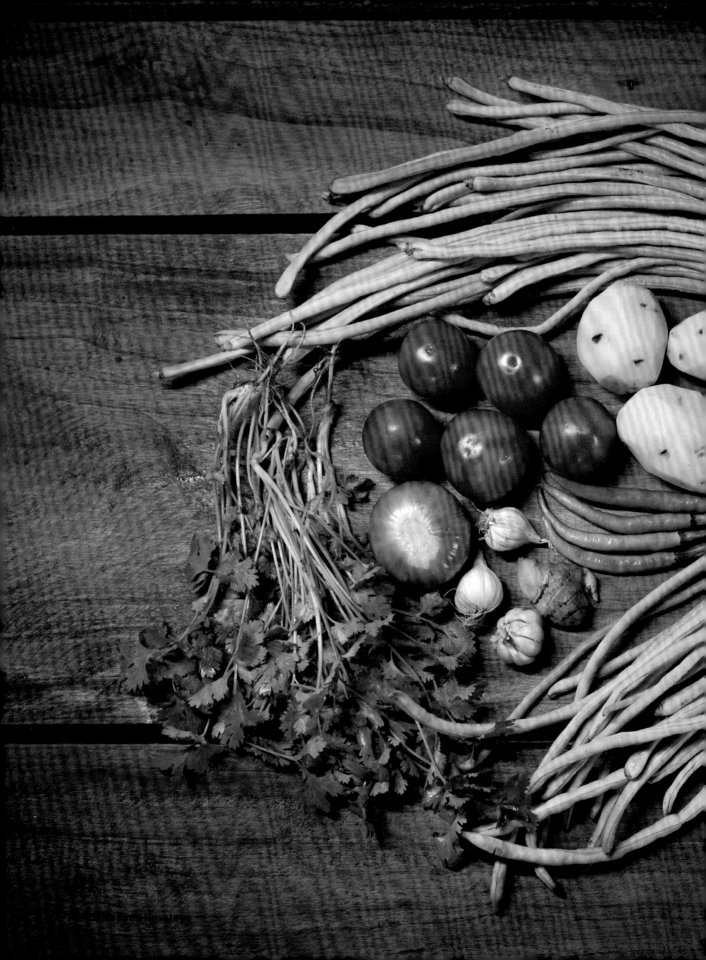

SERVES ~ 4
COOK TIME ~ 45 minutes

INGREDIENTS

Green bean: 1 lb

Onion: 1 medium

Potato: 4 medium

Tomato: 5 small

SPICES

Soybean oil: 2 tbsp

Cumin seed: 1 tsp

Fresh green chili: 4 medium

Garlic: 3 cloves

Ginger: 2 slices

Turmeric: ½ tsp

Cumin powder: 1 tsp

Cilantro: ½ cup

Salt: 1 tsp

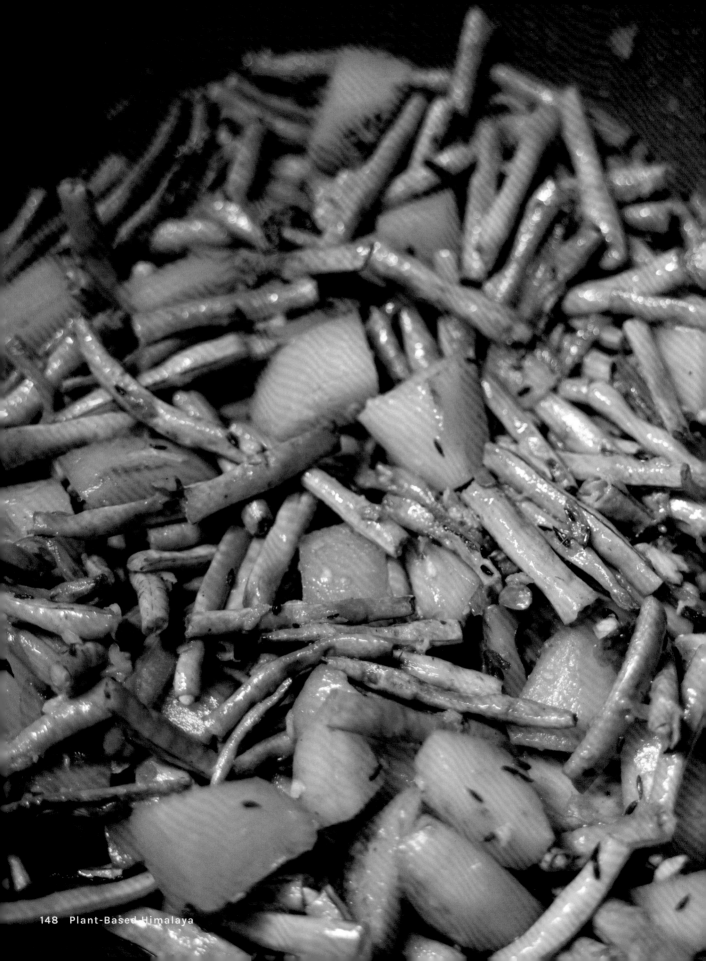

STEPS

1. Wash the green beans. Remove the ends and cut into 2" pieces.

2. Wash the potatoes and cut them evenly into small pieces.

3. Heat a pan on medium and add oil. Once the oil is hot, add cumin seeds. After a few seconds, add the chopped onion and fry for a minute.

4. Add potatoes, stir, then cover the lid for 2 minutes.

5. Add the green beans and mix for few seconds. Then add salt. Stir well and close the lid to cook for 2 minutes.

6. Stir the vegetable thoroughly and cover for an additional 2 minutes.

7. Grind the ginger and garlic with a mortar and pestle and then add to the curry. Fry the dish for 1 minute.

8. Add turmeric and cumin powder, stirring well for a minute, and then cover again to cook for 2 minutes.

9. Add chopped tomatoes, mix well, and cover. Cook on medium heat for 2 minutes more.

10. Remove the lid and stir well one last time.

11. Garnish with handful of chopped cilantro on top. The green bean curry (bodi) is ready to serve.

QUICK TIPS

☻ *I like bodi with rice, musuro ko dal, and golveda ko achaar. This is one of my absolute favorite veggies in the whole world.*

☻ *Bodi means "asparagus bean" in English. You can also cook other styles of green beans found in your area using the same method.*

☻ *This particular green bean is not found everywhere in the world, but it is a staple of Nepali cuisine.*

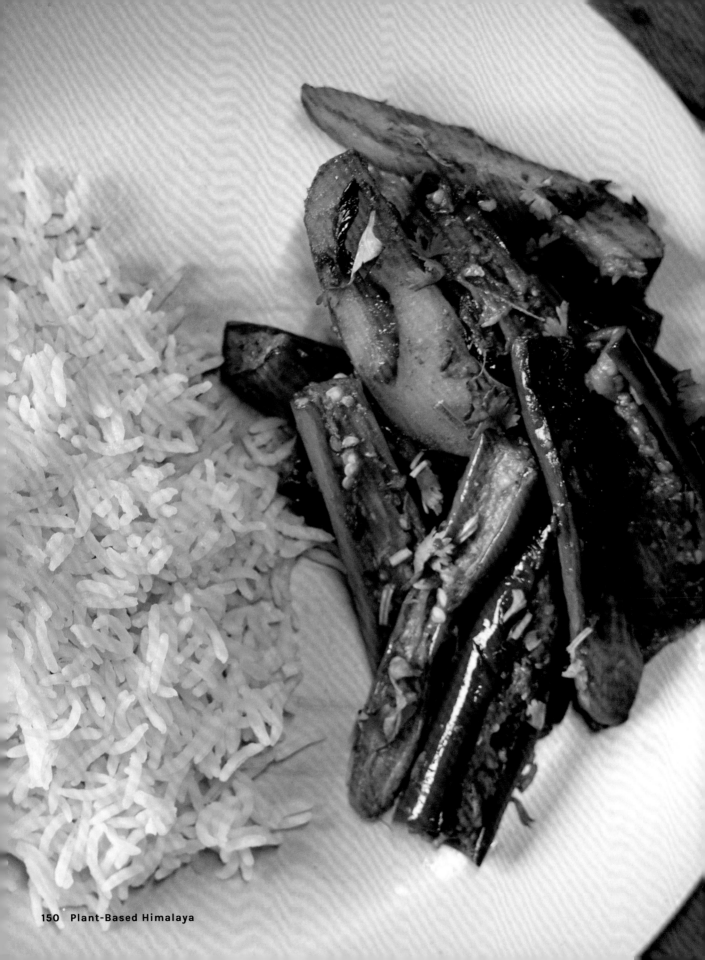

भान्टा

BHANTA

Eggplant Curry

Eggplant curry was not a dish I enjoyed until becoming vegan, mainly due to not knowing how to cook it properly. Honestly, in my experience, most restaurants do not make a delicious bhanta either. But because of this recipe, I now cherish eggplants in all shapes and sizes. An interesting fact, this nightshade is considered a berry and not a vegetable.

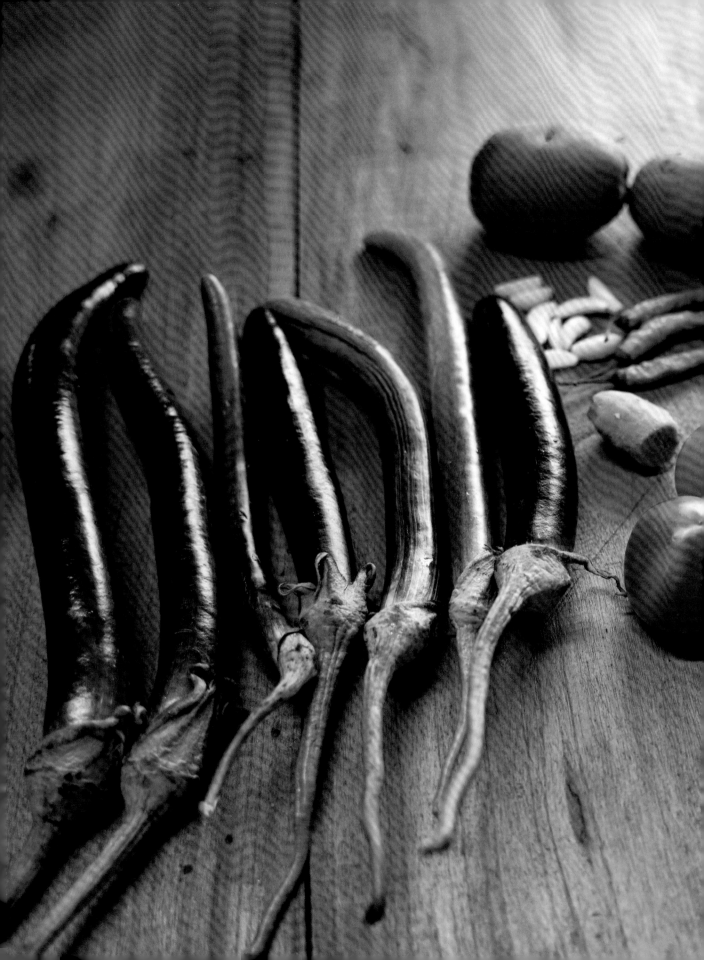

SERVES ~ 4
COOK TIME ~ 45 minutes

INGREDIENTS

Eggplant: 1 lb

Potato: 2 medium

Onion: 1 medium

Tomato: 4 medium

SPICES

Sunflower oil: 2 tbsp

Cumin seed: 1 tsp

Fresh green chili: 3 medium

Garlic: 3 big cloves

Ginger: 2 slices

Turmeric: ½ tsp

Cumin powder: 1 tsp

Cilantro: ½ cup

Salt: 1 tsp

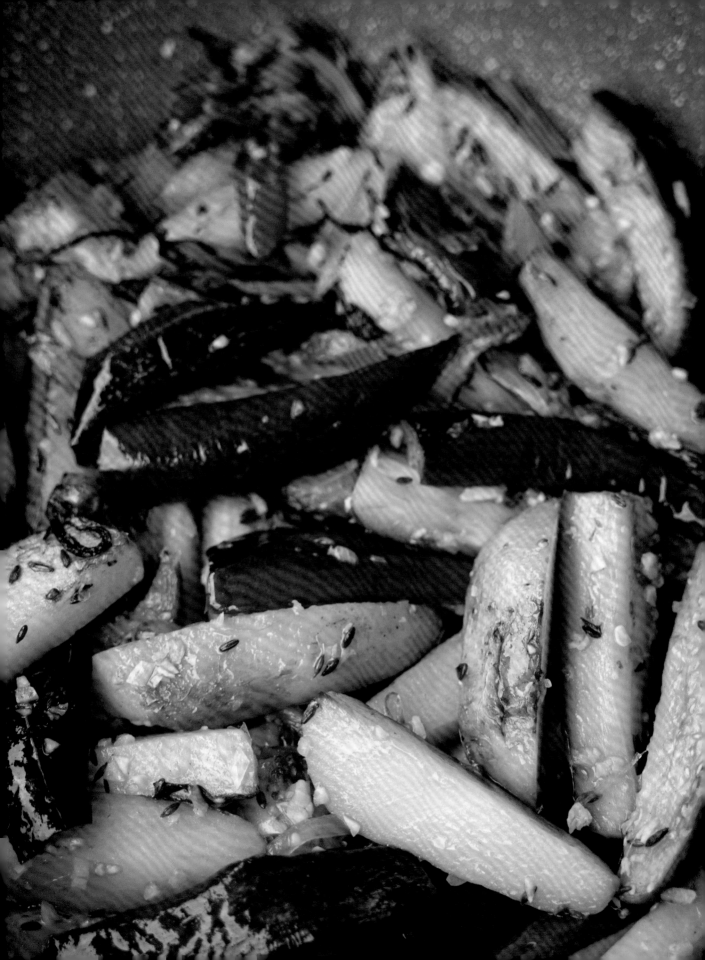

STEPS

1. Wash and cut the veggies into even sizes.

2. Heat a pan on medium and add oil. Once oil is hot, add the cumin seeds. When it starts to crackle, add onion and potatoes. Fry for a few seconds and then cover with a lid.

3. Cook for 4 minutes on medium heat. Stir it and again cook with the lid on for 3 minutes.

4. Add eggplant, turmeric, and salt. Mix it all together, cover, and cook for 3 more minutes.

5. Stir it again and then cover for another 3 minutes.

6. Grind ginger and garlic, and add in the pan. Fry for a minute and then add cumin powder. Stir thoroughly, cover, and then cook the dish for 5 minutes on medium heat.

7. Add chopped tomatoes and stir well. Again, cover and cook for 5 minutes more.

8. Add chopped cilantro and mix the curry.

9. Delicious eggplant curry is ready to serve!

QUICK TIPS

- *I like eggplant curry with rice, musuro ko dal, and timur ko achaar. It is also fantastic with roti and can be used making wraps and sandwiches.*

- *I use the long and slender eggplants. I cut them lengthwise into 4" pieces. Once the eggplant is cooked, it is soft and mushy, so I don't cut it into small pieces. If you can find only round eggplants, just make sure to cut them in bigger sections.*

- *I used to cook eggplant curry with water to make gravy, but then I discovered the trick of not adding water, and it has completely changed the taste of my curry. Eggplant is my absolute favorite vegetable, and I'm able to make many different recipes using just this one "berry".*

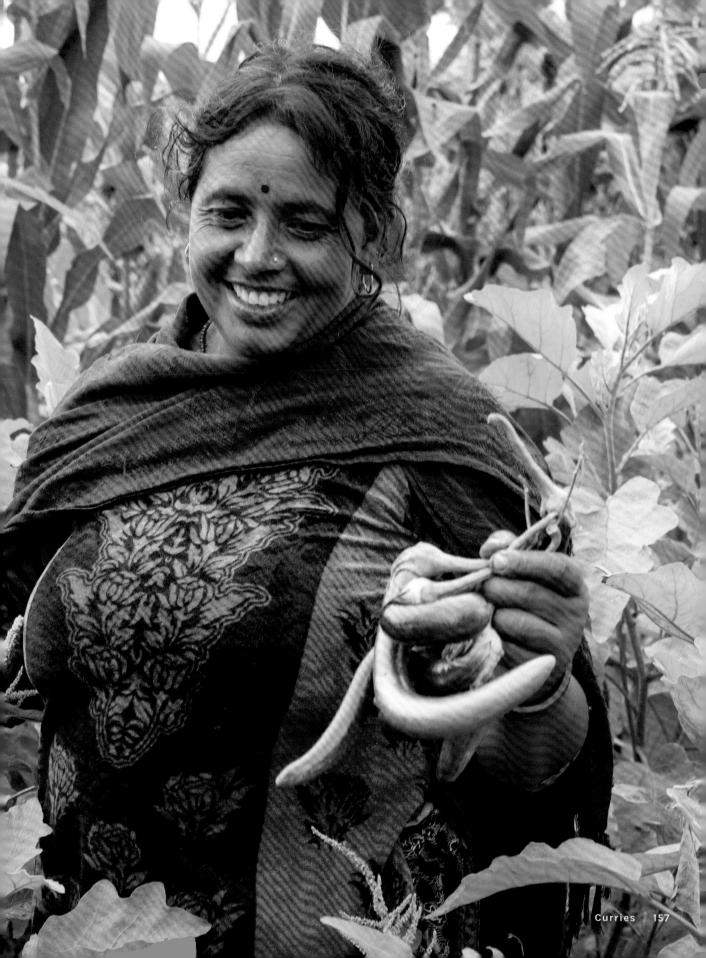

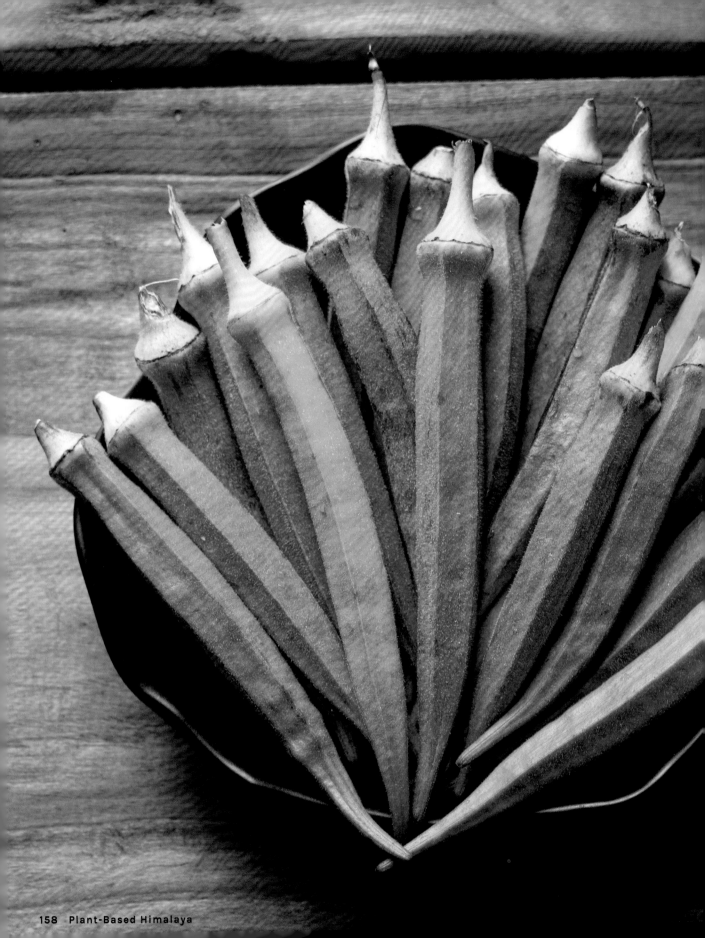

भिन्डी

BHINDI

Okra Curry

Okra curry has held a special place in my heart and stomach since I was very young. I will never forget the day my mother taught me how to master bhindi. The flavors were so good that my mouth waters just thinking about it. Even now just the smell of okra curry cooking in the pan reminds me of my aama.

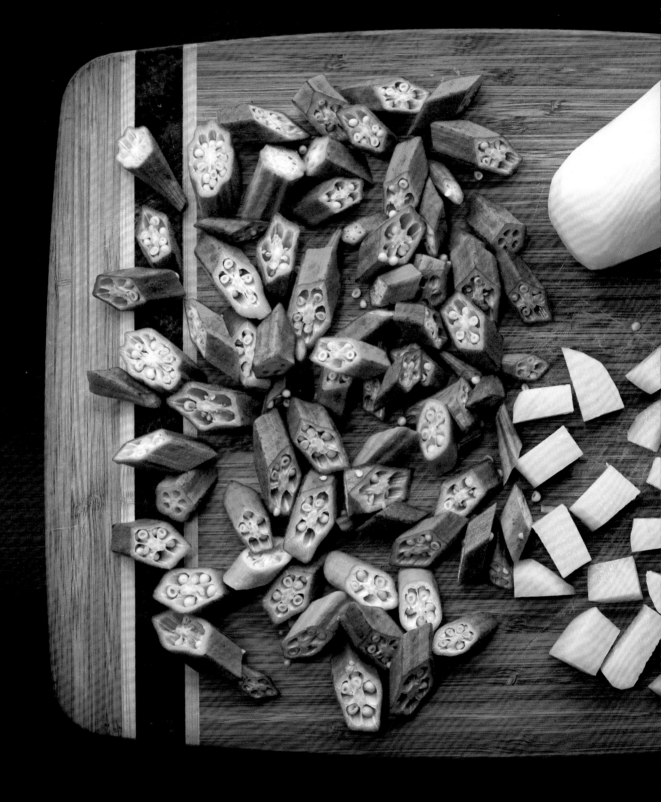

SERVES ~ 4
COOK TIME ~ 1 hour

INGREDIENTS

Okra: 1 lb

Onion: 1 medium

Potato: 2 medium

Tomato: 4 small

SPICES

Sunflower oil: 2 tbsp

Cumin seed: 1 tsp

Mustard seed: ½ tsp

Dried red chili: 2 medium

Fresh green chili: 3 medium

Garlic: 3 cloves

Ginger: 2 slice

Cumin powder: 1 tbsp

Turmeric: ½ tsp

Cilantro: ½ cup

Salt: 1 ¼ tsp

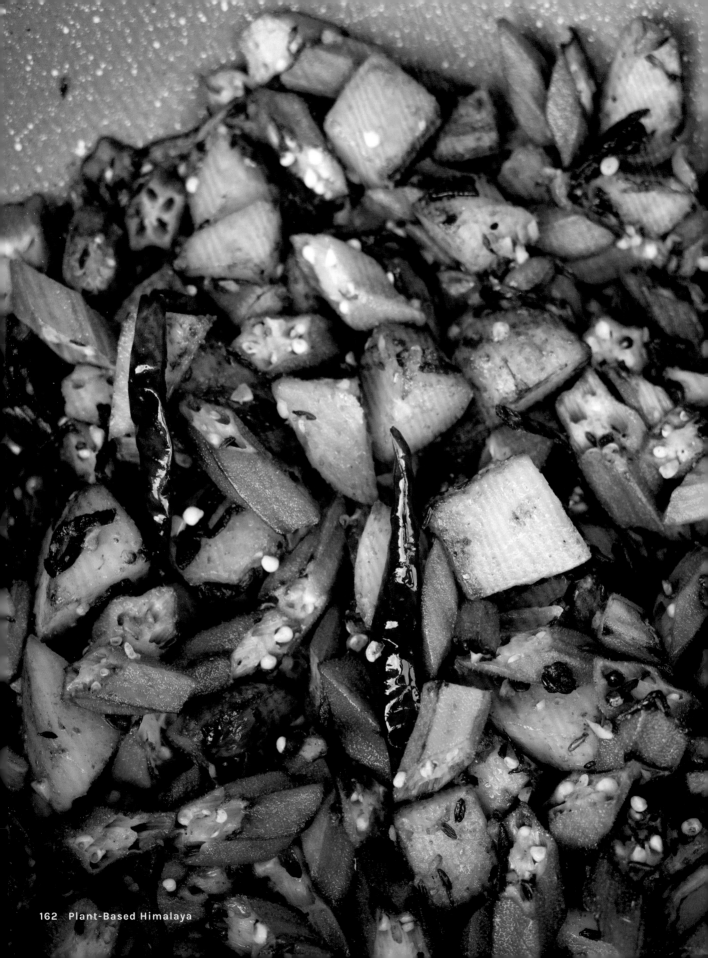

STEPS

1. Wash the okra and dry with a cotton cloth.

2. Cut the okra evenly into thin slices.

3. Wash the potatoes and chop them into tiny cubes about the same size.

4. Heat a pan on medium and add oil. Once the oil is hot, add cumin seeds, mustard seeds, and whole dried red chilis.

5. When the seeds start crackling, add finely chopped fresh green chilis and thinly chopped onions. Fry for a few seconds and add potatoes.

6. Mix well and cover to cook for 2 minutes in medium heat.

7. Remove the lid and stir. Cover again and cook for 2 minutes more.

8. Add okra, mix, and cover for another 5 minutes in medium low heat.

9. Grind ginger and garlic with a mortar and pestle. Add them to the curry and fry for a minute. Cover again and cook for 2 minutes.

10. Stir and then add cumin powder, turmeric, and salt. Mix and fry for 2 minutes in medium heat. Cover and cook for 2 minutes more.

11. Take the lid off and stir for a minute.

12. The potatoes and okra should be cooked by now. Add chopped tomatoes, mix, and cover for the final 2 minutes in medium heat.

13. Take the lid off, mix the curry, garnish with cilantro, and enjoy. Spicy okra curry is now ready to serve.

QUICK TIPS

- *I prefer okra with rice and golveda ko achaar. Sometimes I also make spicy okra without tomatoes.*

- *I usually wash okra the night before I plan on cooking so it is completely dry the next day.*

- *This recipe can be a good topping for sandwiches, wraps, and even pizza.*

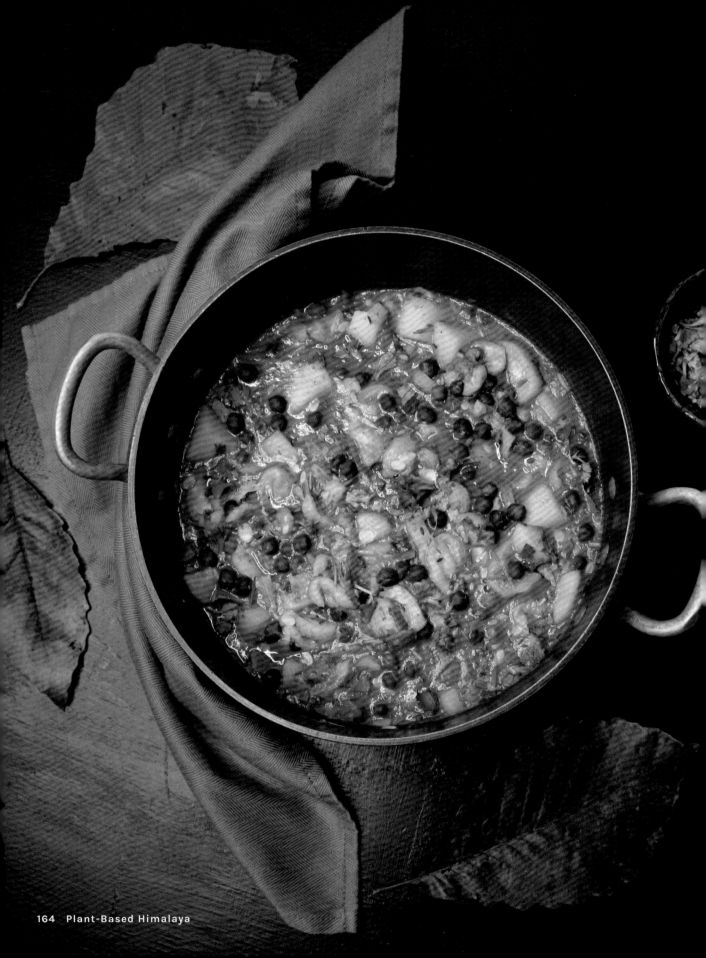

जना धिरौला

CHANA GHIRAULA

Chickpea and Sponge Gourd Curry

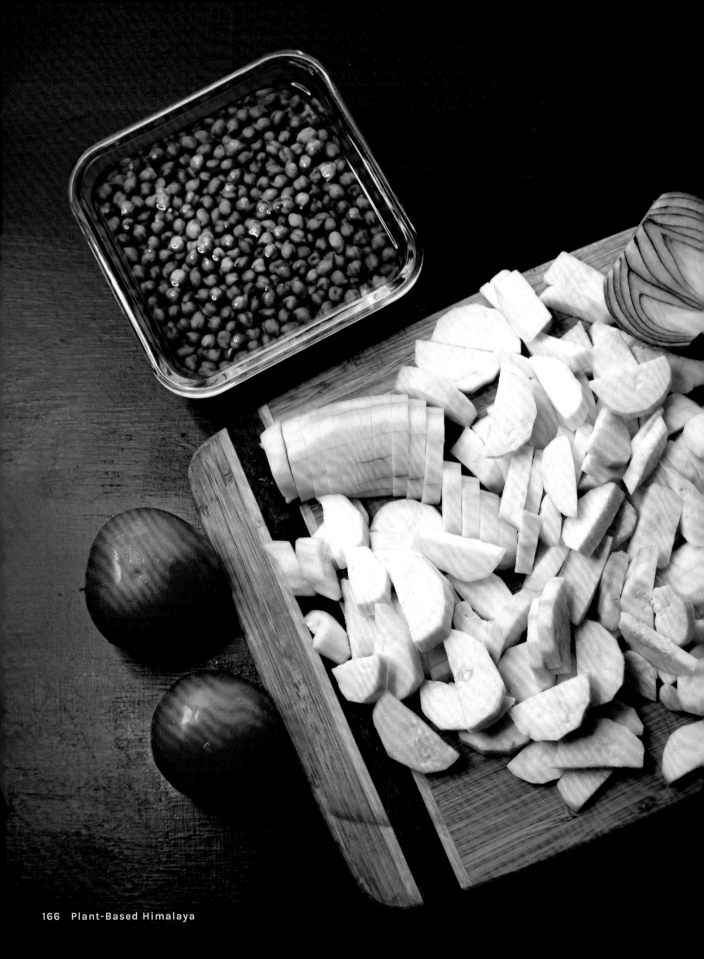

SERVES ~ 4
COOK TIME ~ 45 minutes

INGREDIENTS

Chickpea: 1 cup

Sponge gourd: 1 lb

Tomato: 2 medium

Potato: 2 medium

Red onion: ½ medium

SPICES

Coconut oil: 2 tbsp

Cumin seed: 1 tsp

Bay leaf: 2 leaves

Garlic: 5 cloves

Ginger: 4 slices

Red dried chili: 2 medium

Fresh green chili: 3 medium

Cilantro: ½ cup

Cumin powder: 1 tbsp

Turmeric: ½ tsp

Salt: 1 tsp

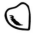

STEPS

1. Wash chana (chickpea) and soak overnight in 4 cups of water (if you use dried chana).

2. Boil the chana in a pressure cooker with the water and ½ teaspoon of salt on medium heat.

3. Once the whistle blows (usually around 10 minutes), turn the heat to low and continue to cook for 10 minutes more. Turn the heat off and let it cool.

4. Wash ghiraula (sponge gourd) and peel the skin. Cut into small pieces (¼ inch).

5. Heat a pan in medium and add oil. Once the oil is hot, add cumin seed and whole dried red chilis. Fry for few seconds and then add chopped onion and green chilis.

6. Fry for few seconds and add chopped potatoes. Mix and cover for 2 minutes.

7. Take the lid off, stir, and cover again. Continue to cook for 5 minutes.

8. Grind ginger and garlic. Add to the curry and fry for 1 minute. Now add turmeric and cumin powder.

9. Mix the gravy well and add the boiled chana. Fry for a minute and then add ghiraula and salt. Mix everything and cover.

10. Cook for around 10 minutes on medium heat, periodically removing the lid to stir and release some of the moisture.

11. Add tomatoes, mix, and cover with the lid for the final 2 minutes.

12. Garnish with cilantro, and the delicious chana ghiraula is ready to serve.

QUICK TIP

☻ *I absolutely love this dish, especially on top of rice with a side of timur ko achaar. It has a very unique flavor and is a seasonal specialty of mine.*

☻ *I usually buy baby ghiraula because they are more flavorful and cook faster. Old ghiraula doesn't have the same flavor. Any local gourd you can get should work. If your dish is too watery, remove the lid, turn the heat up, and smash some boiled chickpea with a spoon to thicken the gravy.*

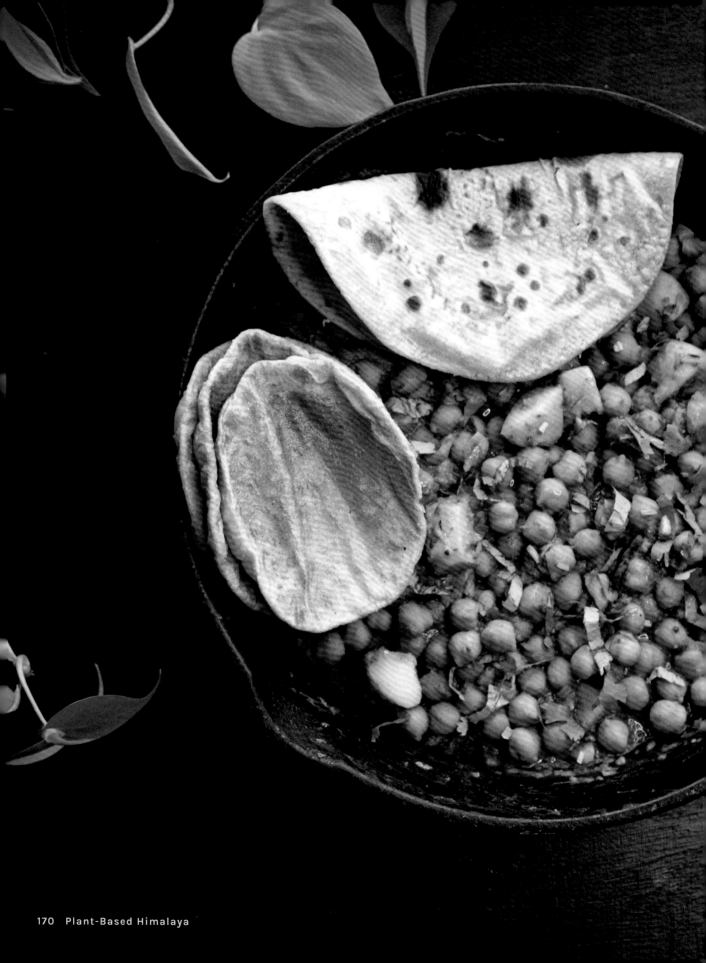

काबुली चना

KABULI CHANA

Chickpea Curry

Chickpea curry with puri has always been and will always be my go-to comfort food. This is our weekend treat in Nepal, much like ordering a favorite pizza in America. Even now I am sure to make kabuli chana for any special occasion, when I want to celebrate, or just to boost my mood.

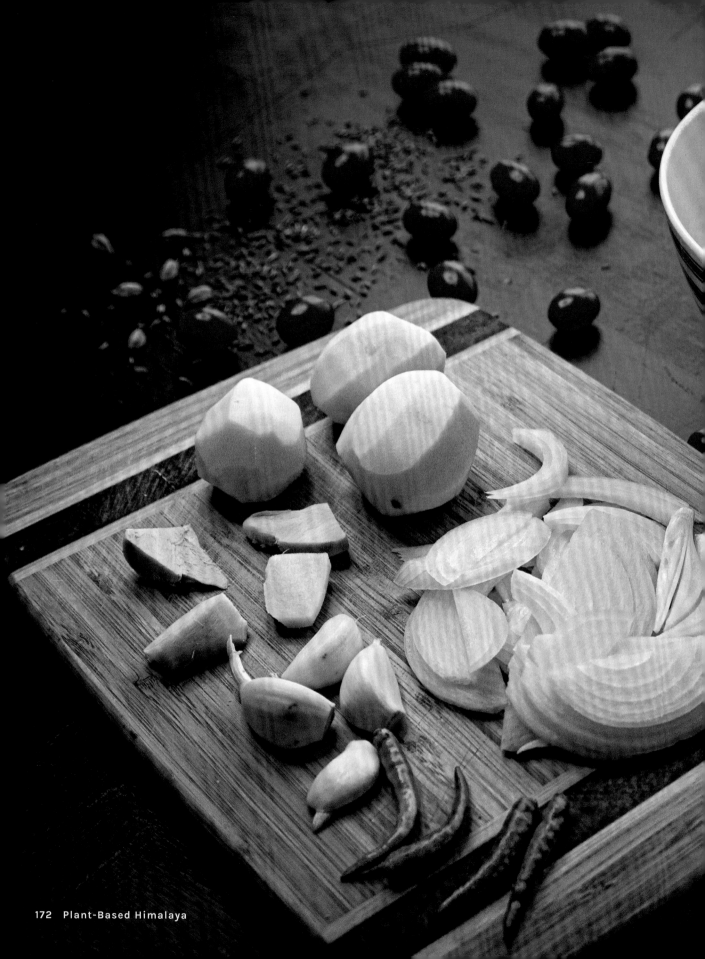

SERVES ~ 4
COOK TIME ~ 1 hour

INGREDIENTS

Chickpea: 1 cup

Potato: 3 small

Onion: 1 medium

Tomato: 5 small

Coconut milk: ½ cup

SPICES

Coconut oil: 2 tbsp

Cumin seed: 1 tsp

Dried red chili: 2 medium

Cumin powder: 1 tbsp

Cardamom powder: ½ tsp

Garlic: 4 cloves

Ginger: 4 slices

Turmeric: ½ tsp

Fresh green chili: 4 medium

Cilantro: ½ cup

Salt: 1 tsp

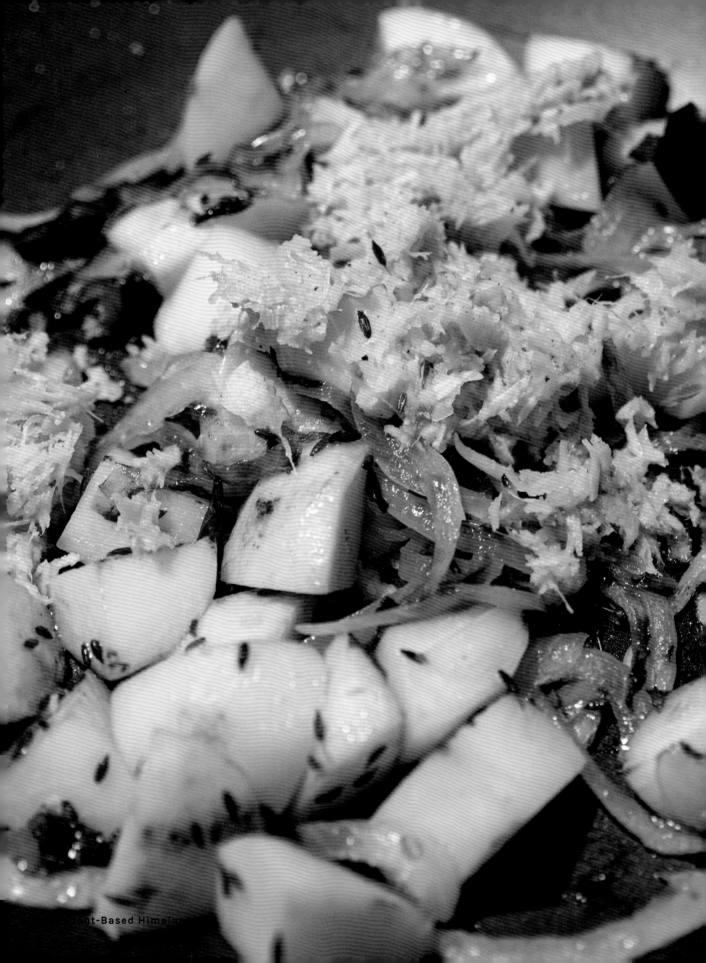

STEPS

1. Wash the chickpeas and soak them overnight. Sometimes, I soak them for 2 days in the fridge to expand fully.

2. On medium heat, boil the chickpeas in a pressure cooker with ¼ teaspoon of salt and turmeric. Once the whistle blows, lower the heat and cook them for another 10 minutes. I like them perfectly cooked but not too mushy.

3. Heat a pan on medium and add oil. Once the oil is hot, add cumin seeds and whole dried red chilis. Temper for a few seconds and then add thinly sliced onion.

4. Fry for several seconds and then add chopped potatoes. Stir and cover. Cook for 2 minutes on medium heat.

5. Take the lid off. Add salt and mix. Cover and cook for 2 minutes.

6. Grind ginger and garlic with a mortar and pestle and add to the curry. Fry for a minute until they look brownish and then add rest of the turmeric, salt and cumin powder. Mix everything together and cook until potatoes are cooked.

7. Drain the chickpea water into a bowl for later use. Then add boiled chickpea into the curry. Fry for a minute until the water evaporates.

8. Add chopped tomatoes and ground cardamom powder. Mix the curry well, cover, and cook for 5 minutes on medium heat.

9. Take the lid off, stir the curry, and then add coconut milk and the water that you previously saved as per your need. Boil for a minute.

10. Garnish with cilantro on top, and the delicious chickpea curry is ready.

QUICK TIPS

- ☻ *Kabuli chana/chana masala/chickpea curry is amazing with puri.*

- ☻ *This curry will also taste really good without potato or coconut milk if you don't have those in the kitchen.*

- ☻ *I like my curry thick, but if you want to eat it as a soup, add some extra boiled water to suit your taste. This curry is always a hit at my parties. Enjoy!*

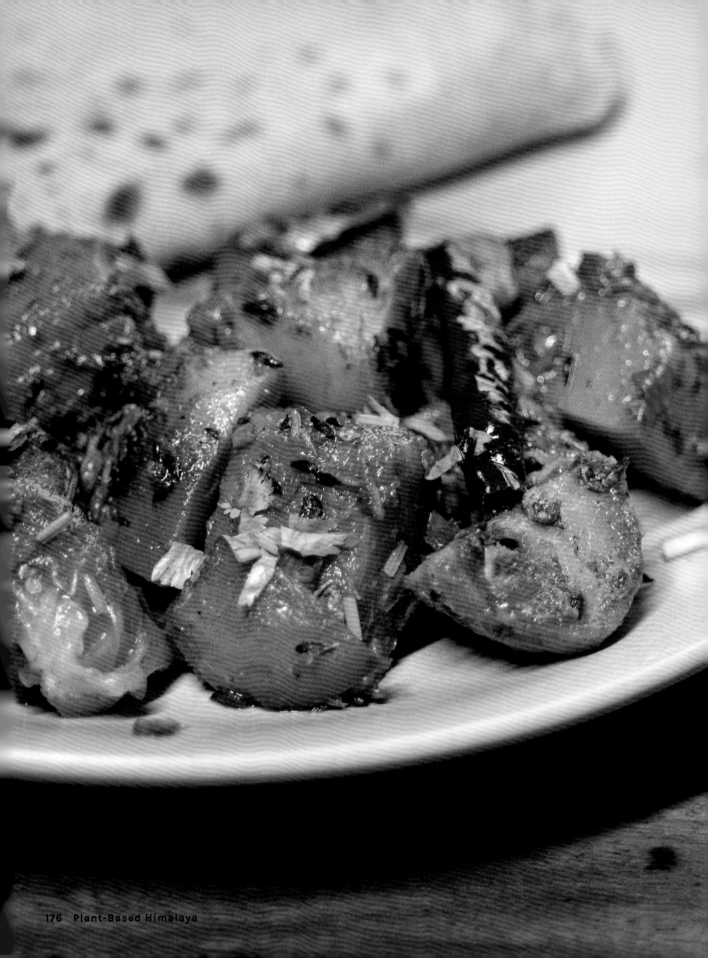

फरसी

FARSI

Pumpkin Curry

Pumpkin curry is a sweet and savory dish that is completely different from the pumpkin pies and soups made in the West. Farsi is technically a fruit and is highly nutritious. Every part of the pumpkin plant is edible, but in this recipe we use only the inside. I suggest making a saag out of the leaves to pair with the curry.

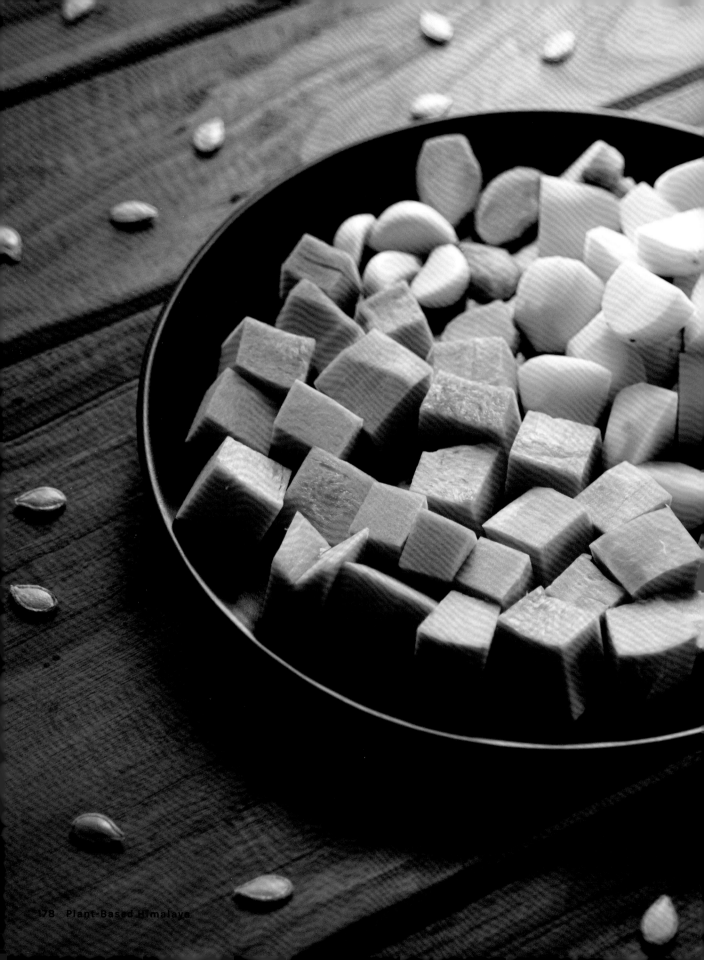

SERVES ~ 4
COOK TIME ~ 45 minutes

INGREDIENTS

Pumpkin: 1 lb

Potato: 2 medium

Tomato: 4 small

SPICES

Sunflower oil: 2 tbsp

Cumin seed: 1 tsp

Garlic: 3 cloves

Ginger: 4 slices

Turmeric: ½ tsp

Fresh green chili: 2 medium

Dried red chili: 2 medium

Cilantro: ½ cup

Black pepper: ⅛ tsp

Salt: 1 tsp

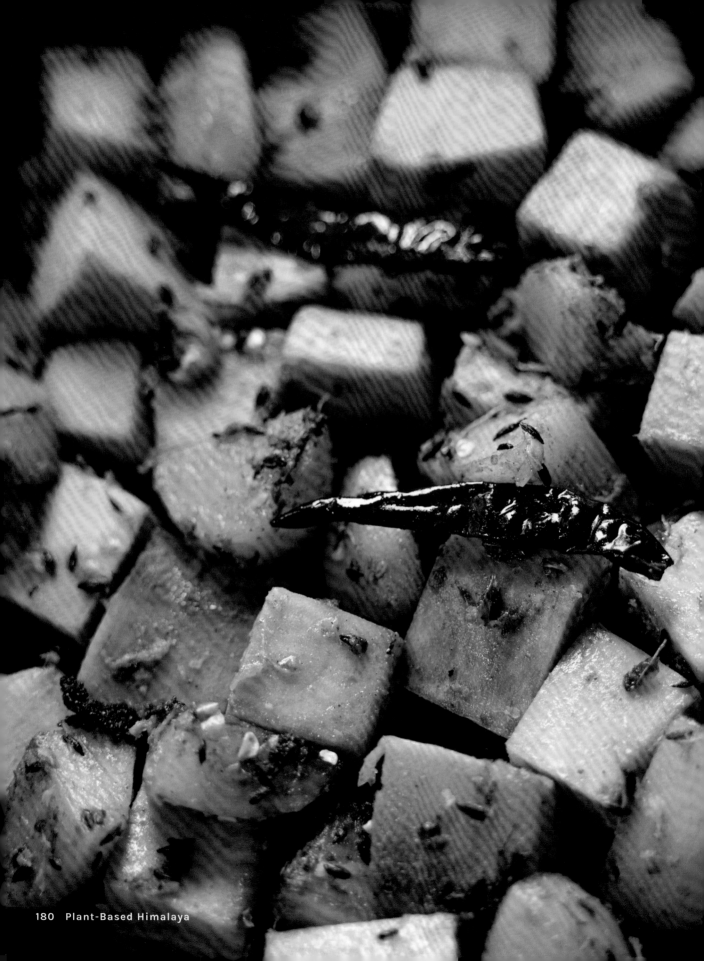

STEPS

1. Wash the potatoes thoroughly and chop them into evenly sized cubes.

2. Peel the skin of the pumpkin with a knife and cut the flesh into cubes the same size as the potatoes.

3. Heat a pan on medium and add oil. Once the oil is hot, add cumin seeds and whole dried red chilis. Fry for a few seconds.

4. Add chopped potatoes, mix well, and cover to cook for 2 minutes on medium heat.

5. Grind garlic, ginger, and black pepper with a mortar and pestle. Then add to the curry and mix well. Cover again and cook for 2 minutes.

6. Take the lid off. When the spices start to look golden brown, add cumin powder and turmeric. Stir well and then add pumpkin, finely chopped fresh green chilis, and salt. Add a tablespoon of water so the curry will not burn on the bottom of the pan. Mix and replace the lid for 3 minutes, cooking on medium low heat.

7. Open the lid and stir. Cover again and cook for an additional 10 minutes. Let the curry cook nice and slow. Stir the curry every 2 minutes so it won't burn on the bottom.

8. Add chopped tomatoes and mix thoroughly. Close the lid and cook for the final 5 minutes on medium heat.

9. Garnish with finely chopped cilantro on top. The soft and delicious pumpkin curry is ready to serve.

QUICK TIPS

- I prefer pumpkin curry with roti, but it also tastes great with rice.

- Be careful while peeling pumpkin skin. It is hard, so your knife might slip and cut your finger.

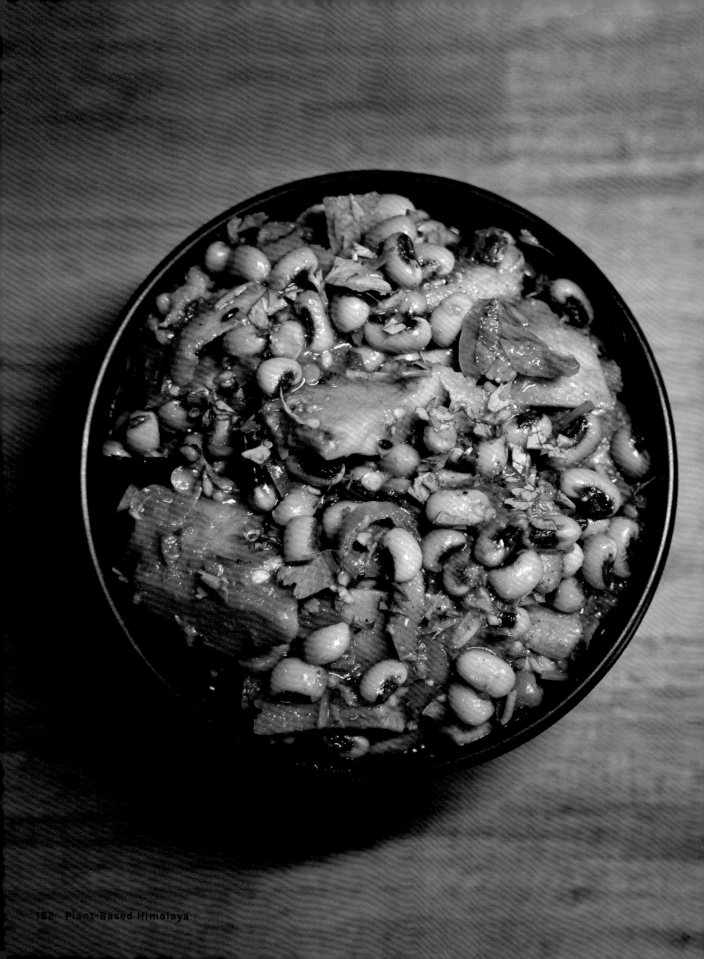

आलु तामा

AALOO TAMA

Bamboo Shoot Curry

A cornerstone of Newari cuisine, bamboo shoot curry is extremely beneficial to healthy living. It's a nostalgic reminder of frigid winter days in Kathmandu and everyone coming together for our Newari bhoj, a cultural feast. Aaloo tama is a hearty soup that will surely enrapture your senses.

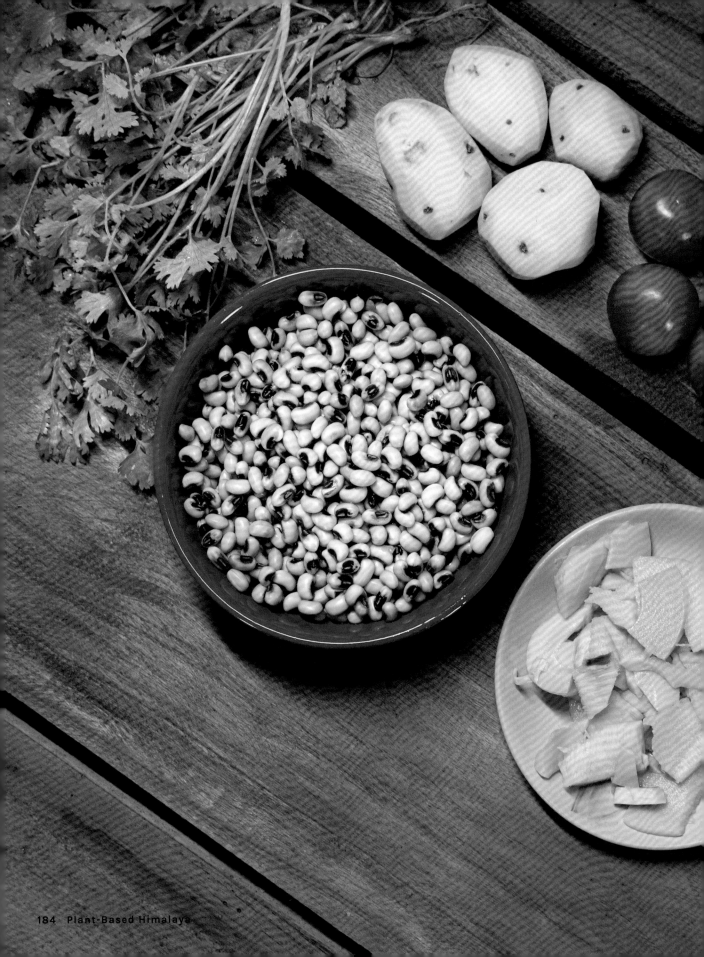

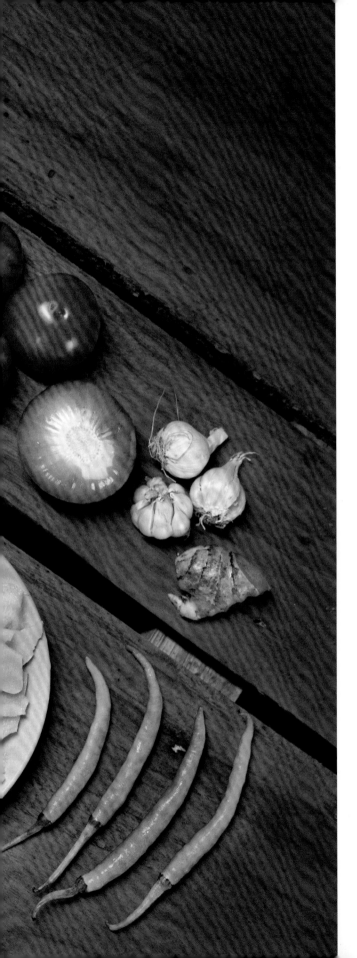

SERVES ~ 4
COOK TIME ~ 45 minutes

INGREDIENTS

Bamboo shoot: 1 cup

Potato: 4 small

Black-eyed pea: 1 cup

Red onion: 1 medium

Tomato: 5 small

SPICES

Sunflower oil: 2 tbsp

Cumin seed: 1 tsp

Cumin powder: 1 tbsp

Fresh green chili: 4 medium

Ginger: 6 slices

Garlic: 5 cloves

Turmeric: ½ tsp

Black pepper: ⅛ tsp

Cilantro: ½ cup

Salt: 1 tsp

STEPS

1. Soak the black-eyed peas in 2 cups of water overnight or for at least 8 hours.

2. Boil the peas in a pressure cooker with ½ teaspoon of salt and a hint of turmeric. Turn the heat off after one whistle. They cook easily.

3. Heat a pan on medium and add oil. Once the oil is hot, add cumin seeds. Temper them for few seconds and then add thinly sliced onion.

4. Fry for a minute. Then add chopped potatoes and salt. Stir and cover for 2 minutes.

5. Take the lid off, stir it well, and then cover and cook for another 2 minutes.

6. Grind the ginger and garlic with a mortar and pestle. Add all the spices to the curry. I make sure the potatoes are nicely half cooked when I add spices. Fry for a minute until they look golden brown, and then add cumin powder and turmeric. Mix well.

7. Add bamboo shoots and mix thoroughly for a minute or so, and then add chopped tomatoes. Stir and cover to cook for 2 minutes.

8. Add the boiled black-eyed peas to the curry, mix everything and cover to cook for the final 5 minutes on low heat.

9. Garnish with cilantro on top, and the mouthwatering bamboo shoot curry is ready to serve.

QUICK TIPS

- *Bamboo shoot curry is best when paired with rice and timur ko achaar. I smash some cooked potatoes and beans to make the gravy thick.*

- *Bamboo shoot curry is a staple Nepali/Newari dish. We usually eat this curry during the winter season to keep us warm. You can also add extra water and eat as soup with a piece of your favorite bread.*

- *Bamboo shoot is not trendy yet, but this most nutritious food is a hit among adults and kids alike during my cooking classes.*

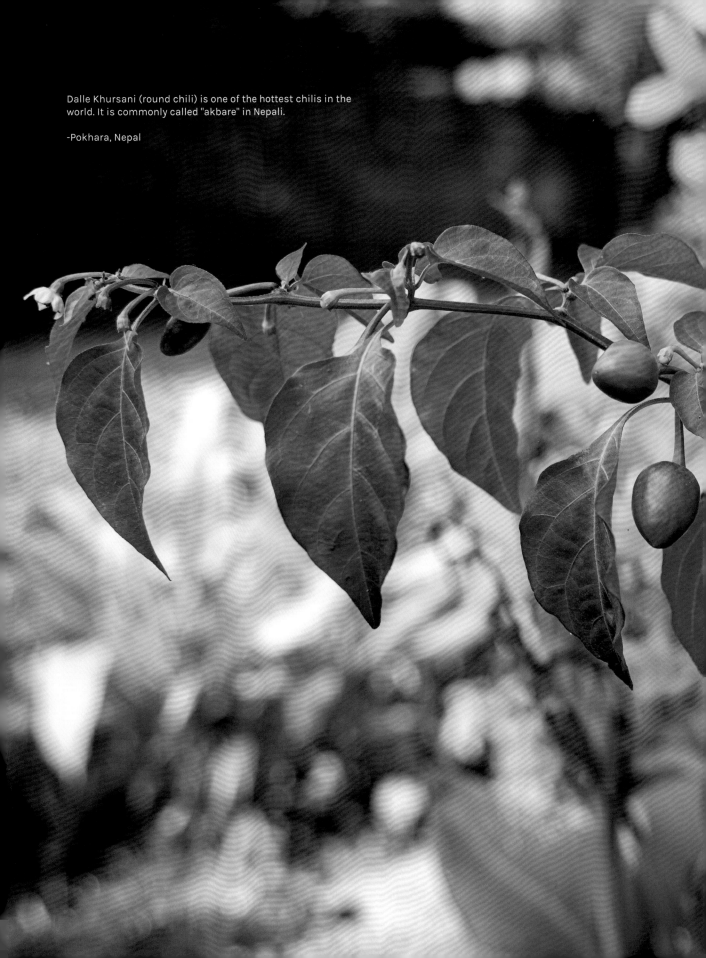

Dalle Khursani (round chili) is one of the hottest chilis in the world. It is commonly called "akbare" in Nepali.

-Pokhara, Nepal

साग
Saag

Greens

Saag means "green-leaf vegetables" in Nepali. It is extremely hard to find wide varieties of saag in many places around the world, but Nepal has a multitude of flavors of greens depending on the season. Most of the time it is the most nutritious part of a plant. They are also very rich in iron and antioxidants. I eat saag to keep my eyesight clear and to maintain a healthy gut.

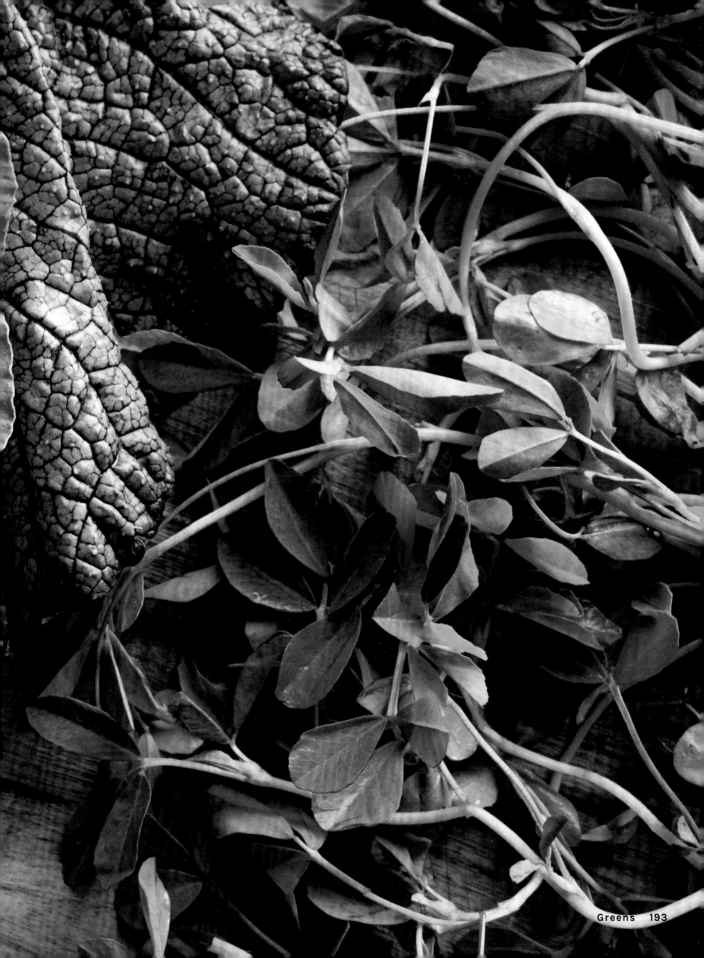

मेथी

METHI

Fenugreek Greens

Even though fenugreek greens grow almost anywhere in Nepal, I did not eat them myself until I was a teenager. I love saag, and discovering new seasonal greens to add to my diet is a passion of mine. Besides being rich in vitamin K, methi is an antioxidant and an excellent source of iron.

SERVES ~ 4
COOK TIME ~ 30 minutes

INGREDIENTS

Fenugreek green: ½ lb

Potato: 2 medium

Tomato: 4 small

Red onion: 1 medium

SPICES

Sunflower oil: 1 tbsp

Cumin seed: 1 tsp

Cumin powder: ½ tsp

Turmeric: ¼ tsp

Ginger: 2 slices

Garlic: 2 cloves

Fresh green chili: 1 medium

Salt: ¾ tsp

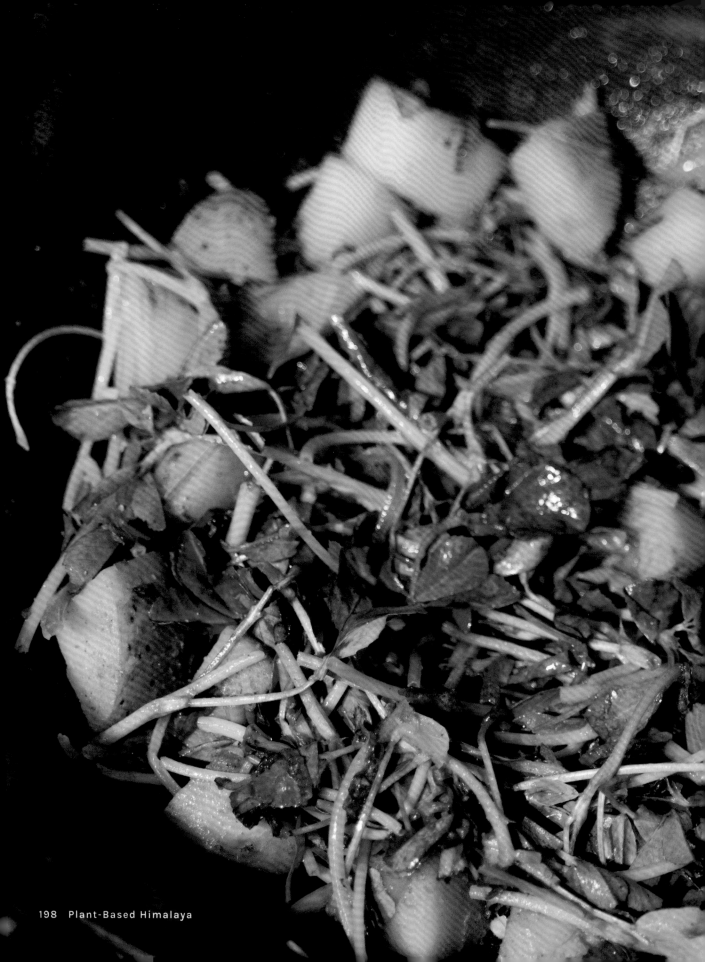

STEPS

1. Remove the leaves from the stem of the fenugreek greens and put them in a bowl.

2. Wash the greens thoroughly, at least three times, because most saag is full of dirt.

3. Chop the onion into thin slices and the potatoes into cubes.

4. Heat a pan on medium and add oil.

5. Once the oil is hot, temper cumin seeds for few seconds and then add the onion and potatoes. Fry for a minute and add salt. Mix it well. Cover and cook for 2 minutes.

6. Stir it well and cover again. Cook for another 2 minutes.

7. Grind the ginger and garlic with a mortar and pestle. Add spices to the pan and fry for 1 minute. Then add cumin powder and turmeric and mix for a few seconds until the spices turn golden brown.

8. Turn the heat to low and cover with the lid for a minute or so.

9. Once the potato is cooked, add chopped tomatoes, mix well and cover for 2 minutes.

10. Add the fenugreek greens and mix well. Cover and cook for 2 more minutes.

11. Stir the saag again and cover for the last minute.

12. Methi saag is now ready to serve.

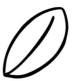

QUICK TIPS

- *Methi saag is the perfect companion to roti and golveda ko achaar.*

- *Be careful not to overcook these greens as the flavors may change.*

- *Salt causes the saag to shrink, so use salt sparingly.*

पालुँगो

PALUNGO

Spinach

*No Nepali set is complete without saag, and spinach is
Nepal's favorite. If it was in season year-round, I would
eat palungo every day. It is also an indispensable dish in a
Newari "Samay Baji" set served during festivals like Indra
Jatra, Dashain, and Tihar.*

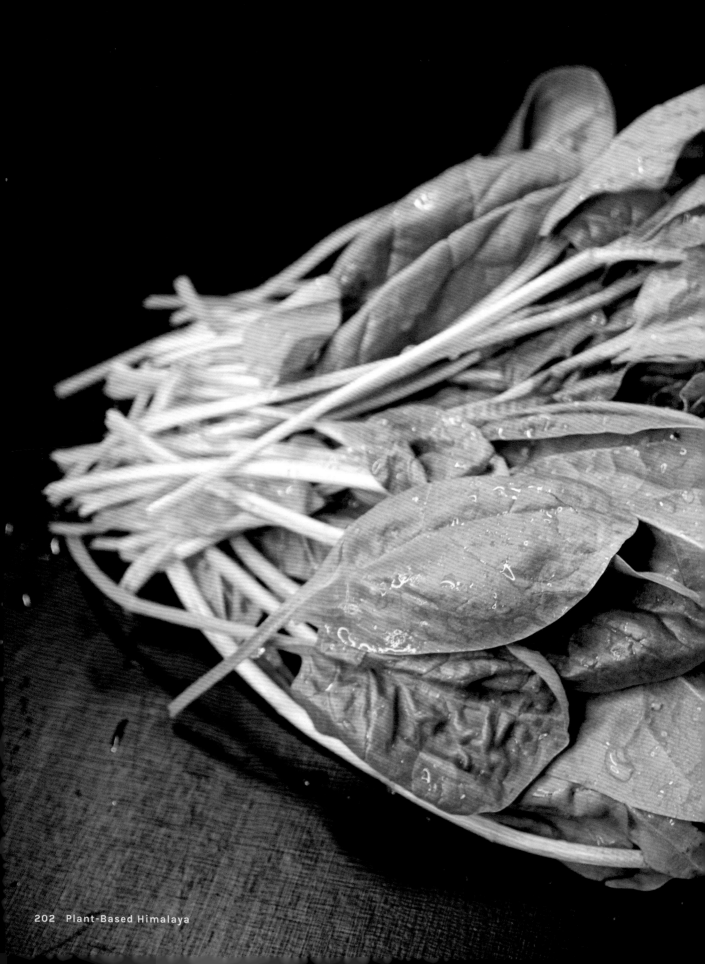

SERVES ~ 4
COOK TIME ~ 10 minutes

INGREDIENTS

Spinach: 1 lb

Onion: 1 small

SPICES

Sunflower oil: 1 tsp

Garlic: 2 cloves

Fresh green chili: 1 medium

Salt: ½ tsp

STEPS

1. Wash the spinach thoroughly in water and drain in a strainer.

2. Heat a pan on medium and add oil.

3. Once the oil is hot, add chopped onion, sliced garlic, and chopped fresh chilis. Fry until they turn golden brown.

4. Add spinach and salt, mix well, and cover with a lid for a minute.

5. Remove the lid and stir the saag.

6. Saute for a minute longer on high heat if you want to dry up the water.

7. Delicious and juicy spinach saag is ready to serve!

QUICK TIPS

☺ *I like spinach saag with rice, dal, and golveda ko achaar. I also cook fried potatoes on the side for more flavors. This is my favorite Nepali set.*

☺ *Wash the spinach at least three times, because fresh greens from the market can be sandy. I do not like the taste of sandy saag. You can also chop the saag in small pieces. I usually like to break them in the middle.*

☺ *Some saag leaves a lot of water. If you like your saag drier, turn the heat high once it is fully cooked and cook off the excess water.*

☺ *I prefer a soupy saag with some juices. Sometimes I even use it as flavoring for my rice and skip making dal.*

राेयो

RAYO

Mustard Greens

Mustard greens are the most common vegetable grown during the winter season in Nepal and are essential in Nepali cuisine. Rayo grows all the way from the Terai up to the mountain regions of Nepal. With a bitter, somewhat spicy flavor, mustard greens are an immunity booster and excellent for heart health.

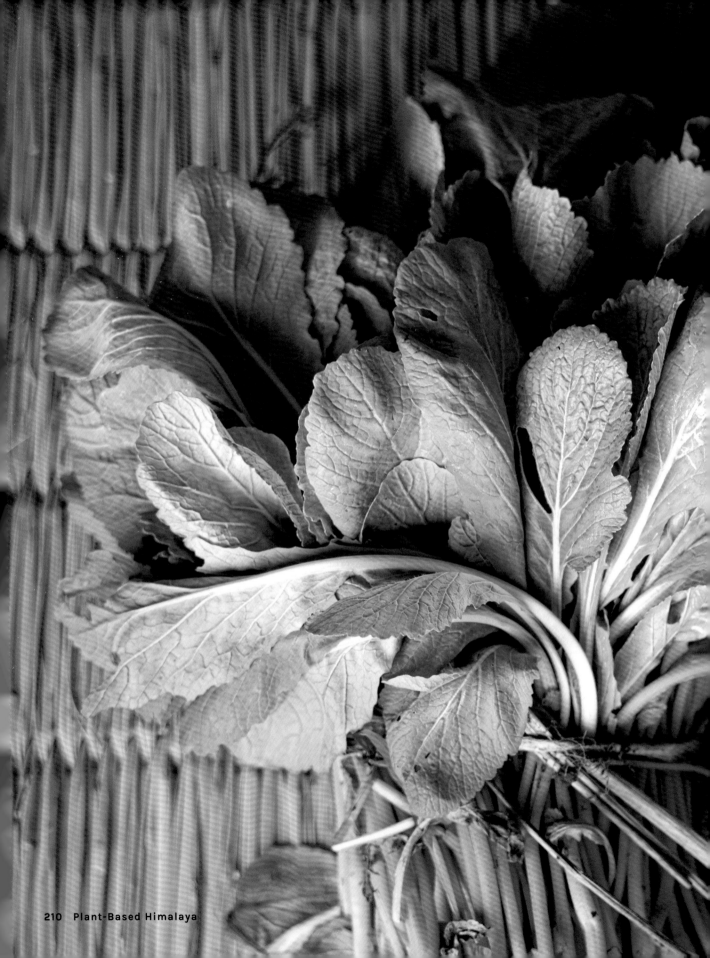

SERVES ~ 4
COOK TIME ~ 15 Minutes

INGREDIENTS

Mustard green: 1 lb

Onion: 1 small

SPICES

Sunflower oil: 1 tsp

Garlic: 2 cloves

Fresh green chili: 2 small

Salt: ¾ tsp

STEPS

1. Break the soft stems and leaves of the mustard leaves. Put them in a bowl, wash thoroughly, and drain.

2. Finely chop the garlic, onion, and fresh green chilis.

3. Heat a pan on medium and add oil.

4. Once the oil is hot, add the garlic, green chili, and onion. Fry until they turn golden brown.

5. Add mustard greens and salt. Mix well and cover for 2 minutes on medium heat.

6. Take the lid off, and stir the saag. Turn the heat high to evaporate excess water if the greens are too watery for your taste.

7. Juicy, nutritious, crunchy, and savory mustard saag is ready to serve.

QUICK TIPS

☺ *Mustard greens are the perfect side to any dish, but most Nepali prefer it in a Nepali set with rice, dal, curry, and timur ko achaar.*

☺ *Cut the stems into small pieces because they are thick and can be chewy if they are mature mustard greens. I usually get baby mustard greens that are about 5 inches tall and are easily found in Nepal during their season. The stems are very soft, crunchy, and juicy.*

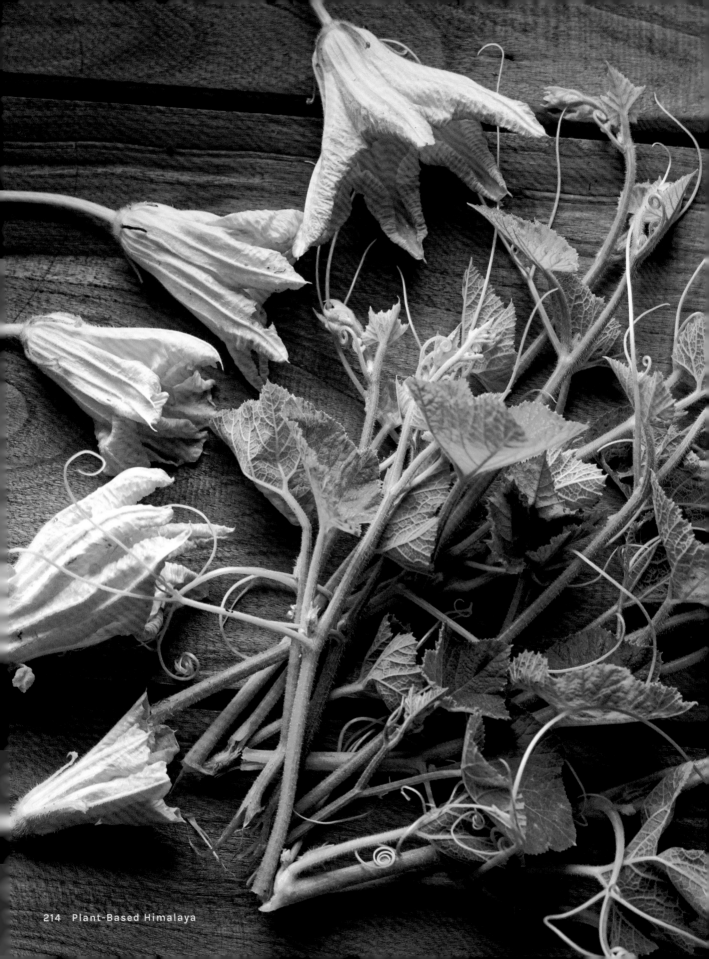

फर्सीको मुन्टा

FARSI KO MUNTA

Pumpkin Leaves

Pumpkin leaves are another very seasonal but prominent saag in Nepal. Farsi ko munta is very high in vitamin A and C, so is an excellent resource for improving eyesight as well as building strong bones.cBeyond just using with curry, I often add them to pastas and soups.

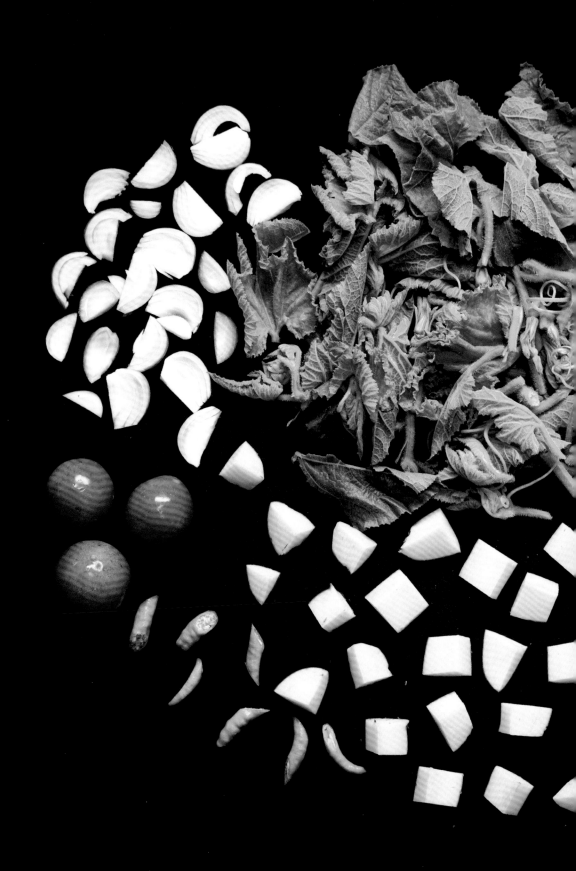

SERVES ~ 4
COOK TIME ~ 30 minutes

INGREDIENTS

Pumpkin shoot: ½ lb

Potato: 2 small

Red onion: 1 small

Tomato: 3 small

SPICES

Sunflower oil: 1 tbsp

Cumin seed: 1 tsp

Garlic : 2 cloves

Ginger: 2 slices

Fresh green chili: 2 medium

Dried red chili: 1 medium

Cumin powder: ½ tsp

Turmeric: ¼ tsp

Salt: ½ tsp

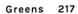

STEPS

1. Cut the leaves and soft stems of the pumpkin shoots. Wash and drain using a strainer.

2. Finely slice the onion and fresh green chilis.

3. Heat a pan on medium and add oil.

4. Once the oil is heated, add cumin seeds. Temper for few seconds and then add dried red chilis, onion, chopped potatoes, and salt. Fry for a minute and cover for about 3 minutes to cook.

5. Grind ginger and garlic using a mortar and pestle. Then add them to the pan with potatoes.

6. Mix everything properly while adding turmeric and cumin powder. Cover for an additional 2 minutes on low heat. The potatoes should be nicely cooked by now.

7. Add chopped tomatoes and stir well. Cook the tomatoes for a minute and then add the pumpkin leaves. Cover and cook for 2 minutes on medium heat.

8. Stir the saag and then cover on low heat for another 2 minutes.

9. Remove the lid and stir the saag one final time.

10. Mouthwatering farsi ko munta is ready to serve.

QUICK TIPS

- *Farsi ko munta is best paired with rice, kalo dal, and timur ko achaar.*

- *I use only the top baby parts of pumpkin leaves that are soft and easy to cook. The stem parts are thick and chewy, which adds flavors in dal. You can also saute the leaves or make pakaura (fritters).*

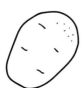

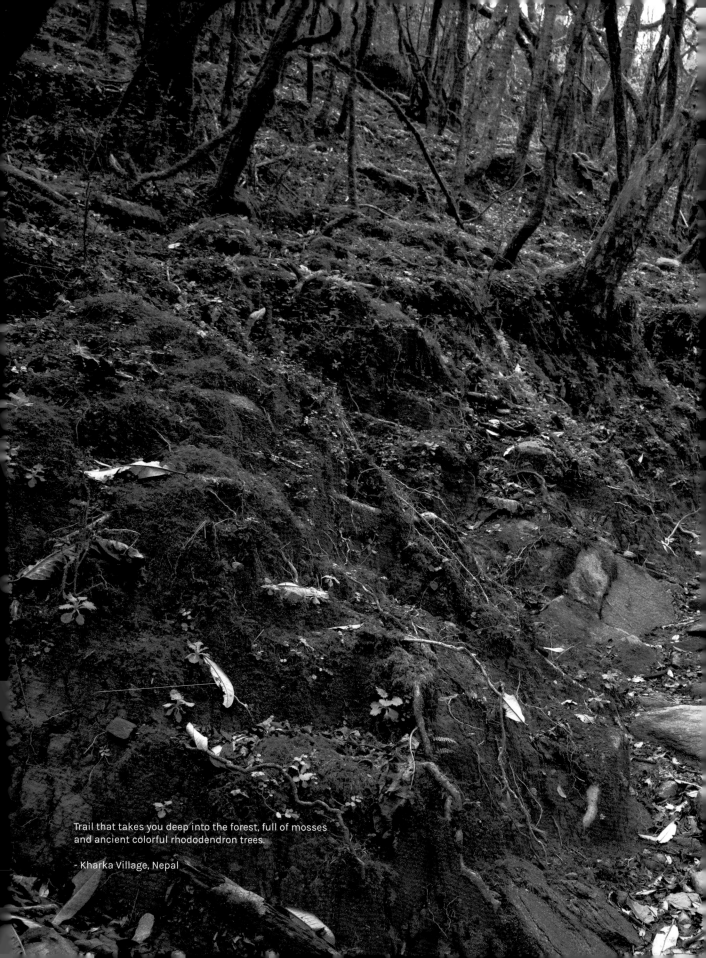

Trail that takes you deep into the forest, full of mosses
and ancient colorful rhododendron trees.

- Kharka Village, Nepal

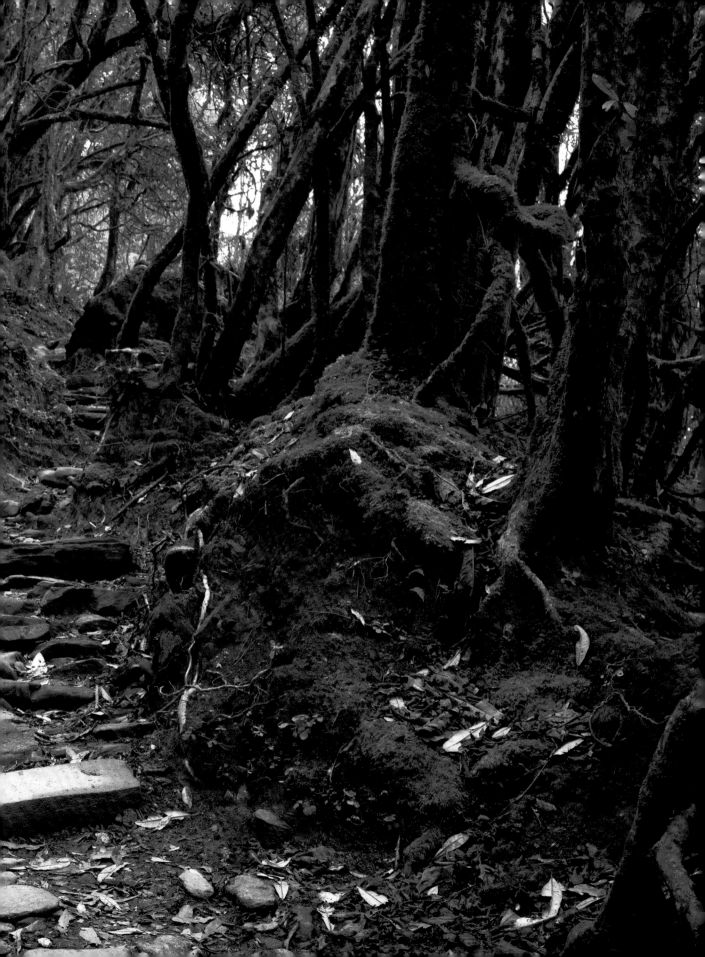

खाजा
Khaja

Snacks

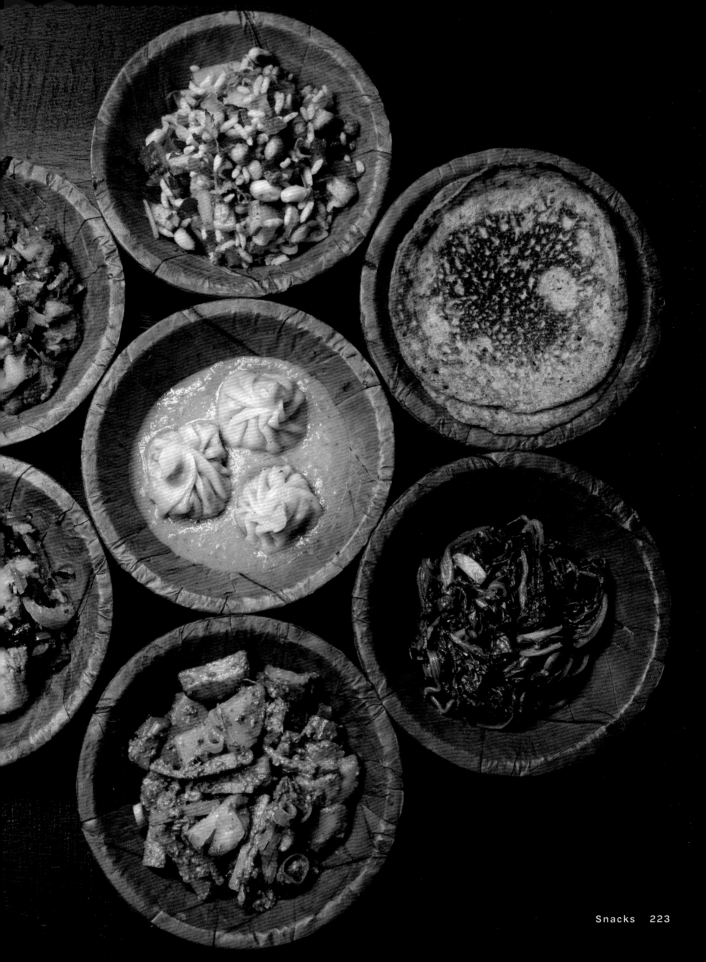

Khaja means "snack" in Nepali. We usually eat khaja in the middle of the day, around 3 o'clock. Nepali snacks are lighter than curries. I have included some of my favorite khaja from different Nepali ethnic groups.

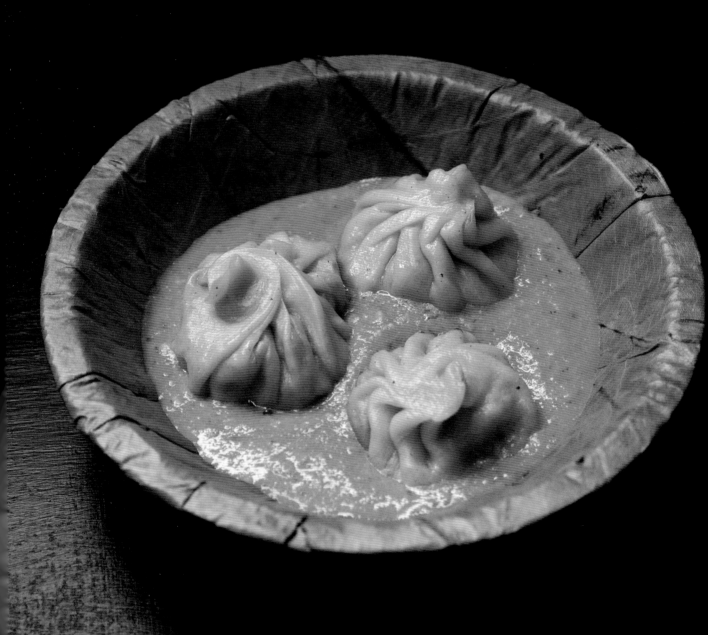

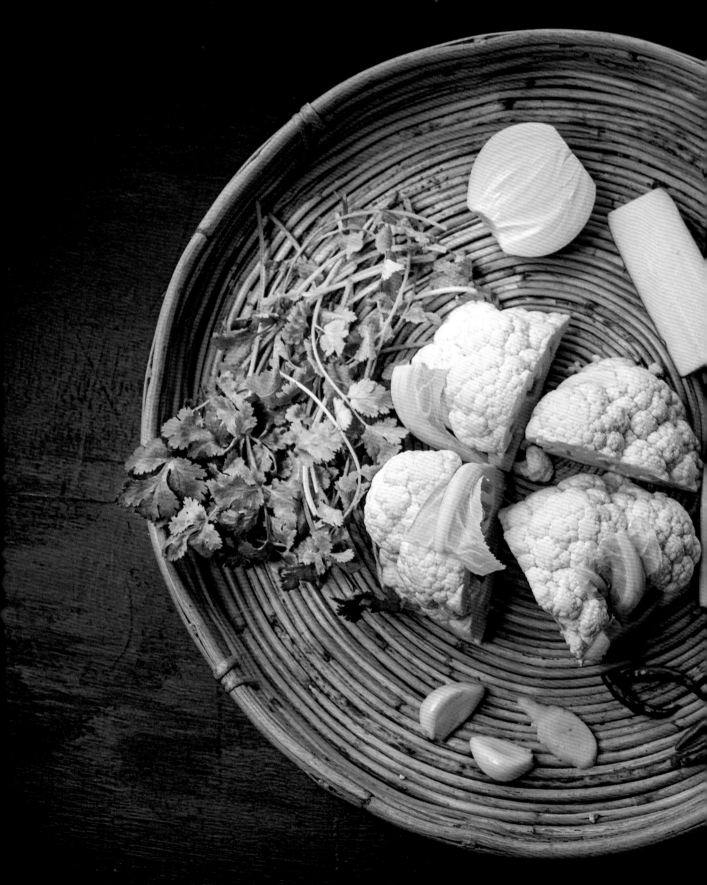

SERVES ~ 4

COOK TIME ~ 2 hours

INGREDIENTS

All-purpose flour: 4 cups

Water: 1⅓ cup

Cauliflower: 1 medium (350g)

Zucchini: 1 medium (350g)

Onion: ½ medium

SPICES

Sunflower oil: 9 tbsp

Garlic: 2 cloves (10g)

Ginger: 1 slice (10g)

Turmeric: ½ tsp

Fenugreek seed: ½ tsp

Cumin powder: ½ tsp

Fresh green chili: 4 medium

Cilantro: ½ cup

Salt: 1 tsp

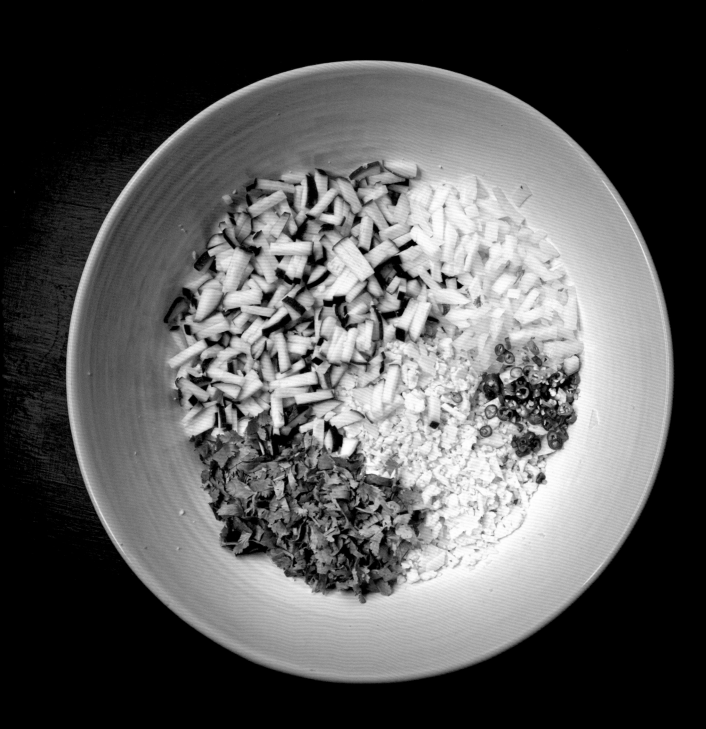

STEPS

1. Wash and thinly chop the cauliflower, zucchini, onion, fresh green chilis, and cilantro. Combine with the salt and mix in a large bowl.

2. Grind the ginger and garlic with a mortar and pestle and add them to the bowl. Take turmeric on a spoon and pour over the bowl.

3. Heat a pan on medium and add 4 tablespoon of oil. Once the oil is hot, add fenugreek seeds. As the fenugreek turns a darker brown, pour the oil into the bowl on top of turmeric. Mix the contents thoroughly with your hand or spoon to create the momo filling.

4. Cover the bowl and let settle for 10 minutes.

5. In another large bowl, add the flour. Save ⅓ cup of flour for dusting. Slowly mix in the water, a few tablespoons at a time, and mix until the dough is easy to handle and smooth but not mushy. Continue to knead the dough for 10 minutes and let it settle for 10 minutes.

6. Take a small ball of dough (12g) and flatten it with the palm of your hands. Use a rolling pin to flatten each piece into a 3½-inch-diameter round wrap.

7. Add 1 full teaspoon of filling to each wrap and fold them from the edges to make a circle dumpling. You can also make other designs if you like.

8. Boil water in the steamer. Apply some oil on the momo steamer pan evenly. Once the water is boiling, place the momo in the steamer, keeping an inch of space between so they won't stick together. Cook for 10 minutes.

9. Juicy and flavorsome momo is ready to serve.

QUICK TIPS

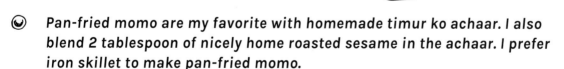

☻ *Pan-fried momo are my favorite with homemade timur ko achaar. I also blend 2 tablespoon of nicely home roasted sesame in the achaar. I prefer iron skillet to make pan-fried momo.*

☻ *For pan-fried dumplings, heat a pan on medium with one tablespoon of sunflower oil. Place momo in the pan keeping them an inch apart. Once the bottom is golden brown, in about a minute, add a half cup of water and cover for 8 minutes in medium heat. Crunchy on the bottom and juicy vegan momo is ready to devour when it's hot!*

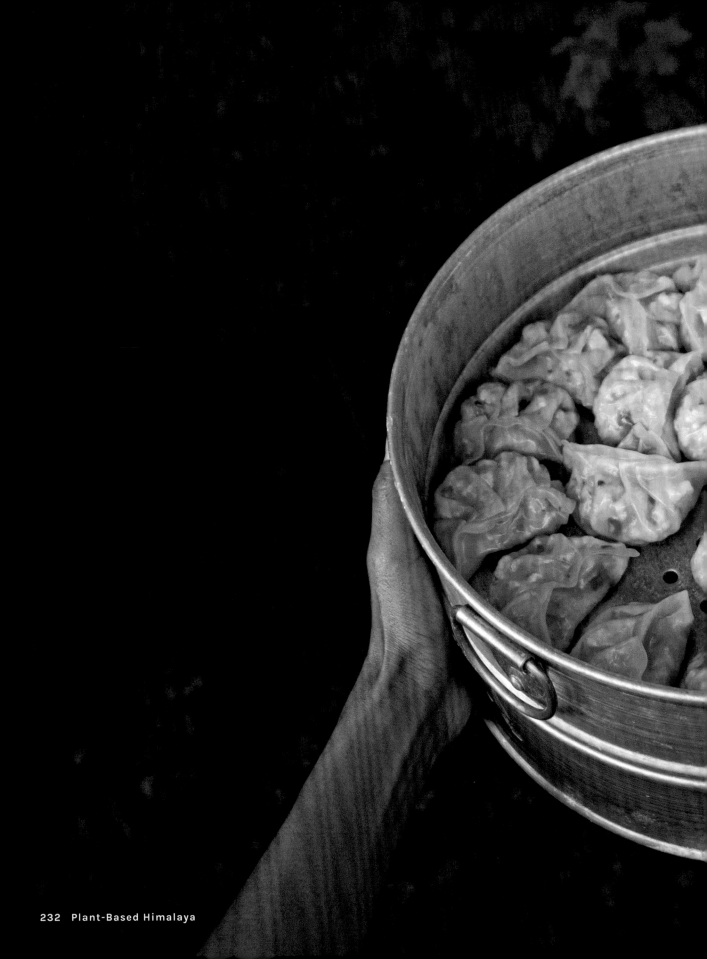

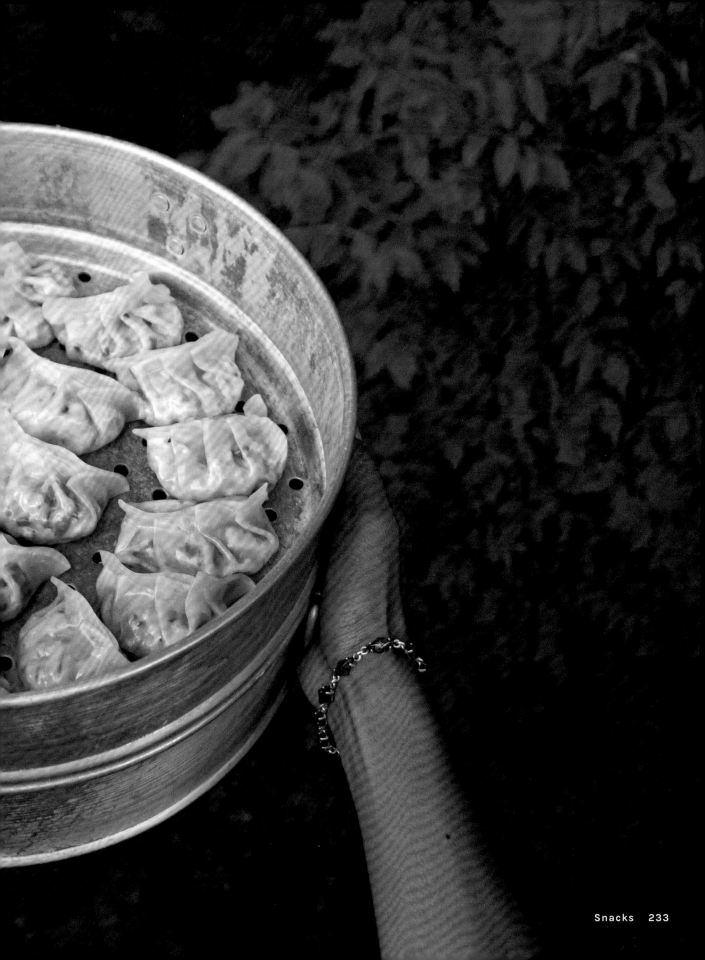

BARA

Black Lentil Pancake

Growing up as a Newar in Kathmandu meant I ate a lot of Newari delicacies. Bara is a prominent Newari dish that is beloved among all Nepali. These black lentil pancakes reminds me of Patan Durbar Square and the small pop-up shops in the alleys where women used to make this divine morsel in a tawa, a flat pan made of cast iron.

SERVES ~ 4
COOK TIME ~ 45 minutes

INGREDIENTS
Black lentil: 1 cup

Water: 2 cups

SPICES
Sunflower oil: 1 cup

Ginger: 4 slices

Turmeric: ¼ tsp

Salt: 1 tsp

STEPS

1. Soak black lentils overnight in 2 cups of water. I usually soak them for 2 days so they blend easily and are fluffier when cooked.

2. Drain the water into a bowl and combine the black lentils in a blender with ¼ cup of water, salt, ginger, and turmeric. Blend thoroughly.

3. Slowly add water with a tablespoon and continue to blend. Make sure you don't put a lot of water in the blender at once. Your mix should be a little thicker than a pancake batter. Put the mix in a bowl.

4. Heat a flat pan on medium. Add 2 teaspoon oil and spread it all over the pan.

5. Take a big soup spoon full of batter and pour it into the pan. Slowly flatten it by moving the spatula around from inside to outside, as when you make a pancake. Cover for 2 minutes on medium heat.

6. Take the lid off. Add 1 teaspoon of oil on top and around the bara. Flip on other side. Cook for a few seconds and cover for another 2 minutes.

7. Cook the bara on both sides until it looks golden brown for a few more minutes. I usually flip a few more times to bring out that golden color.

8. Heavenly tasting bara is ready to serve.

QUICK TIPS

- *Bara is a typical Newari dish. They can be found in every alleys of Kathmandu, Bhaktapur, and Patan.*

- *If you are using black lentils without the skin, you don't have to worry about taking it off, but if they have skin, then you need to rub the soaked lentils gently and drain the water several times until the skins are almost gone.*

- *Use a good blender for a thicker batter. A weak blender might start smoking.*

- *I prefer to use an iron skillet to fry them because it adds extra flavor.*

- *Bara is basically a thicker and fluffier version of a black lentil crepe. It can be enjoyed as breakfast, lunch, brunch, snack, or dinner. You can also store extras in the refrigerator for a few days. I enjoy kakro ko achaar (cucumber salad) to go with it on the side.*

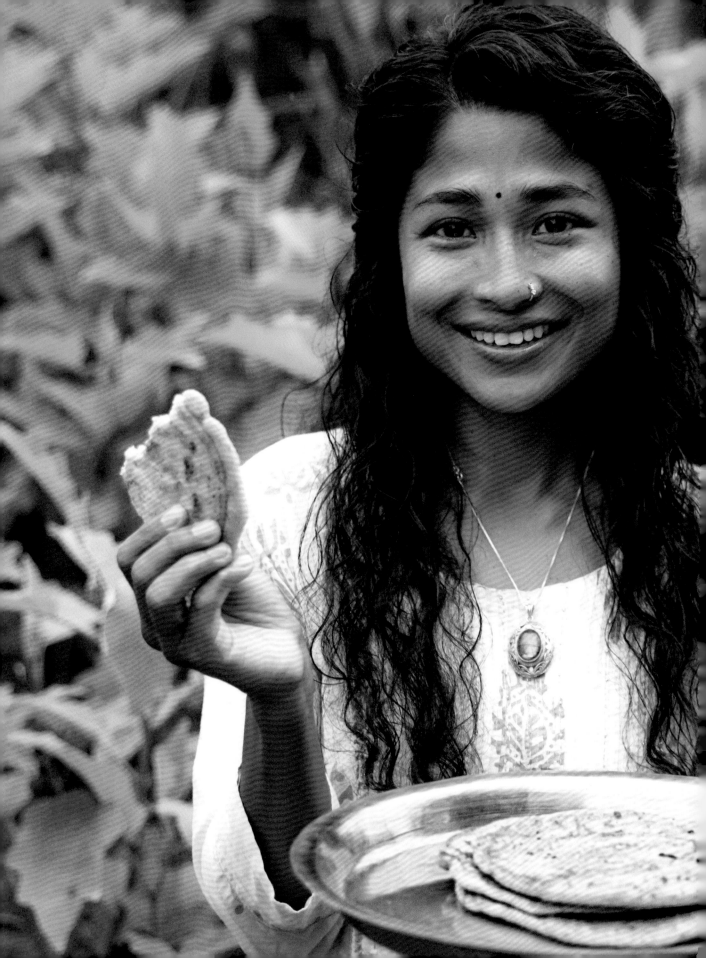

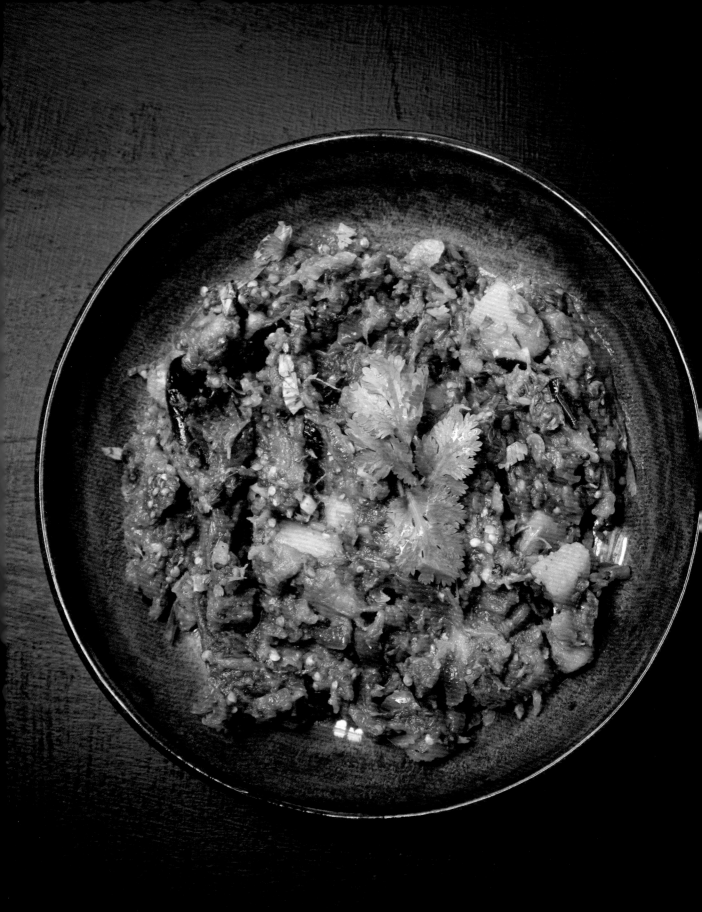

भर्ता

BHARTA

Mashed Eggplant

Bharta awakens memories of the joy I saw in my mother's face while she cooked. I remember Aama was the only one who used to make this recipe in our neighborhood. When I was young, eating at restaurants was not part of our culture. Although I have dined at restaurants around the world, my mother remains one of my favorite chefs, and this mashed eggplant dish is one of her finest.

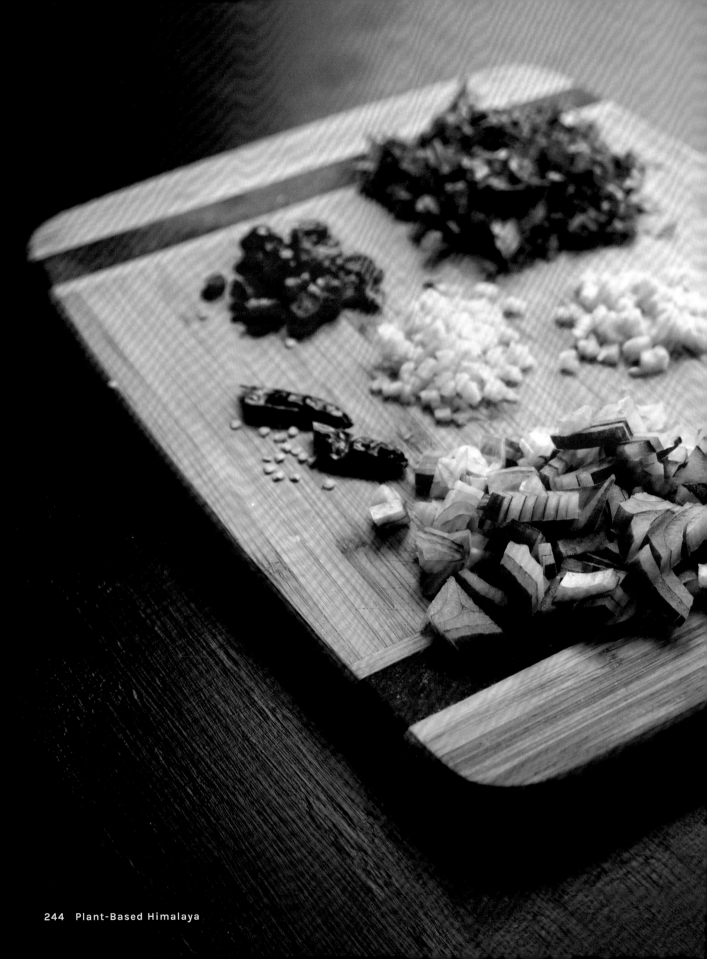

SERVES ~ 2
COOK TIME ~ 30 minutes

INGREDIENTS

Eggplant: 1 large

Tomato: 1 medium

Potato: 1 medium

Red onion: ½ medium

Fresh red chili: 2 medium

SPICES

Coconut oil: 2 tbsp

Cumin seed: ½ tsp

Garlic: 2 cloves

Ginger: 2 slices

Dried red chili: 1 medium

Fresh red chili: 2 medium

Cumin powder: ½ tsp

Turmeric: ½ tsp

Cilantro: ½ cup

Salt: 1 tsp

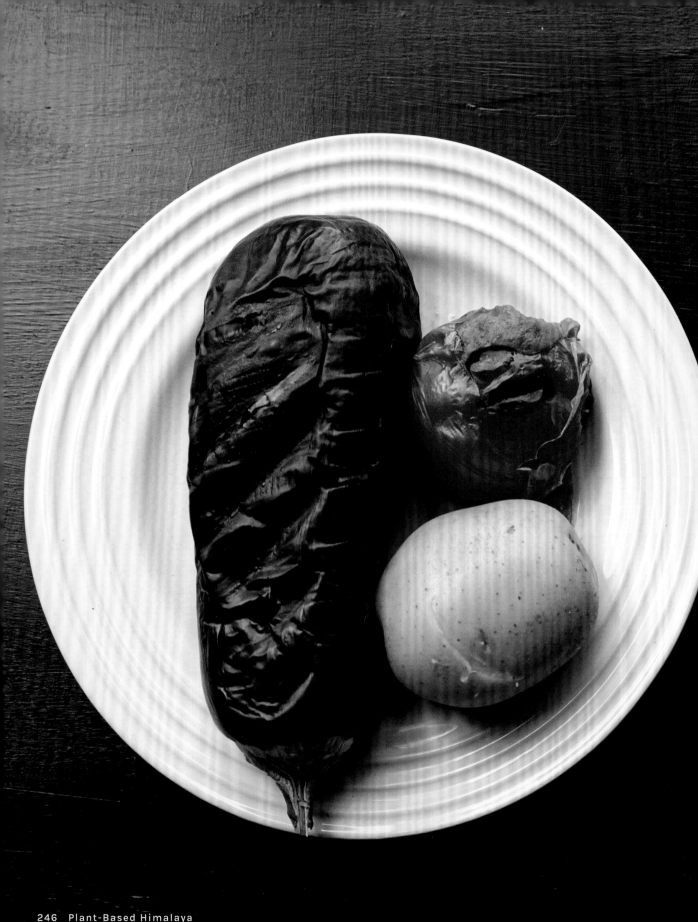

STEPS

1. Grill the eggplant and tomatoes directly on the stove. Keep turning them on the grill for the best flavors and also to keep them from burning on one side.

2. Once the eggplant and tomatoes are fully grilled, let them cool down.

3. Boil the potato in a pan or pressure cooker for about 15 minutes or until it is soft in the middle.

4. Take the potato out of the water, cut in the middle, and let it cool down.

5. With a fork, slowly peel the skin off the eggplant, tomatoes, and potato. Be ready to get messy!

6. Mash the eggplant, tomatoes, and potato on a shallow plate. I keep my potato chunky.

7. Heat a pan on medium and add oil. Once the oil is hot, temper cumin seeds for few seconds. Add the whole dried red chili, chopped ginger and garlic.

8. Cook for a minute and then add finely chopped onion and fresh green chilis. Fry until they turn golden brown and then turn the heat to low.

9. Add cumin powder and turmeric. Mix well.

10. Add the mashed potatoes next and turn the heat to medium. Fry for a few minutes and then add the eggplant, tomatoes and salt. Stir well and turn the stove off.

11. Add chopped cilantro and mix thoroughly. Also garnish with some fresh cilantro and roasted sesame seeds on top. The mouthwatering bharta is ready to serve.

QUICK TIP

☻ *This recipe is absolutely amazing with anything. I eat it with rice, naan, or with a good sourdough toast. This might become your new favorite side dish.*

☻ *Buy only fresh and light eggplant! There are times when I have bought older eggplants that did not cook nicely inside. In that case, cook the eggplant a little longer on low heat once you've mixed it with the spicy potatoes.*

☻ *I love the smoky flavor of roasted eggplant, but you can also bake them in the oven. This dish is also a huge hit at dinner parties.*

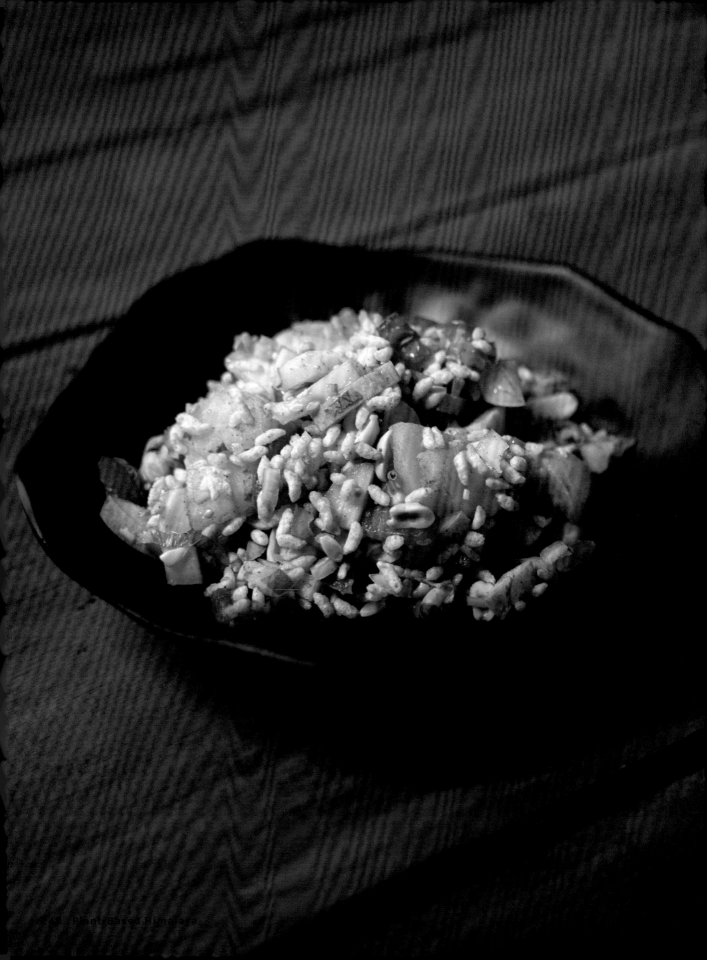

चट्पटे

CHATPATEY

Puffed Rice Salad

I have no words to describe how much I love chatpatey. It requires only few ingredients and is astonishingly easy to make. This puffed rice salad can be found in even the smallest village of Nepal. It is common to see served by street vendors in chat stands, homemade bicycle vending carts, and even by women wearing plastic containers strapped to their shoulders, all with a crowd of people eager to devour the yummy treat.

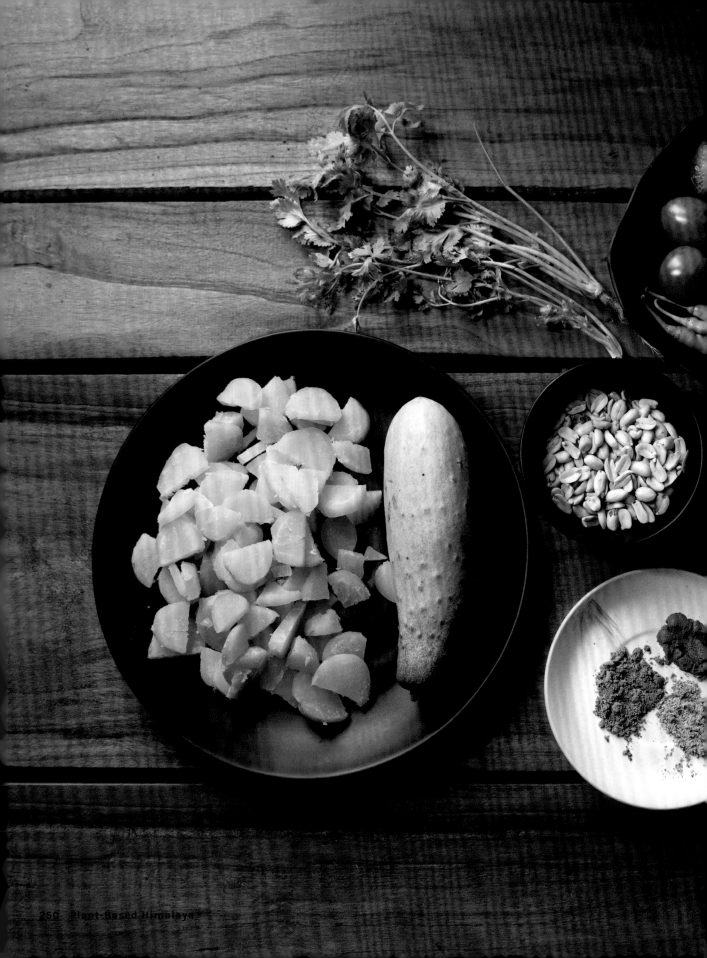

SERVES ~ 4
COOK TIME ~ 30 minutes

INGREDIENTS
Potato: 4 medium

Tomato: 6 small

Cucumber: 1 medium

Red onion: 1 medium

Puffed rice: 2 cups

Peanut: ½ cup

SPICES
Chat masala: 1 tsp

Black salt: ½ tsp

Mustard oil: 1 tbsp

Red chili powder: 1 tsp

Fresh green chili: 3 medium

Cilantro: ½ cup

STEPS

1. Wash potatoes. Add 2 cups of water in a pan and boil the potatoes for about 10 minutes. You can also use a pressure cooker (wait 2 whistles).

2. When they are soft in the middle, remove them, cut from the middle, and let the potatoes cool. Remove the skin and cut into bite size.

3. Wash and finely chop tomatoes, onion, cucumber, cilantro, and fresh green chilis. Mix them in a big bowl while adding chat masala, salt, oil, lemon juice, and red chili powder. You can also add your choice of oil if you don't like the strong flavor of mustard oil.

4. Add peanuts and mix it properly with hands for the best flavors.

5. Try the mix. Make sure the salt, chili, and lemon are balanced perfectly before adding puffed rice. Add more to suit your taste.

6. Finally, add puffed rice and mix thoroughly.

7. Mouthwatering chatpatey is now ready to serve. Enjoy!

QUICK TIPS

- *Chatpatey is one of the most popular snacks in Nepal after momo. It is very light and packed with flavors. Sometimes I add more toppings like soaked chana (chickpeas), fried chana, nimki, fresh green peas, or bhujiya (crunchy mix) to add more flavors.*

- *Eat this snack quickly after it is prepared, otherwise it will start to get soft and soggy. I love the crunchy texture of chatpatey packed with flavors.*

- *Fried instant noodle chatpatey is very popular in Nepal these days, but I am trying to consume less packaged food, so instead of noodles, I added nicely home-roasted crunchy peanuts.*

- *For people who are buying puffed rice, please try it before you make chatpatey. There are many times when the packaged puffed rice is not crispy enough. In that case, heat it in a pan on low heat for 5 minutes. Let it cool down before adding to the recipe.*

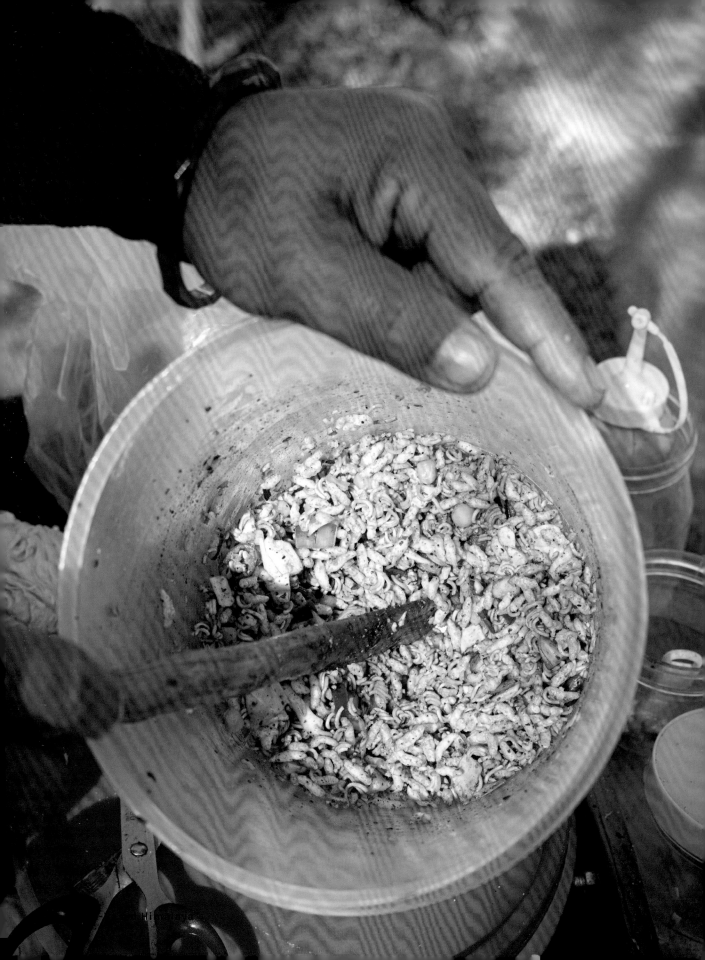

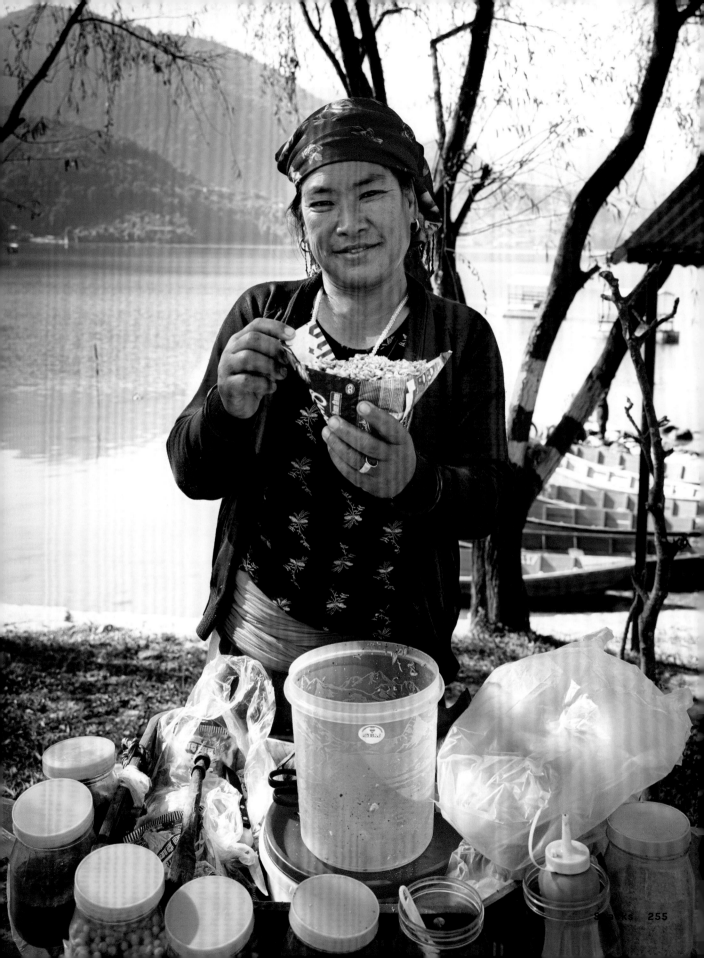

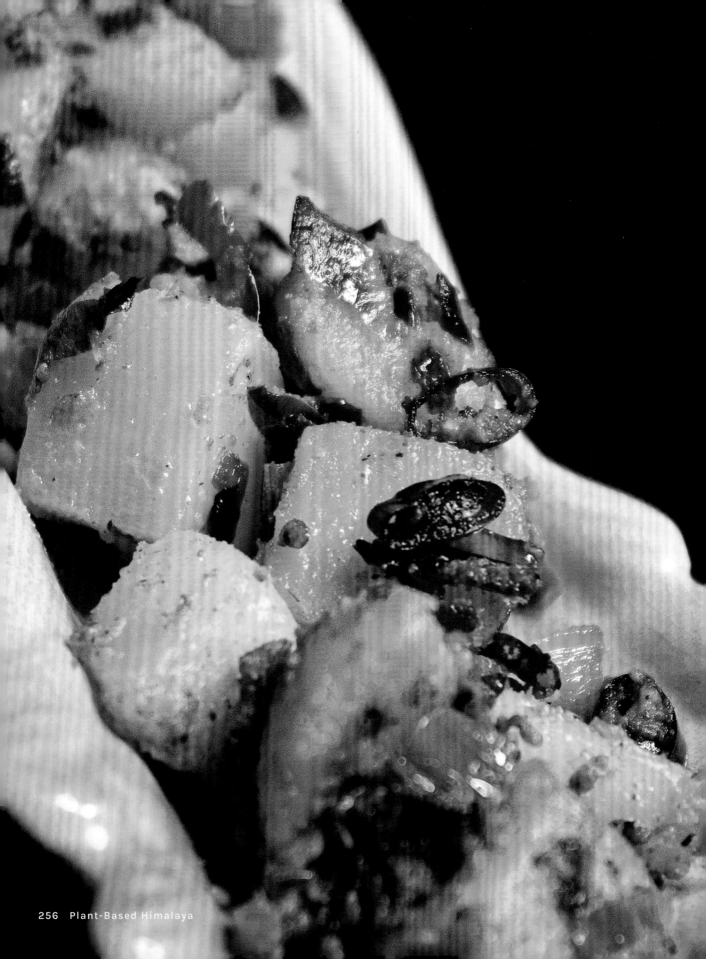

साँधेको आलु

SANDHEKO AALOO

Potato Salad

As an Asian woman, I am surprised that often I prefer to eat potatoes more than rice. One bite of this sandheko aaloo recipe and my tastebuds are transported to the mystical Buddhist kingdom of Shambhala. I developed this potato salad recipe purely for the love of spicy and quick potato snacks prevalent all over Nepal but with a little more flavor to satisfy the foodie in me.

SERVES ~ 4
COOK TIME ~ 30 minutes

INGREDIENTS
Potato: 4 medium

Bell pepper: 1 medium

Red onion: 1 medium

Green onion: ¼ cup

SPICES
Sunflower oil: 6 tbsp

Cumin seed: 1 tsp

Fenugreek seed: ½ tsp

Sesame seed: 4 tbsp

Ginger: 2 slices

Garlic: 4 cloves

Fresh red chili: 3 medium

Turmeric: ½ tsp

Timur (Sichuan pepper): ½ tsp

Cumin powder: 1 tsp

Red chili powder: ½ tsp

Lemon juice: 1 tbsp

Cilantro: ½ cup

Salt: 1 tsp

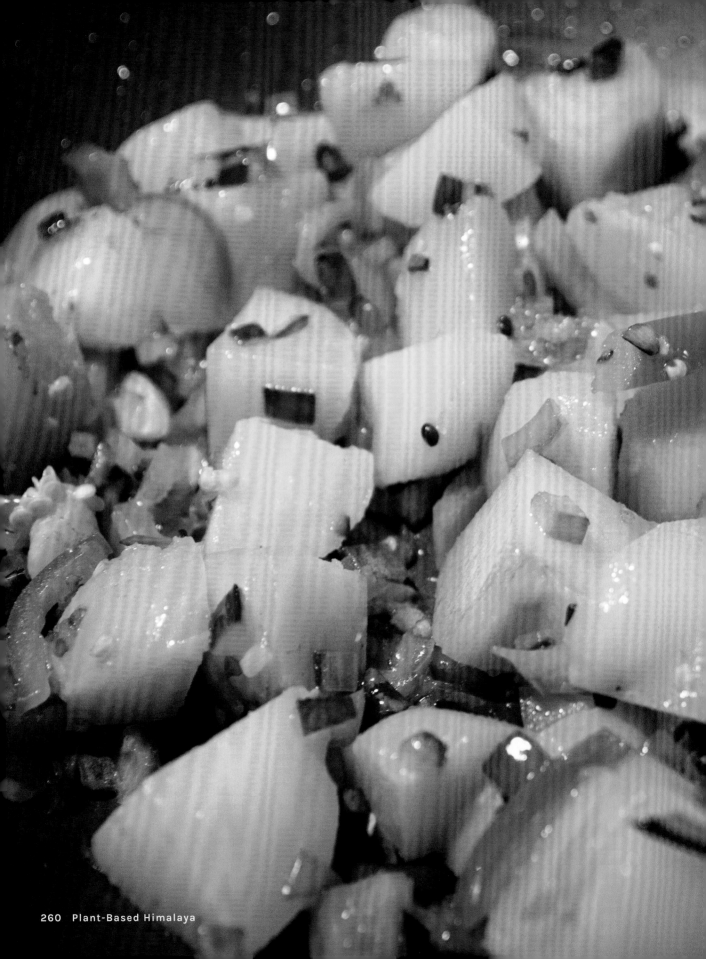

STEPS

1. Wash potatoes thoroughly, making sure to remove all of the dirt.

2. Add 2 cups of water in a pan and boil the potatoes for about 10 minutes. You can also use a pressure cooker (wait 2 whistles). When they are soft in the middle, remove them, cut from the middle, and let the potatoes cool. Remove the skin and cut into equal-sized squares.

3. Heat a pan in low and roast sesame.

4. Heat another pan on medium low and add oil. Once the oil is hot, temper fenugreek and cumin seeds for a few seconds.

5. When fenugreek starts turning darker brown, add chopped onion, bell peppers, and fresh red chilis. Fry everything until the onion turns golden brown.

6. Add the chopped boiled potatoes and turmeric. Fry for 5 minutes until they start looking golden brown as well.

7. In a blender add ginger, garlic, cumin powder, salt, timur, roasted sesame seeds and 4 tablespoon of water. Blend well.

8. Add it to the potatoes and mix everything for few minutes, until the spices are blended with potatoes and look golden brown.

9. Garnish with thinly chopped green onions, fresh cilantro, and lemon juice on top. Savory, yummy and divine potato salad is ready to serve.

 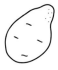

QUICK TIPS

☺ *I like this dish by itself but it can be enjoyed with puffed rice, flatbread and rice. Make some spicy golveda ko achaar with extra cilantro and throw it on top to add even more flavor. They are also great for wraps.*

☺ *I added this recipe especially for spicy potato lovers. I am sure you know hundreds of ways to make potato dishes, but this one might become your new favorite. It is rich in flavor and an easy-to-fix snack.*

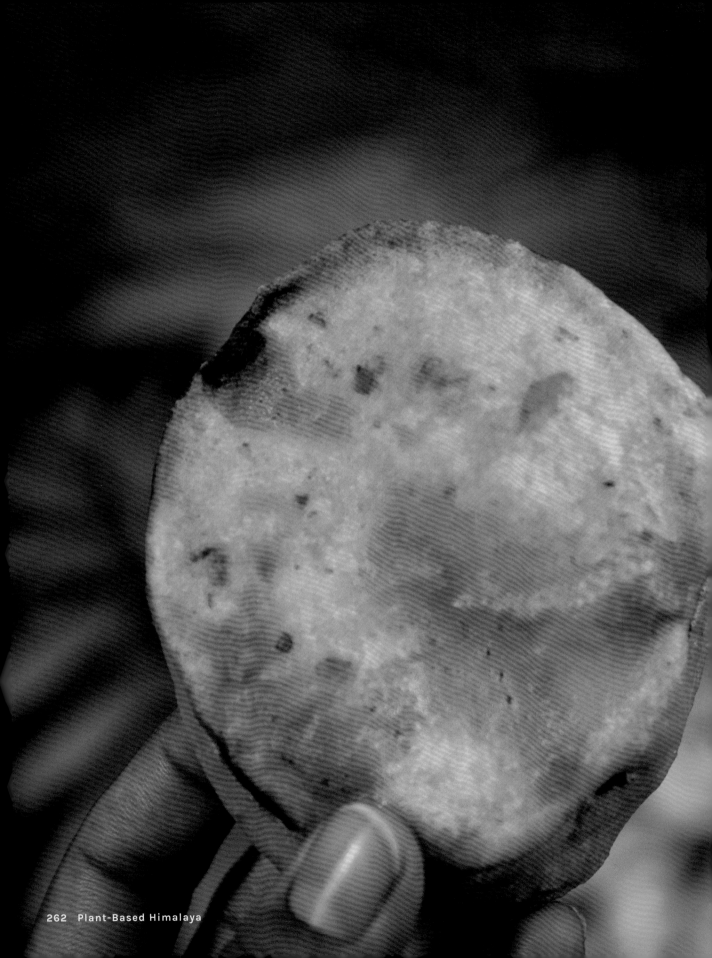

पकौरा

PAKAURA

Vegetable Fritters

This recipe evokes images of being a very young girl living with my grandfather in Kalaiya, Nepal. Along the streets, the seasonal vegetable pakaura was sold by vendors with a tiny kerosene stove or at the farmers market where vendors congregated. Most of them were housewives with their children earning some extra rupees selling these mouthwatering vegetable fritters.

SERVES ~ 6
COOK TIME ~ 45 minutes

INGREDIENTS
Potato: 2 medium

Eggplant: 1 medium

Red onion: 1 medium

Gram flour: 2 cups

Water: 2 cups

SPICES
Sunflower oil: 3 cups

Fresh green chili: 4 medium

Salt: 1 tsp

Garlic: 2 cloves

Turmeric: ½ tsp

Cumin powder: ½ tsp

Ground black pepper: ⅛ tsp

Cilantro: ½ cup

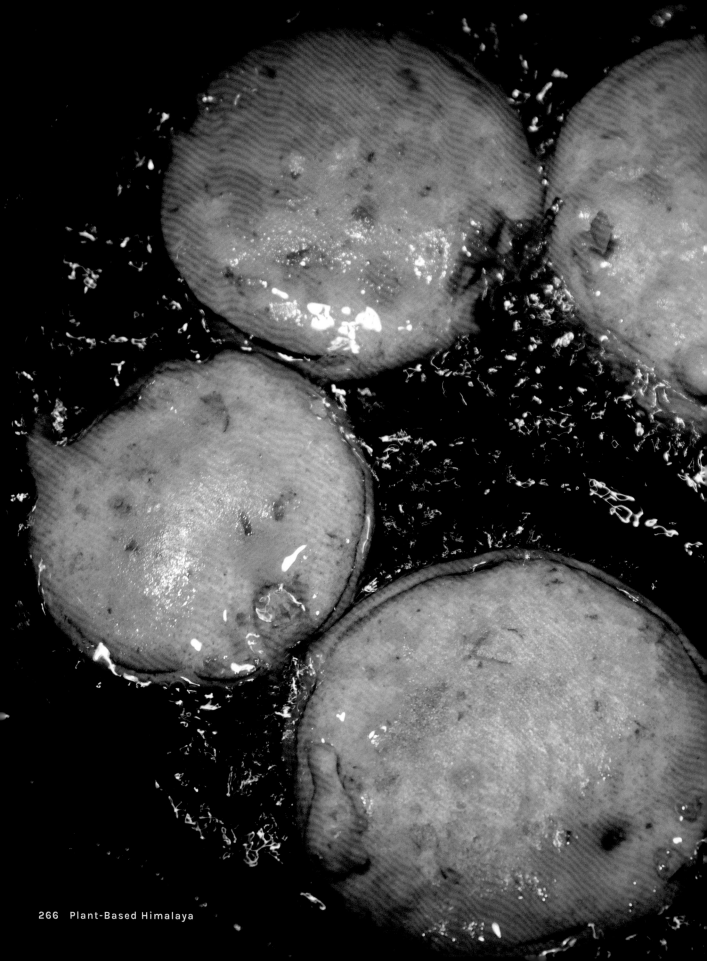

STEPS

1. Thoroughly wash all the vegetables and cut them into equal-sized slices about ¼ inch thick. I prefer to cut them round when planning to make a sandwich but sometimes I thinly chop all the vegetables and mix into the batter to make flavorful and crunchy vegetable fritters.

2. In a large bowl combine gram flour, turmeric, black pepper, cumin powder, and salt (save one-quarter of the gram flour to add later).

3. Mix completely and then add water slowly to create a batter.

4. Add chopped fresh cilantro and green chilis, stir well, and then add a few chopped vegetable to cover in batter.

5. Heat a pan on high and add oil. Once the oil is hot, lower the heat to medium.

6. Slide the battered vegetables into the oil from the side. Flip them when they turn a golden brown color.

7. Turn the heat up. Slowly strain the oil on the side of the pan and take the pakaura out. Place it on a paper towel to soak up the excess oil.

8. Repeat on all your favorite vegetables. Juicy, crunchy and flavorful pakauras are ready to devour.

QUICK TIPS

- *I serve these delicious pakaura/pakora/fried vegetable fritters with my signature spicy golveda ko achaar while they are hot and crispy. They make fantastic sandwiches too!*

- *Do not throw the battered vegetables in the oil from above. Always slide them gently in from the side. If this is your first time, you can use tongs. Be really careful with the hot oil. Sometimes it may pop and splash.*

- *You can make pakauras out of any vegetable—they all taste sensational. Experiment with your favorite vegetable, and you'll be glad you did.*

- *I grew up in a mixed culture of Nepali, Newari, Madhesi, and Bengali family members. Growing up in Terai and Kathmandu, I called this dish by many names including Pakaura, Pakora, and Pakauda.*

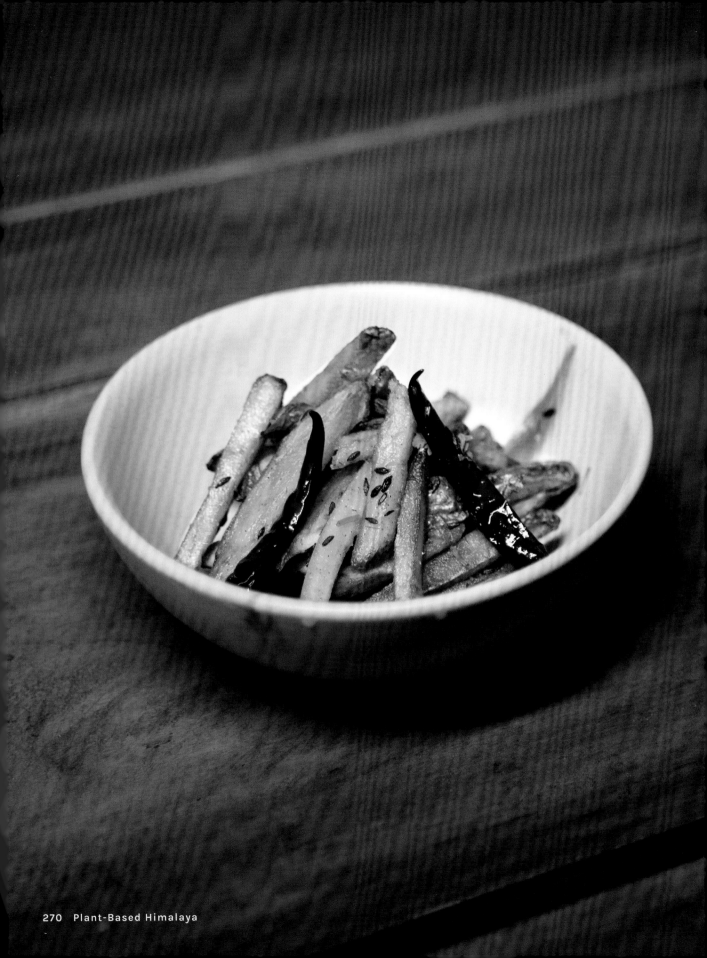

आलु भुजिया

AALOO BHUJIYA

Fried Potatoes

Growing up, I knew nothing about french fries, but I regularly devoured these thinly sliced fried potatoes with rice, red lentil soup, and golveda ko achaar. Aaloo bhujiya is much healthier and flavorful than even the best fast-food fries, plus they make a great topping or addition to other recipes like pizza or tacos.

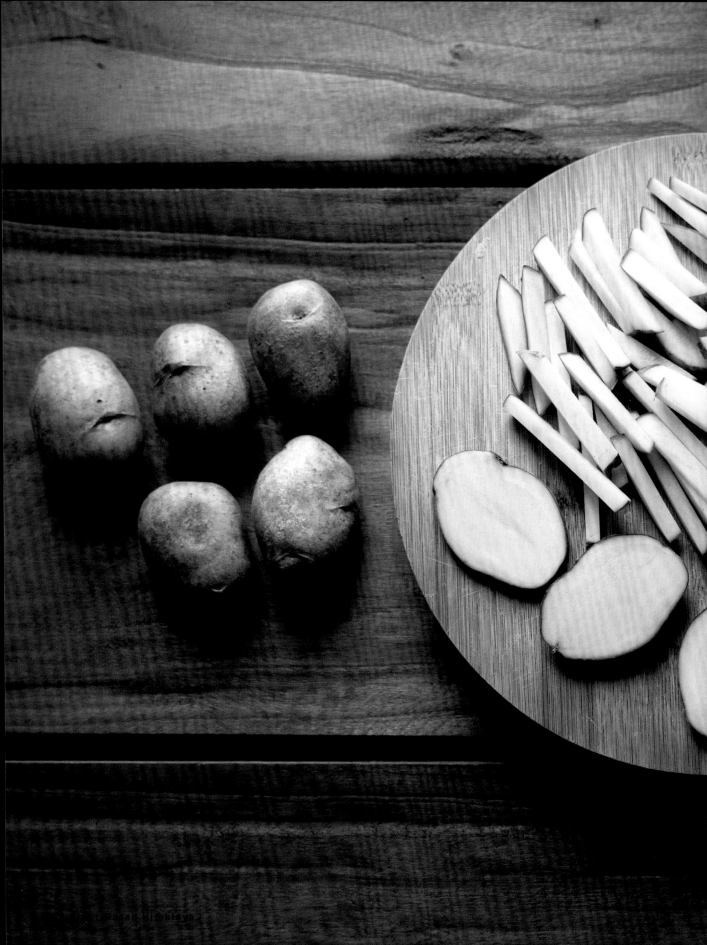

SERVES ~ 2
COOK TIME ~ 45 minutes

INGREDIENTS
Potato: 1 lb

SPICES

Mustard oil: 4 tbsp

Cumin seed: 1 tsp

Dried red chili: 2 medium

Fresh green chili: 2 medium

Turmeric: ½ tsp

Cilantro: ½ cup

Salt: ½ tsp

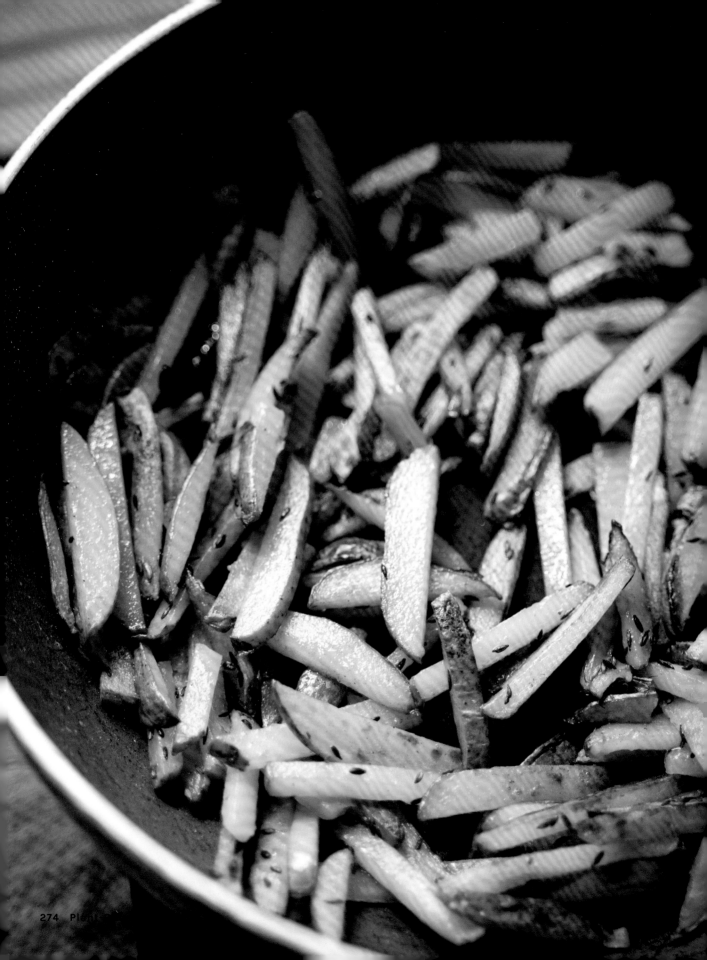

STEPS

1. Wash potatoes and make sure no dirt is left.

2. Cut the potatoes into thin pieces, making sure they aren't too thick. A potato's taste can vary different depending on its size.

3. Heat a pan on medium and add oil. Once the oil is hot, fry the cumin seeds and whole dried red chilis for a few seconds.

4. Add chopped potatoes, mix well, and cover for 2 minutes.

5. Take the lid off and continue to fry the potatoes on medium heat. Stir it thoroughly, cover, and cook for 2 minutes.

6. Turn the heat to medium low. Take the lid off, add turmeric, and mix the potatoes every other minute or so. This is the trick to get nicely roasted and crispy potatoes.

7. The fried potatoes will be ready in about 20 minutes. Once the potatoes are cooked, add salt and finely chopped fresh green chilis. Stir for a minute and turn the stove off.

8. Garnish with some cilantro on top and my all time favorite spicy aaloo ko bhujiya is ready to serve.

QUICK TIPS

- *I like fried potatoes with just about anything, but my go-to dish is rice, potato, saag, and timur ko achaar. They are also great for tacos, snacks, wraps, or even pizza topping.*

- *Spread the potatoes in the skillet so they will cook slowly on both sides. This also helps to dry out excess water in the potatoes.*

- *If you cook a lot of potatoes on top of each other, they will become mushy instead of crispy and roasted, so choose a pan accordingly.*

Boudhanath Stupa standing tall and majestic in the heart of Kathmandu. The energy around this World Heritage Site is very lively. I enjoy shopping and going out to eat here.

- Boudha, Nepal

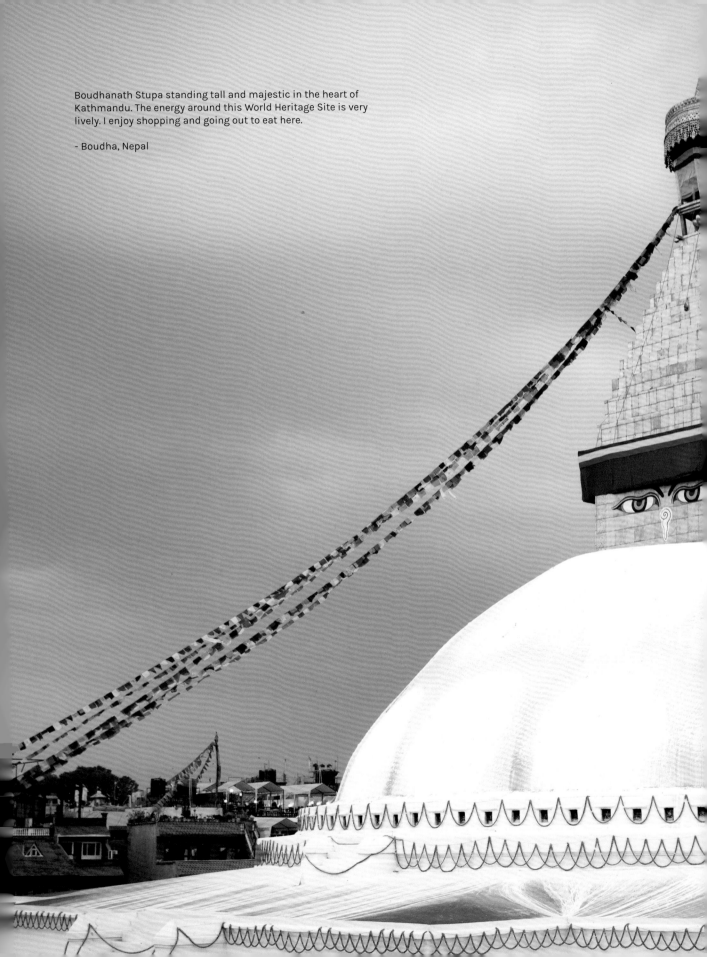

अचार
Achaar
Pickles

Achaar in Nepali translates to "pickle" and is basically a cold and spicy sauce that is made with vegetables and spices. Achaar is limey, sometimes hot, and always full of flavors. Usually it is eaten as a side dish with your meal, but if you are creative, it can add excitement to any dish.

गोलभेडाको अचार

GOLVEDA KO ACHAAR

Tomato Sauce

*You could call golveda ko achaar my Swiss-Army sauce—
this tomato sauce tastes exceptional with anything. After
you learn to make this tangy but spicy sauce, you won't even
think about buying ketchup, marinara, or salsa at the store
ever again. Try it on pizza, sandwiches, tacos, curry, or as a
dip for your favorite fried food.*

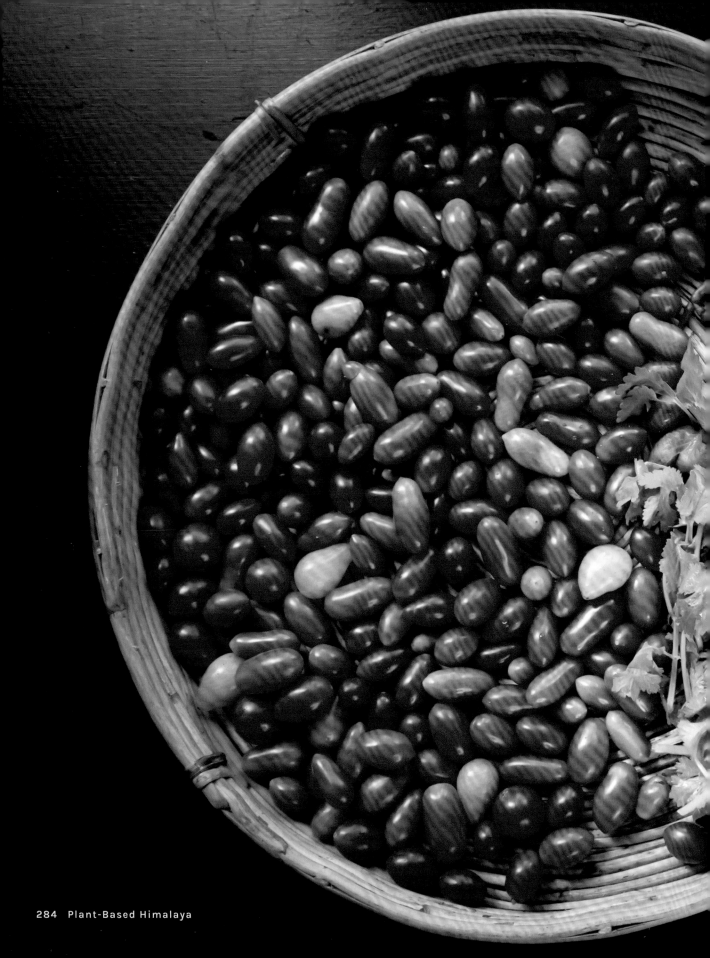

SERVES ~ 6
COOK TIME ~ 15 minutes

INGREDIENTS
Cherry tomato: 1 lb

SPICES
Sunflower oil: 2 tsp

Cumin seed: ½ tsp

Garlic: 1 clove

Fresh green chili: 4 medium

Sesame seed: 1 tbsp

Cilantro: ½ cup

Lemon juice: ½ tsp

Salt: 1 tsp

STEPS

1. Wash the tomatoes.

2. Cut the fresh green chilis and garlic cloves into a few pieces.

3. Heat a big flat pan on medium and add oil. Once the oil is hot, add cumin seeds and the chopped garlic. When the cumin starts turning brown after few seconds, add all the tomatoes.

4. If you are using larger tomatoes, cut them in half.

5. Add salt, mix well, cover, and cook for 5 minutes.

6. Stir and turn the stove off. Let the tomatoes cool down.

7. On low heat in a pan, roast the sesame seeds to a nice brown color.

8. In a blender, combine the cooked tomato mixture with fresh chopped cilantro, lemon juice, and roasted sesame seeds.

9. Blend just a few seconds for thick texture or a little bit longer for more smooth textured sauce.

10. Luxurious and heavenly golveda ko achaar is ready to serve.

QUICK TIPS

- *I absolutely love golveda ko achaar with almost everything. You name it and I'll pair it with this tangy sauce!*

- *Sometimes I make achaar without sesame seeds and add extra cilantro. I grew up making grilled tomato sauce with cilantro, but when I moved to the US, I had access only to an electric stove, so I started frying it in the pan.*

- *You can add this sauce to any curry, pasta, noodles, tacos, or pizza. This is seriously the best sauce you will ever make in your life. It is that addictive, and there is no going back to store-bought sauce.*

- *Sometimes I add as much as 1 cup of fresh cilantro if I am in the mood for dhaniya ko achaar (cilantro sauce). I switch the flavors depending on the dish and what is left in the refrigerator. Also, during mint season, I mix in a handful of cilantro and mint.*

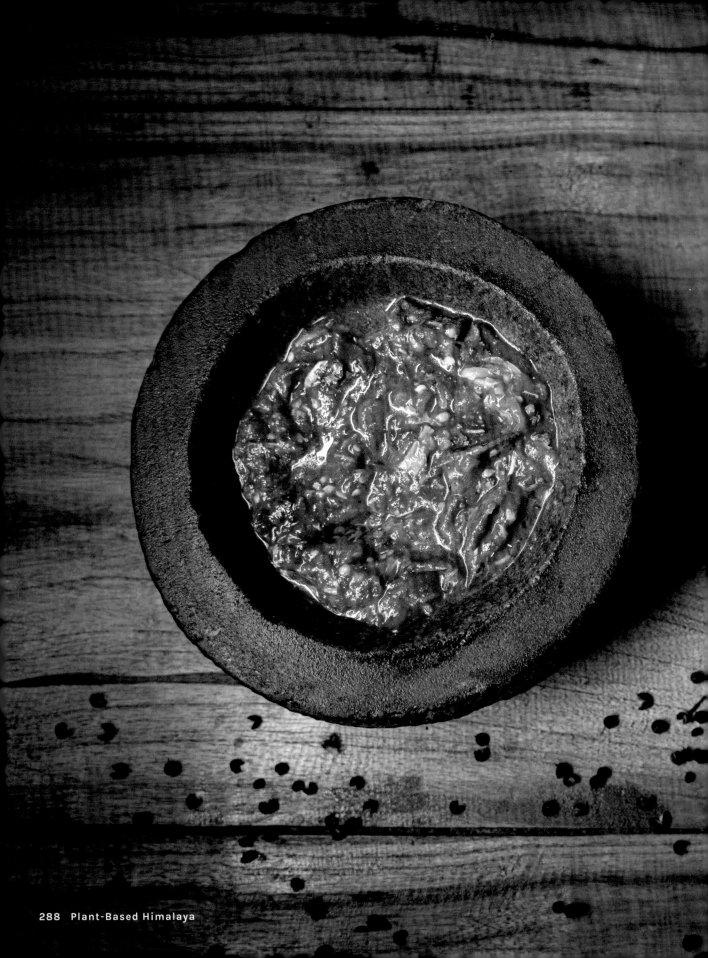

टिमुरको अचार

TIMUR KO ACHAAR

Sichuan Pepper Sauce

Kathmandu is the main hub for Himalayan herbs and spices, so it's no surprise that is where I discovered timur. During winter, farmers throughout the region bring spices to sell in Kathmandu, make some money, and escape the harsh weather. Timur has a unique aroma and flavor. It should be called "Nepali pepper" in my opinion and not "Sichuan pepper." It is absolutely one of the distinguishing spices used in Nepali cuisine and adds that signature Nepali flavor in every dish. Timur is one of the spices that you will find in every single Nepali kitchen. It is the most important elements that makes the perfect "Nepali Set."

SERVES ~ 6
COOK TIME ~ 15 minutes

INGREDIENTS

Tomato: 1 lb

SPICES

Sunflower oil: 2 tsp

Garlic: 1 big clove

Fresh green chili: 4 medium

Timur (Sichuan pepper): ¼ tsp

Cilantro: ½ cup

Lemon juice: ½ tsp

Salt: 1 tsp

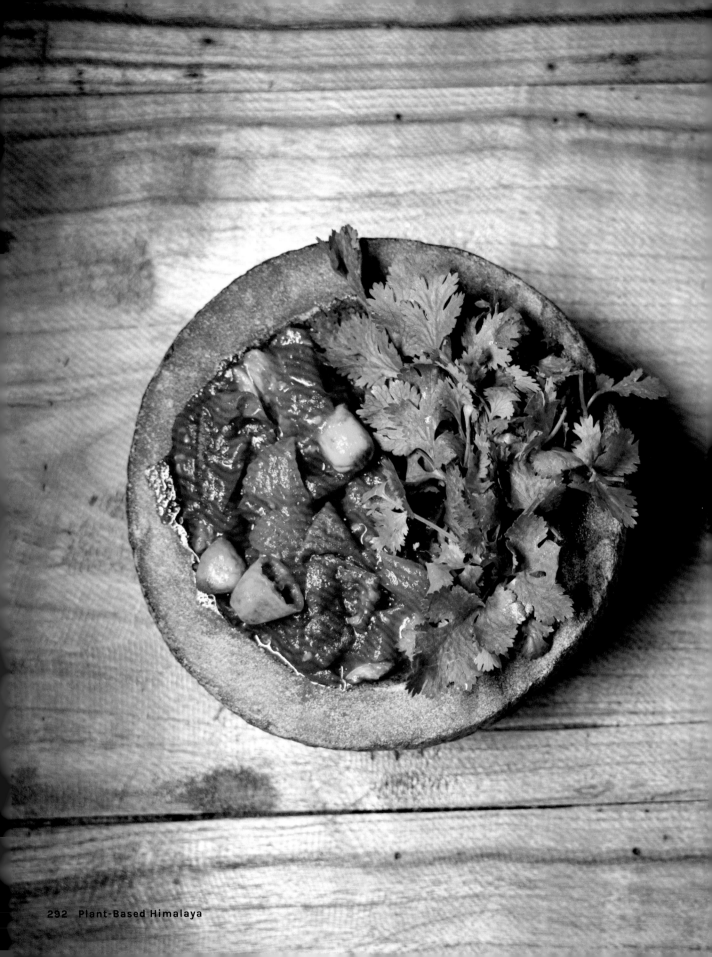

STEPS

1. Wash the tomatoes and fresh green chilis.

2. Cut the chilis and garlic cloves into half.

3. Heat a big flat pan on medium and add oil. Once the oil is hot, add chopped garlic, green chilis, and then tomatoes, in that order.

4. If you are using larger tomatoes, cut them in half.

5. Add salt, mix well, cover, and cook for 5 minutes.

6. Turn the stove off and let the tomatoes cool down.

7. In a blender, combine all the contents of the pan with fresh cilantro and timur.

8. Blend nicely so that the timur is thoroughly ground.

9. Mouth tingling timur ko achaar is ready to serve.

QUICK TIPS

- *I make timur ko achaar especially with my exquisite Nepali set.*

- *You can use any type or size of tomatoes for this pickle. I find small tomatoes more flavorful.*

- *I also love the taste of plain golveda ko achaar without timur (Sichuan pepper) but it definitely adds a unique Nepali flavor. Try it both ways and decide for yourself.*

- *There is not a more versatile sauce than this, and it will seriously spoil you. It can be added or paired to any dish.*

- *I love putting this mood boosting and spellbinding spice in every possible dish. Timur adds amazing flavor to any simple recipe.*

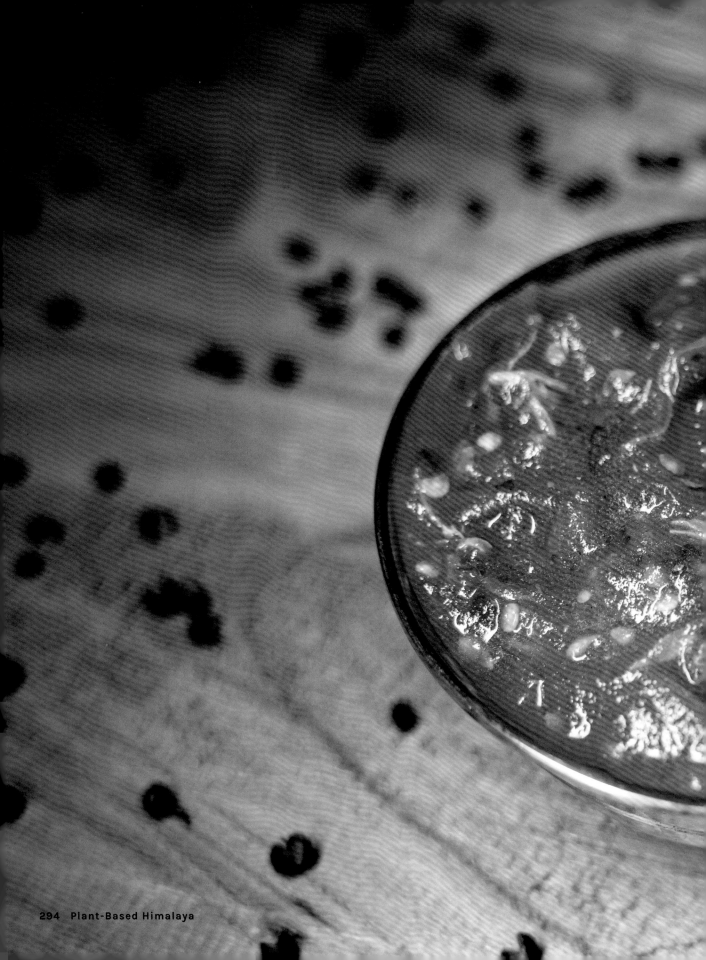

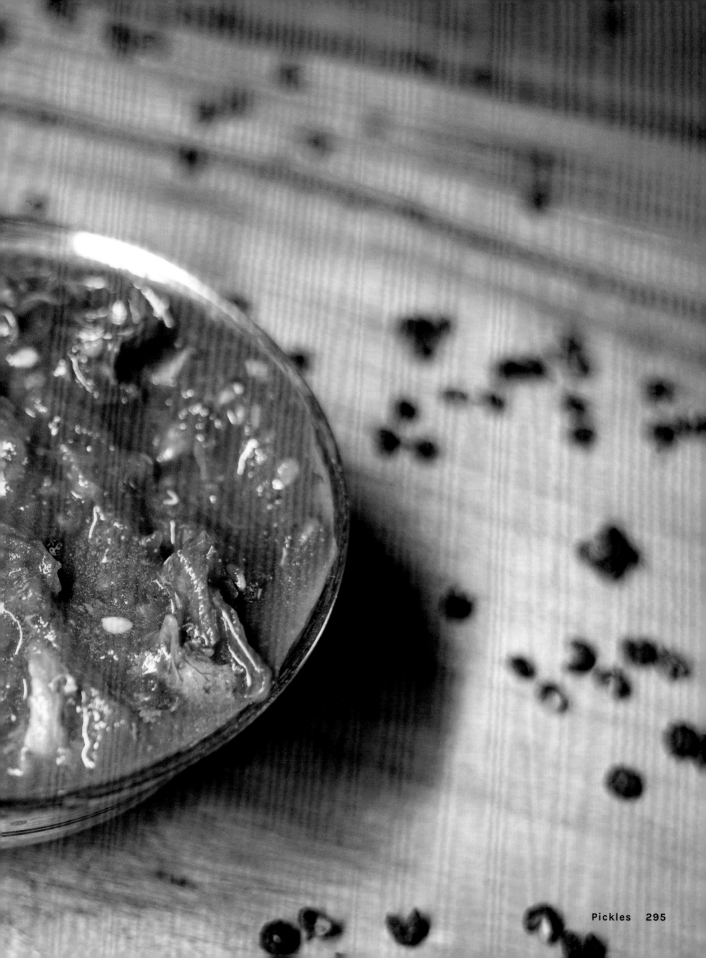

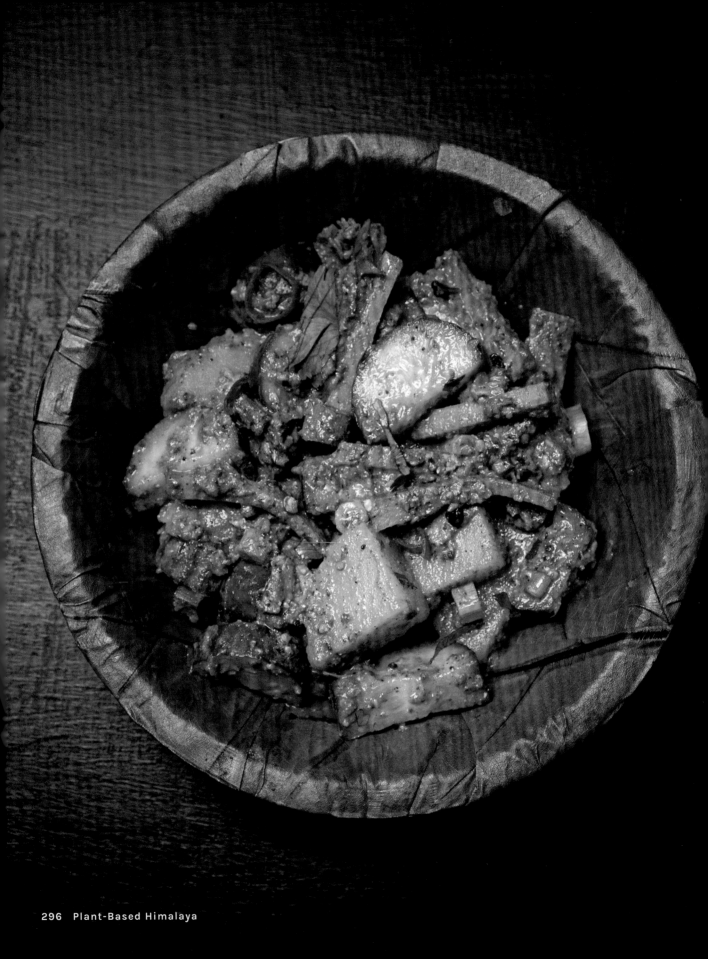

काक्रोको अचार

KAKRO KO ACHAAR

Cucumber Salad

Kakro ko achaar is a one-of-a-kind dish exclusive to Newari cuisine, and I believe my mother taught me the best way to make it. The secret ingredient in this cucumber salad is hog plum, a unique fruit that is only found in Nepal. It provides a particularly sour and tangy kick to the taste buds, especially when blended with perfectly roasted sesame seeds to create a fragrant and heavenly flavor.

SERVES ~ 6
COOK TIME ~ 45 minutes

INGREDIENTS
Cucumber: 1 lb

Carrot: 1 medium

Potato: 2 medium

Red onion: 1 small

SPICES
Sunflower oil: 2 tbsp

Fenugreek seed: ½ tsp

Turmeric: ½ tsp

Fresh green chili: 5 medium

Sesame seed: ½ cup

Dried hog plum powder: 2 tbsp

Lemon juice: 1 tsp

Ginger: 2 small slices

Garlic: 2 small cloves

Cilantro: ½ cup

Salt: 1 tsp

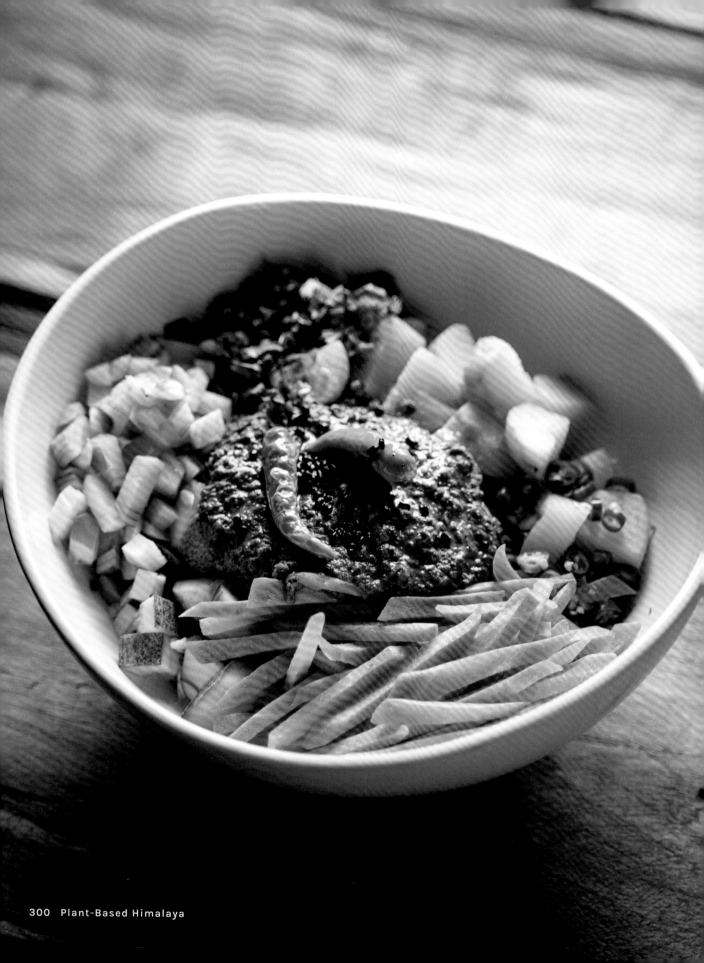

STEPS

1. Wash the potatoes. Boil them for 10–15 minutes in a pan. After the potatoes are soft in the middle, turn the stove off. Cut them in half and let them cool down. Peel and cut into small squares.

2. Wash the cucumbers, carrot, and onion. Cut them into small pieces of equal size. I usually cut carrots in long and thin slice for the crunch.

3. Take a half cup of warm water and soak the lapsi ko dhulo (hog plum powder) for 15 minutes, until it becomes softer.

4. Toast the sesame seeds in a small pan on low heat.

5. Create the sauce by blending the toasted sesame seeds, hog plum, garlic cloves, 3 fresh green chilis, salt, and a half cup of water.

6. Add the chopped cucumber, carrot, onion, potato, cilantro, lemon juice, and newly created sesame paste in a large bowl. Mix thoroughly so everything is covered with the sesame paste.

7. Take turmeric in a spoon and pour it on top of the mix. Heat a pan on low and add oil. When it is hot, temper the fenugreek seeds for a few seconds until it starts turning dark brown. Turn the stove off.

8. Cut 2 fresh green chilis in the middle and add to the oil. Pour the oil mixture on top of the turmeric and stir well.

9. I let the achaar marinate for 15 minutes and eat it fresh while it is crunchy. Unique and crowd-pleasing kakro ko achaar is ready.

QUICK TIPS

- *This recipe can be a good salad substitute. You can skip ginger, garlic, and onion for a simpler flavor.*

- *I like to mix this dish by hand to bring out a more homemade flavor. This is a very Newari and one-of-a-kind dish that is a huge hit during dinner parties.*

- *You can also add cayote (iskus) to add extra flavor. Just boil them with the potatoes and cut them to a similar size.*

- *Keep the heat low when you fry fenugreek—they can turn black quickly. Fenugreek has a bitter taste, but it is really good with a well-marinated achaar.*

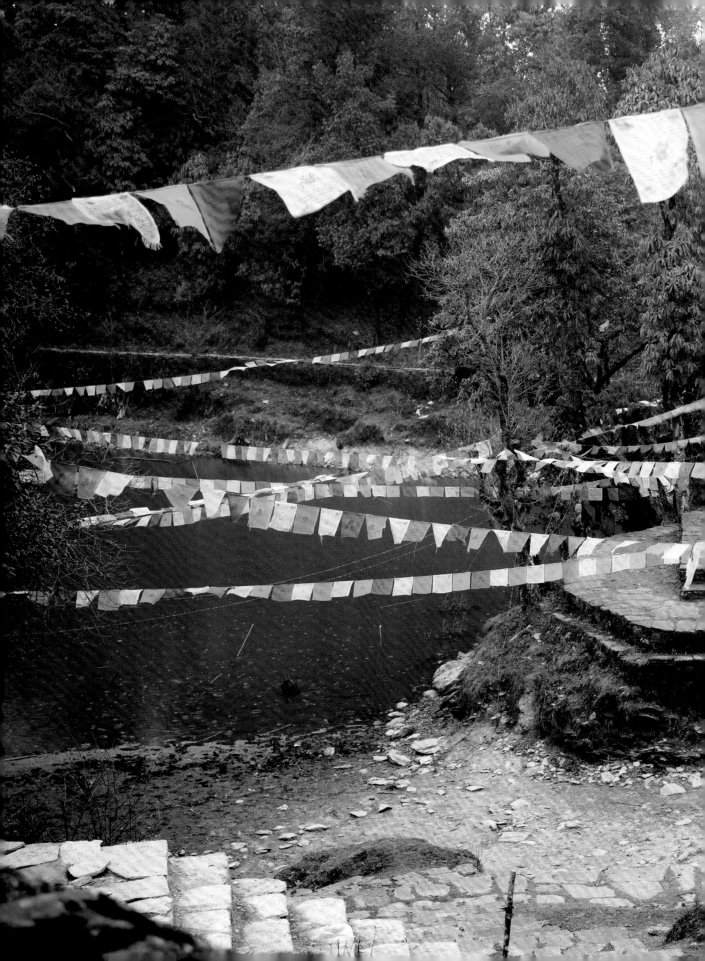

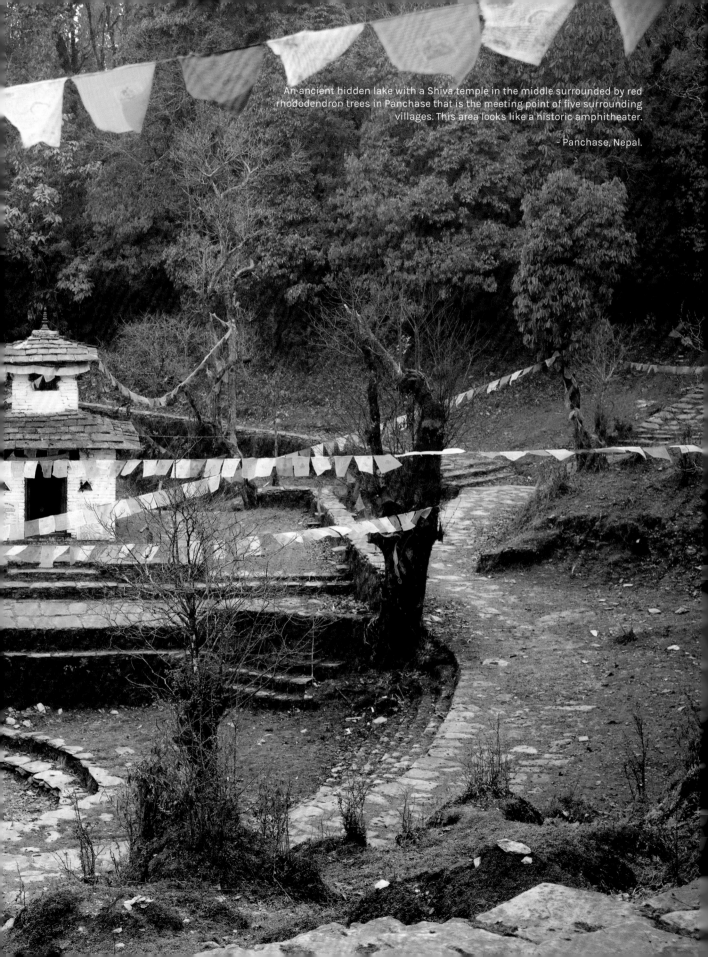

An ancient hidden lake with a Shiva temple in the middle surrounded by red rhododendron trees in Panchase that is the meeting point of five surrounding villages. This area looks like a historic amphitheater.

- Panchase, Nepal.

मिठाई

Mithai

Desserts

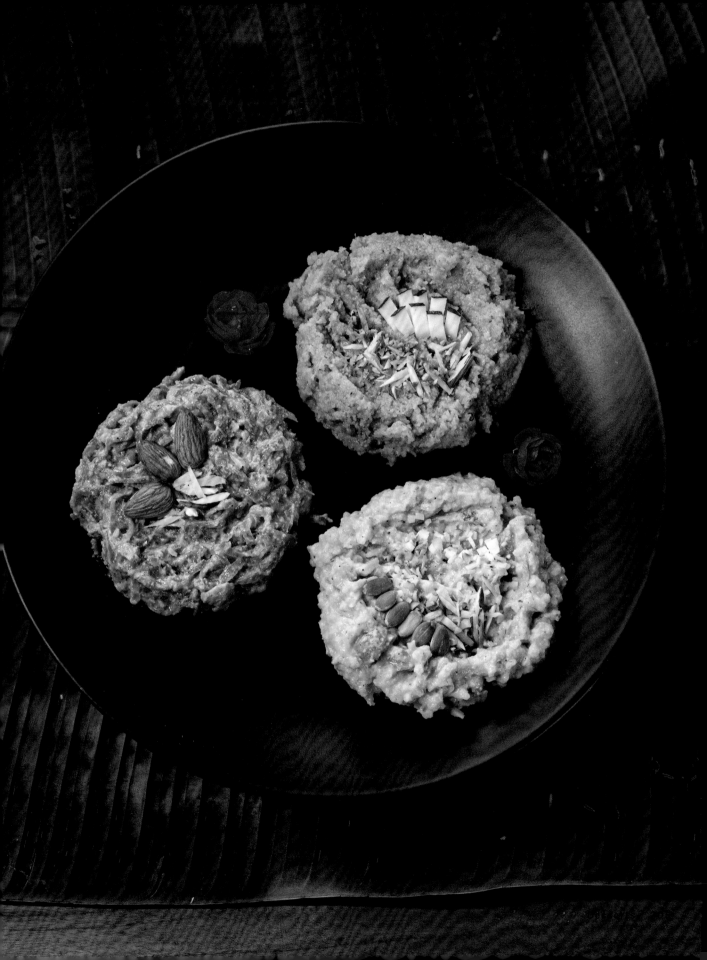

When I was a young girl growing up in Nepal, dessert was for special occasions only. We have no culture of eating sweets after lunch or dinner. Desserts are special treats during festivals or offerings for the gods. Once we are done worshiping, we eat the offerings.

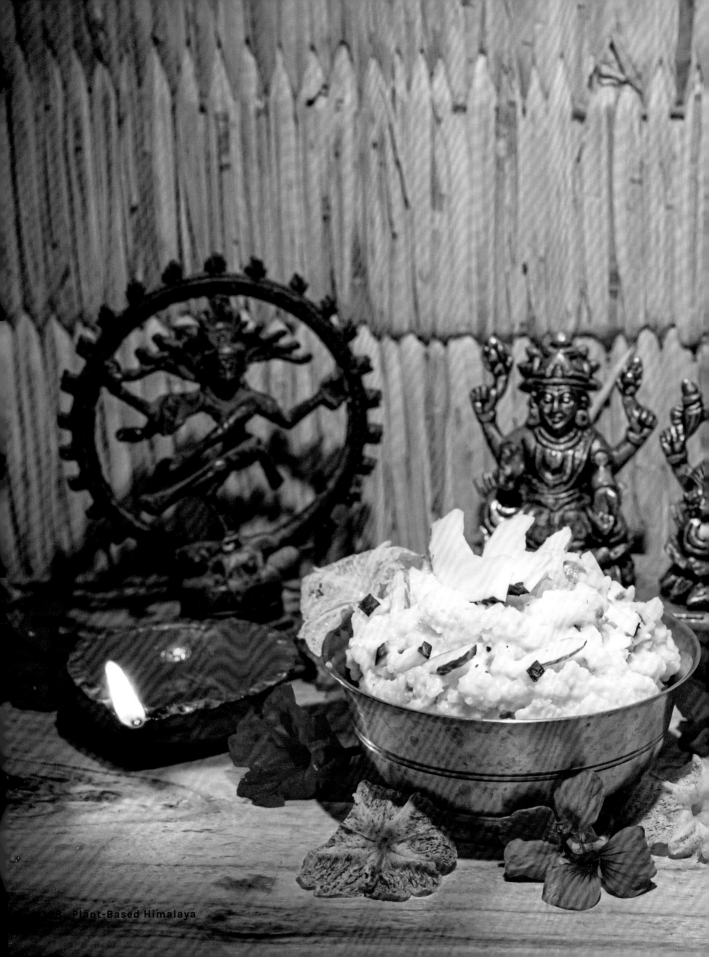

खीर

KHEER

Rice Pudding

In Nepali culture, kheer is considered to be the purest dessert and is usually offered to the gods before being served to people. The taste and creamy texture is beyond divine. Instead of the traditional buffalo milk, this recipe uses coconut milk, providing an even more luxurious and easier-to-digest alternative.

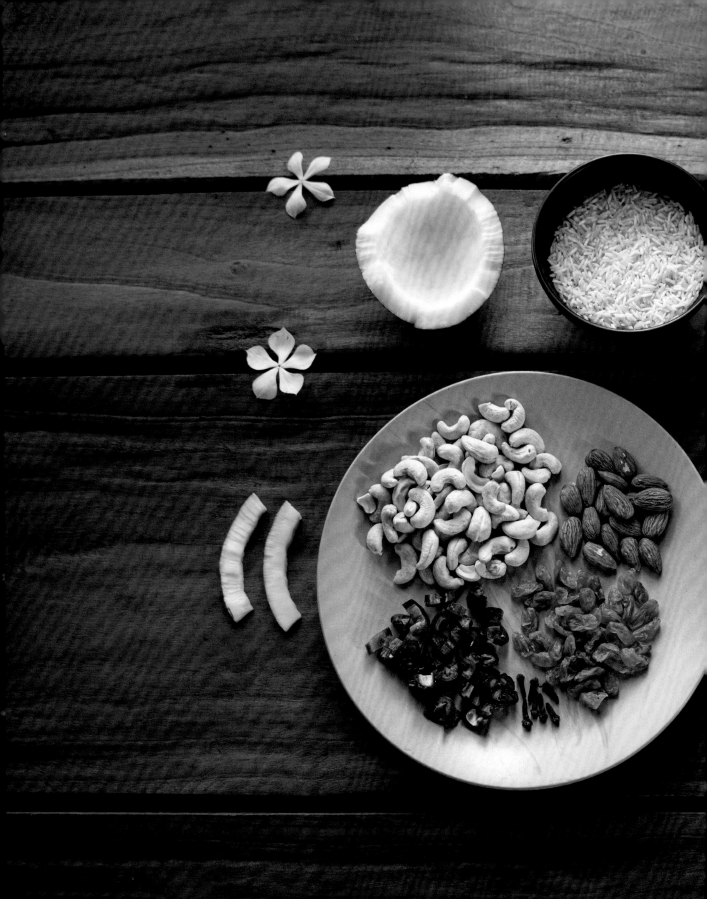

SERVES ~ 4
COOK TIME ~ 40 minutes

INGREDIENTS

Basmati rice: ½ cup

Coconut milk: 4 cups

Golden raisin: 2 tbsp

Brown sugar: 4 tbsp

Coconut: 4 tbsp

Almond: 2 tbsp

Date: 2 tbsp

Water: 1 cup

SPICES

Cardamom powder : 1 tsp

Clove: 7 buds

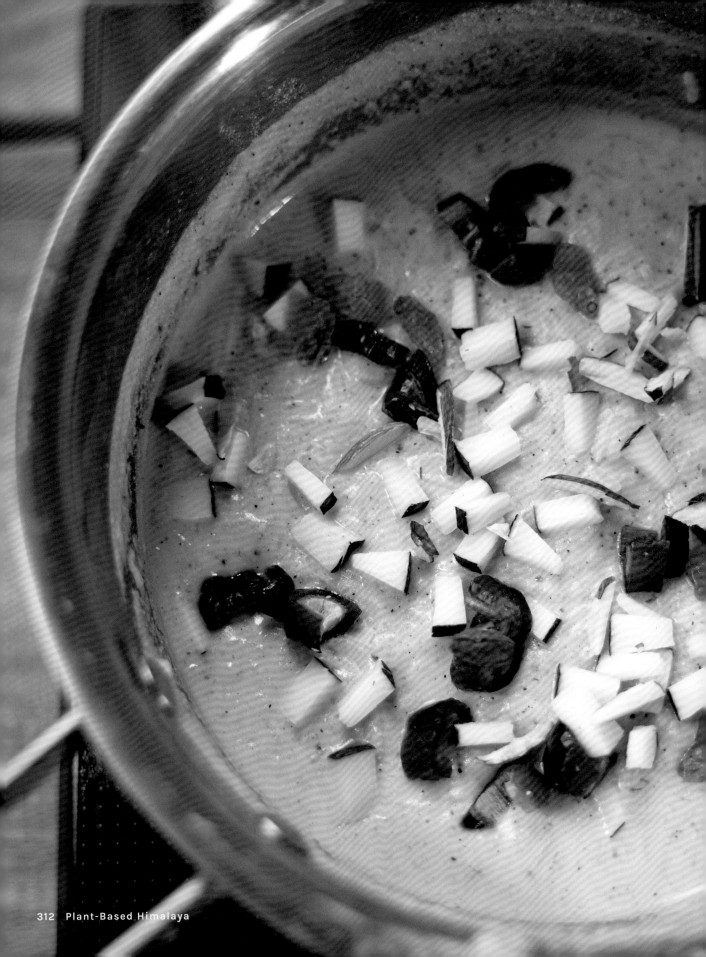

STEPS

1. Wash the basmati rice and soak for 30 minutes or more in a cup of water. I prefer to soak for a few hours if there is time.

2. Chop all the coconut, nuts, and dates.

3. Add coconut milk in a pan and boil on medium heat.

4. Add all the rice and water to the coconut milk, and then cover to cook for 2 minutes.

5. Once the coconut milk boils again, remove the lid and cook on low heat for another 2 minutes.

6. Stir and replace the lid to let it cook for 2 more minutes.

7. Add the golden raisins, dates, cloves, coconut, almonds, sugar, and cardamom powder. Stir thoroughly and cook for an additional 30 minutes on low heat.

8. Stir continuously, otherwise the rice will stick to the bottom of the pan.

9. Garnish with more chopped almonds, cashews, dates, and coconut shavings on top.

10. Creamy and blissful kheer is ready to serve. You can eat it warm or refrigerate it for few hours. I like it chilled.

QUICK TIPS

- *Kheer is by far my favorite dessert. I prefer it over ice-cream any day.*

- *It can be refrigerated for up to one week but is definitely better fresh. When you are ready to serve, heat it in a pan.*

- *I like kheer paired with seasonal fruits, especially mango.*

- *Remove any cardamom skin; otherwise it is bothersome to chew.*

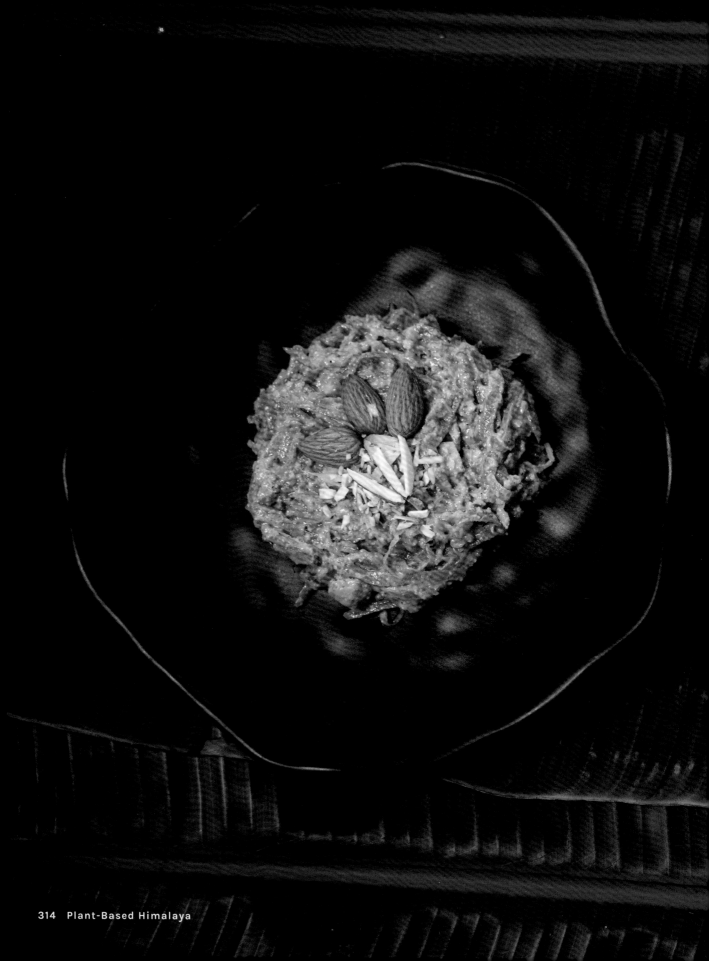

गाजरको हलुवा

GAJAR KO HALUWA

Carrot Pudding

Root vegetables may not make you think of luscious desserts, but this healthy and versatile carrot pudding is absolutely mouthwatering. You can eat gajar ko haluwa as warm pudding or even freeze it for few hours to create an ice-cream alternative. If carrots are the perfect health food, this must be the perfect dessert.

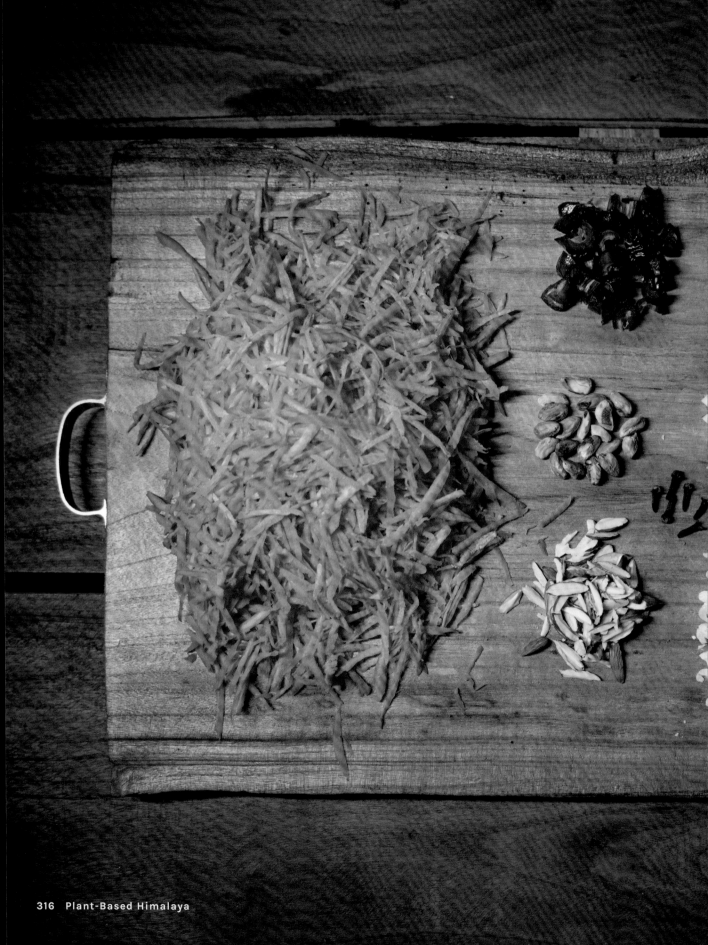

SERVES ~ 4
COOK TIME ~ 45 minutes

INGREDIENTS

Carrot: 1 lb

Cashew: 1 cup

Golden raisin: 3 tbsp

Maple syrup: ½ cup

Coconut: 4 tbsp

Date: 3 tbsp

Pistachio: 2 tbsp

Water: 1 cup

Coconut milk: 3 cups

SPICES

Coconut oil: 4 tbsp

Clove: 6 buds

Cardamom powder: 1 tsp

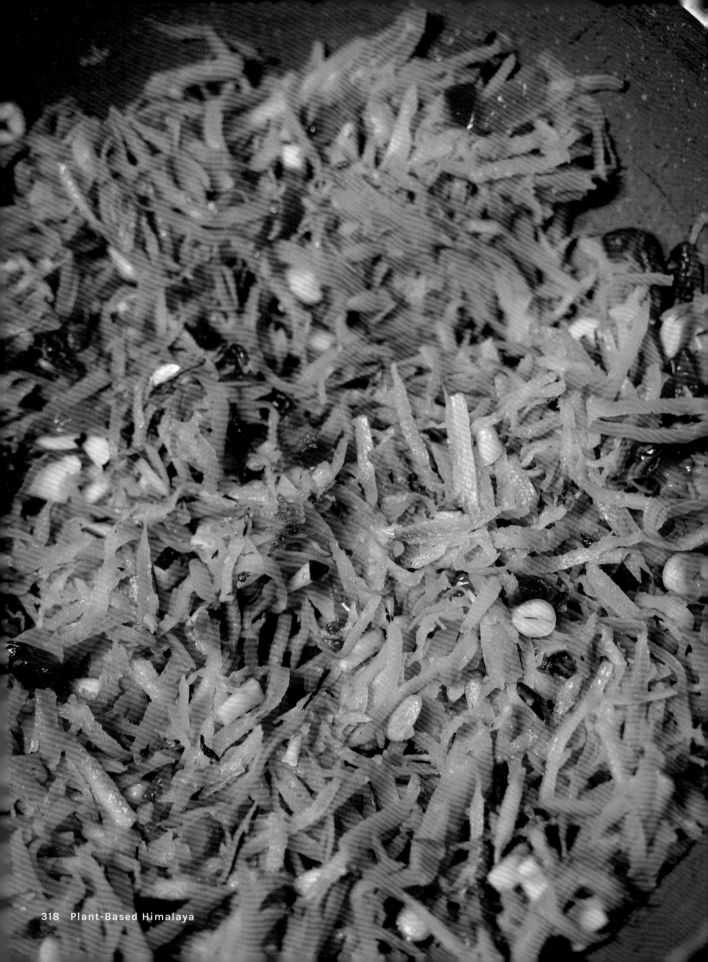

STEPS

1. Soak a half cup of cashews for 30 minutes or overnight.

2. Clean and peel the carrots, and then grate them into a bowl.

3. Chop all of the coconut, dates, and almonds as well as another half cup of unsoaked cashews. Save some to garnish in the end.

4. Heat a pan and add oil. Keep the heat low—this dish can burn easily. Add the chopped cashews, raisins, dates, almonds, and cloves to the pan. Fry until they turn slightly brown and then add the chopped coconut, mixing well.

5. Add carrots to the pan and fry them for a minute or so. Cover with the lid for 5 minutes on medium low heat.

6. Stir thoroughly and then turn the heat to low. Add a tablespoon of water if the mixture starts to burn on the bottom. Cover and cook for another 5 minutes.

7. Blend the half cup of soaked cashews, cardamom, maple syrup, and one cup of water.

8. Add coconut milk and the blended mix to the pan. Add a half cup of water to the blender to clean everything out and add it to the pan. Stir everything together.

9. Bring the heat to medium so everything comes to a boil. Cover and cook on low heat for another 10 minutes. Stir every 2 minutes.

10. Garnish the carrot pudding with chopped almonds and pistachios on top. Mouthwatering gajar ko haluwa is ready to serve.

QUICK TIPS

- ☺ *Gajar ko haluwa can be refrigerated for up to one week. When you are ready to serve, you can heat it up in a pan. I like it fresh.*

- ☺ *I love my pudding thick, so if the mix is a little too watery, heat the dish for few extra minutes and dry out the liquid.*

- ☺ *Haluwa will dry and thicken as it cools down, so cook it moist.*

- ☺ *Instead of maple syrup, you can use any sweetener or 4 tablespoon of sugar. Sometimes I also add half teaspoon of saffron with the milk for more flavor.*

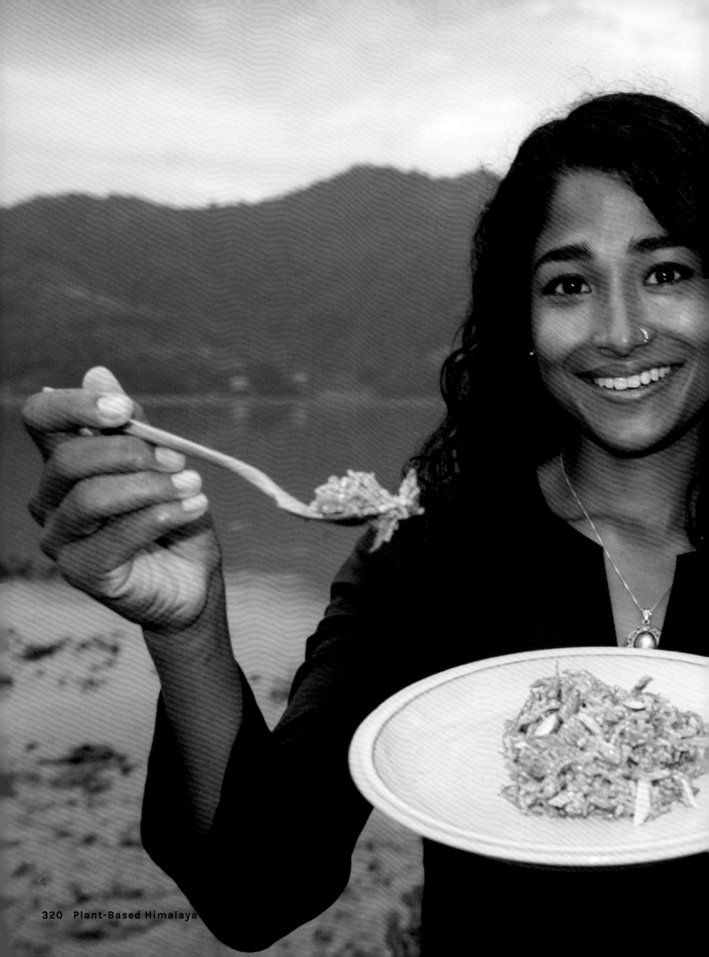

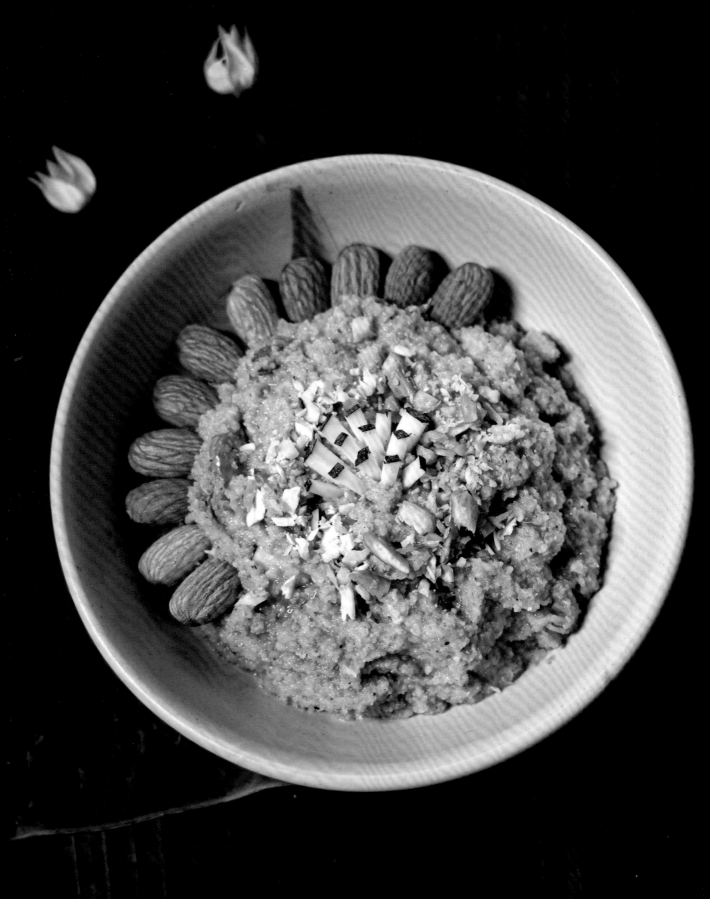

सुजीको हलुवा

SUJI KO HALUWA

Semolina Pudding

Semolina flour is most commonly used to make cakes, but this incredibly easy-to-make pudding recipe reminds me of after-school snacks. Suji ko haluwa floods my mind with childhood memories of savoring the fluffy delight on the rooftop watching my friends playing tag in the field below.

SERVES ~ 4
COOK TIME ~ 30 minutes

INGREDIENTS

Semolina flour: 1 cup

Coconut milk: 1 cup

Water: 3 cups

Sugar: 5 tbsp

Golden raisin: 3 tbsp

Fresh coconut: 4 tbsp

Cashew: 3 tbsp

Almond: 2 tbsp

Date: 2 tbsp

Pistachio: 1 tbsp

SPICES

Coconut oil: 3 tbsp

Clove: 4 buds

Cardamom powder: ½ tsp

STEPS

1. Chop the cashews, almonds, pistachios, dates, and coconut. I usually cut them into half-inch pieces, but you can do larger pieces if you prefer.

2. Heat a pan on medium and add oil. Once the oil is heated, add semolina flour and stir it continuously for 10 minutes.

3. It will start changing color to a more brown hue.

4. Turn the heat to low because once it is brown, flour can burn easily.

5. Add the cashews, almonds, dates, coconut, cardamom powder, golden raisins, and cloves then stir for 5 minutes. The semolina flour will turn into an even more beautiful golden brown color.

6. Add the coconut milk, water, and sugar to the pan. Stir everything for a minute or so then cover the pan for 5 minutes on low heat.

7. Remove the lid and cook for few more minutes to dry up all of the water. Suji ko haluwa should be a dry gravy consistency because when it cools down it becomes thicker.

8. Garnish using some chopped coconut, pistachios, and almonds on top.

9. The delicious suji ko haluwa is ready to serve.

QUICK TIPS

- ☽ *Semolina pudding brings back memories of my childhood. I used to eat this dessert as an after-school snack. It was also often offered to the gods. Traditionally, suji ko haluwa is made only with water and no milk.*

- ☽ *Suji ko haluwa must be the cheapest and tastiest dessert ever. If you don't have any spices, it will still taste great with just semolina flour and sugar.*

- ☽ *You can also replace the sugar with maple syrup or your favorite sugar alternative. I love adding jaggery too.*

- ☽ *Use cardamom powder or grind 6 fresh cardamom seeds with a mortar and pestle for extra richness in fresh flavor.*

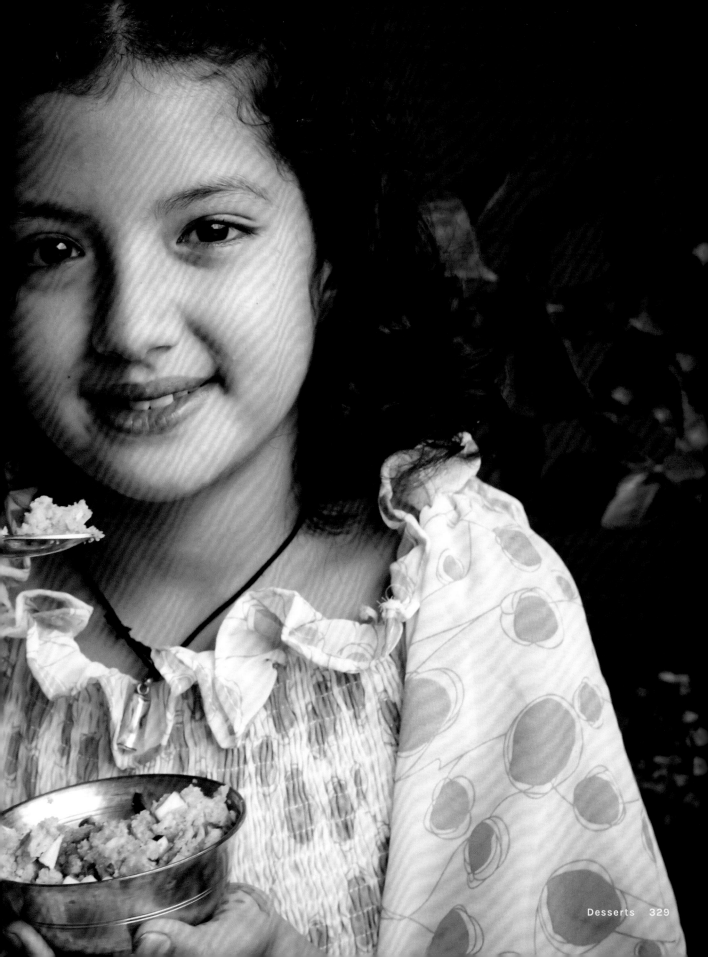

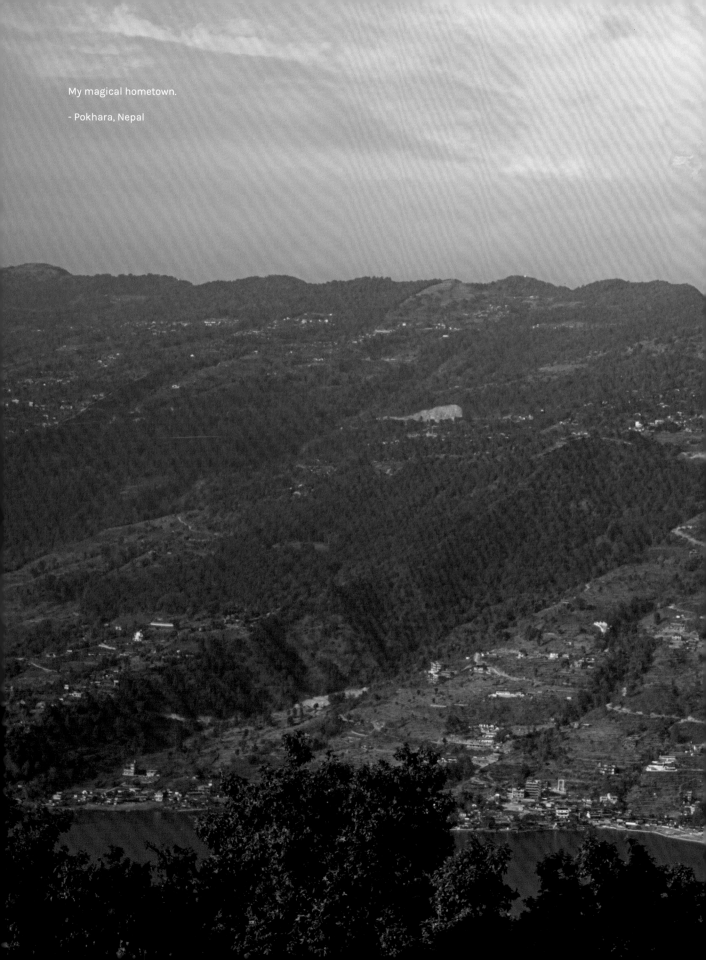

My magical hometown.

- Pokhara, Nepal

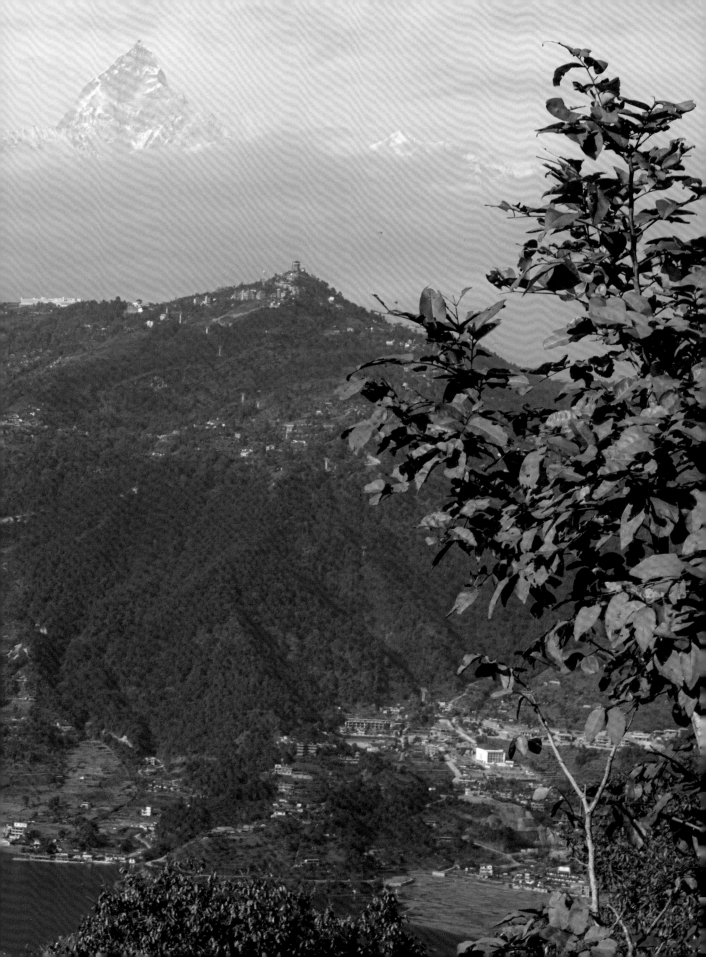

INGREDIENT SUBSTITUTIONS

Eating local, seasonal and fresh is very important to me, but I understand this can be difficult sometimes. You might not find all the ingredients I mention in some of my recipes because of the time of year or your location. Do not worry though, here are some alternatives and suggestions.

Bamboo shoot: i prefer to find fresh bamboo shoots, but if you are using canned bamboo shoots, wash them with water before cooking.

Black salt: it can be replaced by Himalayan pink salt or even table salt if that's all you have.

Coconut: i prefer to use fresh coconut for my desserts. Fresh coconuts are really juicy and milky with rich flavors compared to dried. But if there are none to be found, you can use dried or shredded coconut.

Coconut milk: soy, almond, and oat milk are my favorite substitute.

Dried hog plum powder (lapsi): hog plum can be found only in Nepal. It tastes sour and is used to add a sour tang to cucumber salad. It also has a unique flavor and texture when blended with other spices. Therefore, I highly recommend you order some online. If this is not an option, add lemon juice or anything with limey flavors.

Fenugreek seed: this spice has amazing flavors and is a key ingredient to bring the flavor in dumpling and cucumber salad. If you cannot find it, use cumin seed instead—it will still taste amazing!

Fresh vegetables: obviously, fresh vegetables are seasonal and depend on locality so if something from my recipes cannot be found fresh, you can use canned goods if needed.

Greens (saag): for the saag section, you might not be able to find fenugreek and pumpkin shoots where you live. Honestly, you can use any edible greens that you find locally. Some of my other favorites include kale, spinach, and mustard greens. Also, You might try growing one saag in a small flowerpot or perhaps encourage a farmer to grow these greens. Home grown always tastes the best.

Green beans: you can use any green beans available in your area.

Mixed beans (kwati): kwati is mixed beans consisting of garden pea, green mung bean, cow pea, red kidney beans, chickpea (chana), soybean, black-eyed peas, black lentils, and fava beans. If you cannot find all of these beans, just substitute with what you have. Mixed beans will still tastes great regardless of the specific beans you use. As a last resort, you can always use the canned beans available at your local grocery.

Oil: please feel free to cook with any of your favorite oils. Coconut, soybean, mustard, and sunflower are my go-tos.

Puffed rice: if you cannot find puffed rice, you can use any crunchy snack like peanuts, dried fried noodles, or chips.

Sichuan pepper (timur): this spice is difficult to find in some areas. I strongly suggest you search for it online or in a grocery spice section because it really adds a typical Nepali taste to your dish. Ground black pepper or tellicherry peppercorn could work in a pinch, but to be honest, timur has a unique flavor that cannot be replaced.

Spices: some spices like chat masala, saffron, or mustard seeds can be hard to find in some places. They can just be omitted all together or substituted with your favorite spices in your rack.

Sponge gourd: you can replace sponge gourd with any of your favorite gourds. I prefer green pumpkin and zucchini.

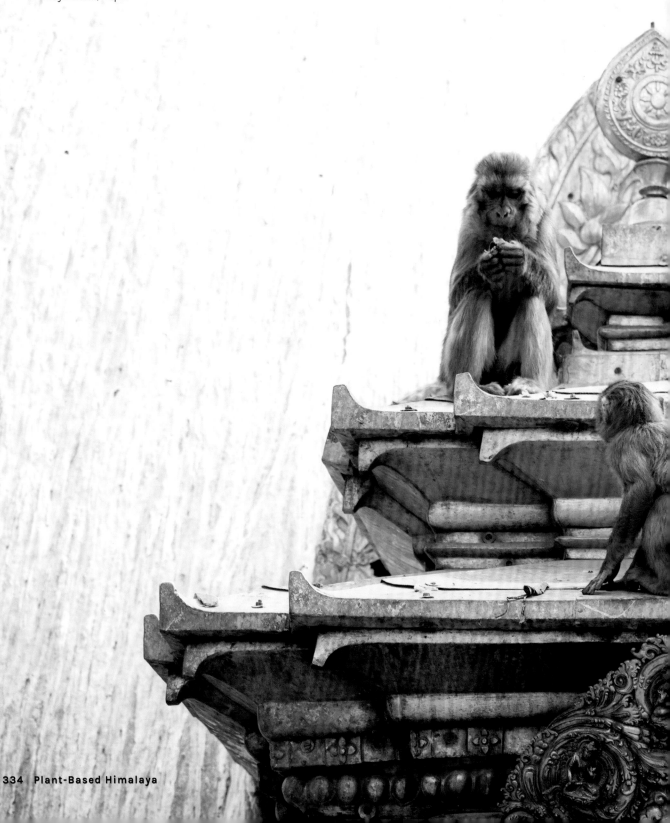

Monkeys having a quick snack next to pigeons at the
ancient World Heritage Site, Swayambhunath Temple.

- Swayambhu, Nepal

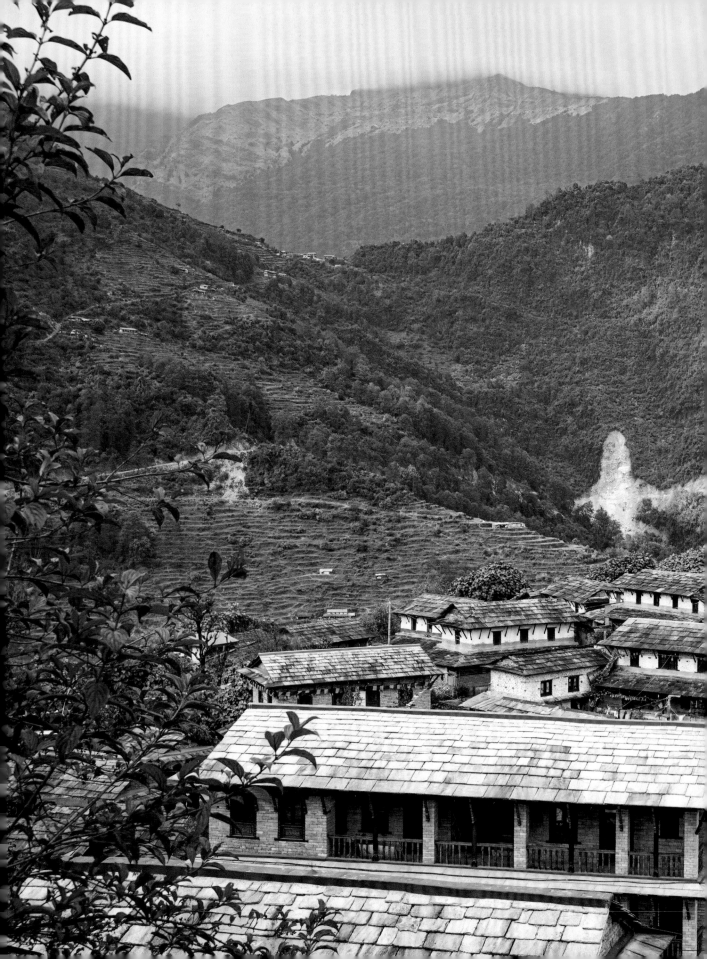

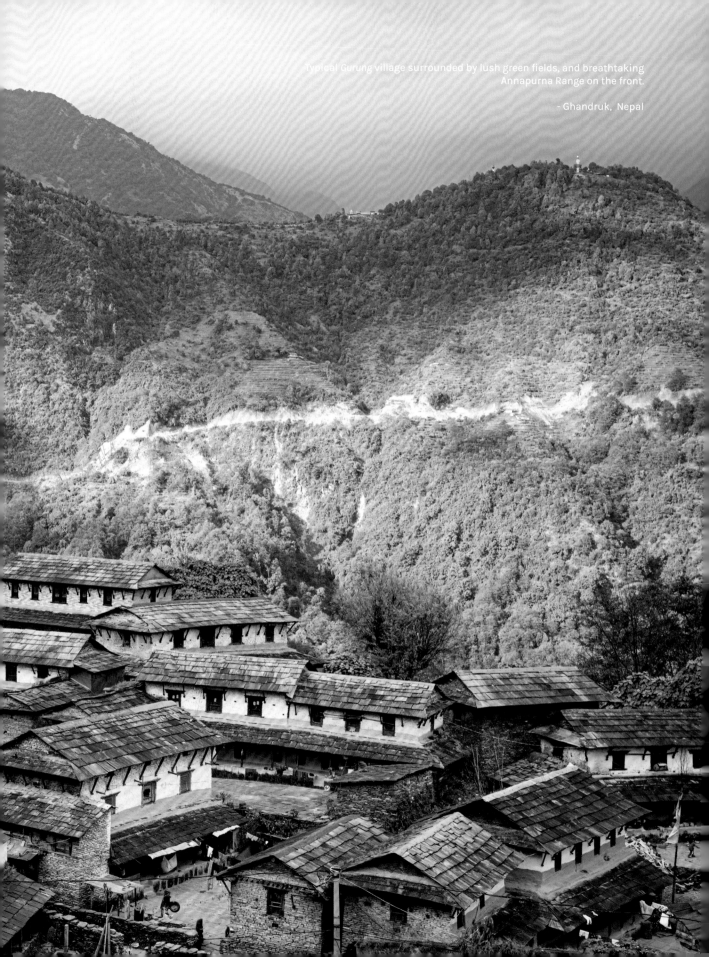

Typical Gurung village surrounded by lush green fields, and breathtaking
Annapurna Range on the front.

- Ghandruk, Nepal

ACKNOWLEDGMENTS

I'd like to start by thanking my dear husband Charles F. Moreland III for his continuous love and support and for dreaming, curating, and editing my book with me. You are the light of my life. Thank you for taking all my profile photos.

Dherai Dherai dhanyabad to my sweet and amazing sister Soni Shrestha. Because of you, I got a chance to travel Lexington, Kentucky, and start my Vegan Nepal journey. It has been a wonderful experience in my life.

Thanks to Sameer, my brother-in-law, for always being there for us.

A special thank-you to my father-in-law and mother-in-law, Charlie and Brenda, for always loving my work and motivating me to live my dreams. You have been my number-one motivators.

I really want to thank my mother for teaching me the basics of eating fresh, healthy, and spice-filled foods at a young age, a skill that I still apply in my daily life.

Thanks to all the people who loved and supported my work continuously in Lexington. You are an important part of my Vegan Nepal journey, my main motivator to go out and make delicious Nepali food.

Another thank-you to my amazing publisher Indiana University Press for putting this book out there in the world.

And most importantly, thanks to you, the reader! Thank you for choosing *Plant-Based Himalaya.* Let's cook delicious plant-based meals every day together!

Index

R

Rajma vi, 111, 115

**Dried Red Chillies 161,
173, 179, 273**

Red Kidney Beans vi, 111

Red Lentils vi, 91, 93

Region 6, 7, 11

Hilly region 6

Mountain 5, 6, 101

Scenery 6

Terai 5, 7, 267

Rice Crispies 251

Rice Pudding vii, 309

Root Vegetables 11

S

Saag 190, 192

Farsi Ko Munta 215

Fenugreek Greens vii, 195

Greens vii, 190, 195, 209, 211

Methi vii, 195, 199

Mustard Greens vii, 209,
211

Pumpkin Leaves vii, 215

Rayo vii, 209

Salad vii, 249, 257, 297

Sauce vii, 283, 289

Golveda ko Achaar 81, 95,
131, 149, 163, 187, 199,
205, 219, 261, 267, 283,
287, 293

Tomato Sauce vii, 283

Seasons 10, 16

Monsoon 10

Weather 6, 10

Semolina Flour 325

**Sesame Seeds 259, 285,
299**

Simi 145, 147

Snacks vii, 222

Aaloo Bhujiya 271

Aaloo Fry vii

Bara vii, 16, 235, 239, 349

Bharta vii

Black Lentil Pancake vii,
235

Chatpatey vii, 16, 249, 253

Dumpling vii

Fried Potatoes vii, 271

Khaja 222, 224

Mashed Eggplant vii, 243

Momo vii, 16, 227, 231

Pakaura vii

Potato Salad vii, 257

Puffed Rice Salad vii, 249

Sandheko Aaloo vii

Vegetable Fritters vii, 263

Spices

Ayurvedic vi, 11, 41

Bay Leaves 107, 113, 167

Black Pepper 29, 43, 113,
179, 185, 265

Cardamom 29, 31, 55, 113,
121, 173, 311, 317, 325

Chat Masala 251

Cilantro 55, 93, 107, 113, 121,
129, 141, 147, 153, 161,

167, 173, 179, 185, 229,
245, 251, 259, 265,
273, 285, 291, 299

Cinnamon 29, 55, 113

Cloves 29, 39, 43, 55, 57,
107, 113, 115, 121, 129,
141, 147, 153, 161, 167,
173, 179, 185, 197, 211,
217, 229, 245, 259,
265, 287, 293, 299,
301, 311, 313, 319, 325

Coconut Oil 55, 107, 121, 141,
167, 173, 245, 325

Cumin Seeds 43, 113, 121,
129, 141, 147, 153, 161,
167, 173, 179, 185, 197,
245, 259, 273, 285

Fenugreek Seeds 259

Fresh Green Chilli 93, 121,
203, 211

Fresh Green Chillies 129,
141, 147, 153, 161, 167,
173, 179, 185, 197, 217,
229, 251, 265, 273,
285, 291, 299

Garlic 93, 107, 113, 121, 129,
141, 147, 153, 161, 167,
173, 179, 185, 197, 203,
211, 217, 229, 245, 259,
265, 285, 291, 299

Ginger vi, 29, 31, 35, 37, 39,
43, 99, 107, 113, 121, 129,
141, 147, 153, 161, 167,
173, 179, 185, 197, 217,
229, 237, 245, 259,
299

Lime 57

Mustard Seeds 161

Salt 55, 71, 79, 93, 99, 107,
113, 121, 129, 141, 147,

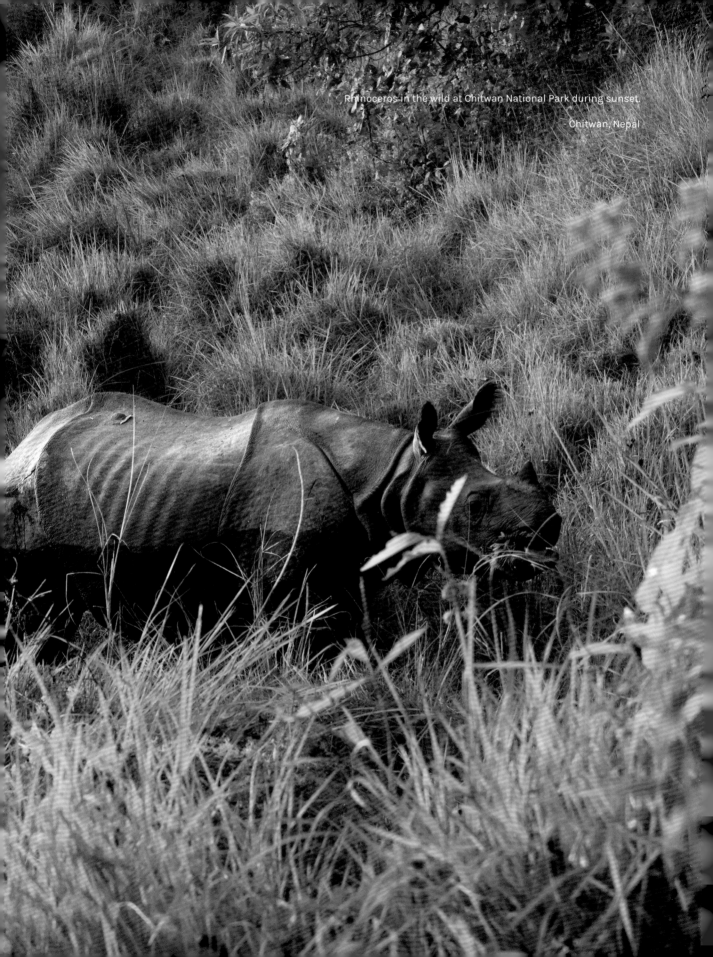

Rhinoceros in the wild at Chitwan National Park during sunset.

- Chitwan, Nepal

ABOUT THE AUTHOR

Cooking is my inspiration to make art, and it is where I find joy. I grew up with my grandfather and younger sister in Kalaiya, a remote village situated in Nepal's Bara district. Helping my grandfather in the kitchen is where I learned basic cooking skills and discovered my lifelong devotion to savory sustenance.

I moved to the metropolitan city of temples, Kathmandu, at the age of twelve to live with my parents. It is there I had the opportunity to cultivate my culinary techniques with my mother. Aama (Nepali for mother) cooked many delicacies from different parts of Nepal and India. She is a first-generation Nepali-Indian who often worked as a private chef. At that time, those chefs were viewed more as servants than artisans, as they are known today.

Years later, a deteriorating political situation in Nepal and my interest in the visual arts led me to study graphic design and photojournalism in the United States. Previously, I was acquainted only with Nepali and Indian fare. As an international student living with people from around the globe, I expanded the scope of my eating habits to include different cultural dishes. The decade I spent in the United States opened my eyes to endless possibilities in culinary artistry.

Creating recipes has always been an integral part of my life. After converting to veganism in 2016, I became even more passionate about cooking delicious and healthy, plant-based meals. Combinations of ingredients that I had never imagined in the past became more common in my daily life.

My personal cooking journey started more than twenty years ago, so if you fail a couple of times when trying to cook a new recipe, it's all right. You will get better with time. The key to success is to never stop cooking! Good food will heal you from inside and help shape your life for the better.

Plant-Based Himalaya is my love letter to Nepali cuisine and to you. My hope is that you will enjoy this book, savor the dishes you create with it, and experience the bliss of a sublime meal made with compassion.

—Babita Shrestha